ILSE BING: PHOTOGRAPHY THROUGH THE LOOKING GLASS

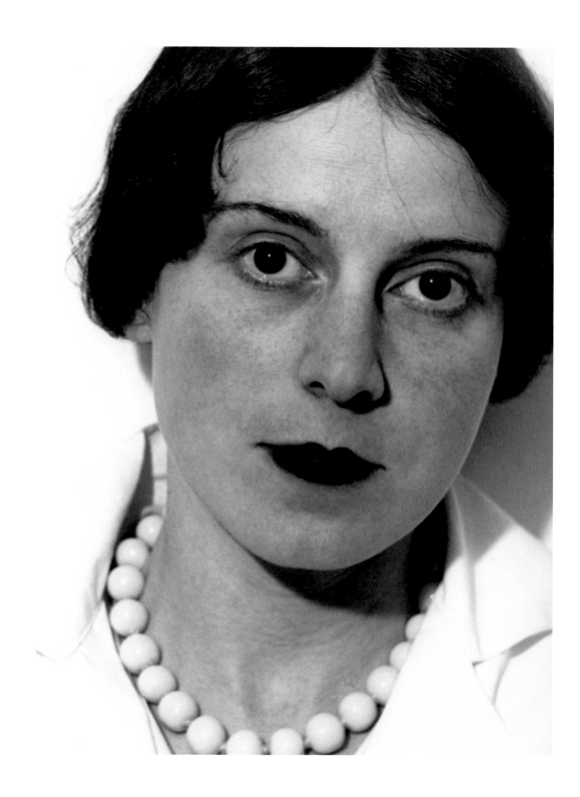

Self-Portrait, Paris, 1931

ILSE BING

PHOTOGRAPHY THROUGH THE LOOKING GLASS

BY

LARISA DRYANSKY

PHOTOGRAPHS EDITED BY

EDWYNN HOUK

ABRAMS, NEW YORK

CONTENTS

INTRODUCTION

Celebrated in her day as the "Queen of the Leica,"[1] the German-born photographer Ilse Bing is famous for pioneering the use of the 35 millimeter camera in Paris in the 1930s. She was indeed one of the first professional photographers to use the novel small-format camera in what was then the thriving world center of photography, and one of the very few who relied on it exclusively.[2] Her unrivaled technical command of the Leica enabled her to experiment with amazing freedom. Bending the mechanism of the camera to her imagination and sensibility, she produced in an era of spectacular photographic creativity a singular body of work in which the document is always the gateway to poetry, in which the rigor of composition is always enlivened with the spontaneous rush of life. While she absorbed the influences of the major artistic movements of the period—the Bauhaus, Surrealism, the New Vision—Bing's innovation was the particular delicacy of her pictures. Freed from the constraints of "good" photography, these images seem to be made of the stuff of dreams.

Never limiting herself to one genre, Bing trained her camera on people, architecture, fashion, and landscapes alike. Produced during the golden age of the illustrated press, her images adorned the pages of popular newspapers, the vanguard of art magazines such as *Arts et métiers graphiques* and *L'Art vivant*, and the glamorous issues of *Harper's Bazaar*. They appeared prominently in landmark exhibitions held at established institutions such as the Musée des arts décoratifs in Paris and the Museum of Modern Art in New York, and in avant-garde art galleries such as the Galerie de la Pléiade and the Julien Levy Gallery in those same cities.

Paris in the 1930s was a visual feast, and Bing delighted in depicting its many beauties: the cool elegance of classic monuments, the unexpected poetry of a torn poster on a peeling wall, and the glow of dance halls and street fairs. The enchantment of her photographs transcribes the city's magical aura, which the young woman sought out in every quarter, from the most splendid to the most humble. The stark reality of war, however, brutally jolted her out of her dream. Exiled in New York, she painfully started on a second life and career. The stone and concrete splendor of the American metropolis struck a dryer, more stringent chord that resonated with the echoes of the conflict. The world felt emptier and the excitement surrounding photography was on the wane. In 1959 Bing gave up the camera for good, after having switched to the Rolleiflex, experimented with color, and then briefly taken up film. For nearly twenty years her work remained completely

buried, and she lived on in obscurity, shampooing dogs for a living, until, at age seventy-seven, her photographs were brought to light again. The next two decades were for Bing a time of renaissance. Her work rose to new prominence and achieved international recognition through numerous exhibitions and publications. Famous again, she died in 1998 at the age of nearly ninety-nine.

Unearthed in the mid-1970s, as part of the general rediscovery of the photography scene of the 1920s and 1930s, Bing's oeuvre quickly won new acclaim. As exemplified by the iconic *Self-Portrait with Leica*, shot in 1931, the photography of Ilse Bing epitomizes both the advent of a new art form and the spirit of an age. Central to her work, the Leica was quintessentially a prop of modernism. The first of the small-format, 35mm cameras to be produced on a large scale, it appeared on the market in the middle of the 1920s. Light, handy, unobtrusive, it made the fantasy of the camera eye as an extension of the natural eye a reality, revolutionizing the practice and the art of photography. Seminal in the growth of photojournalism as a genre, it ushered in at the same time the modern definition of photography as the art of capturing passing epiphanies in the flow of reality.

Identified with this turning point in photography, Bing's life and work is also inseparable from the emergence of a new and significant figure: the woman photographer. In the period between the wars, several women not only became professional photographers but also achieved recognition as important pioneers in the art of photography.[3] Along with Germaine Krull, Florence Henri, Dora Maar, Margaret Bourke-White, Dorothea Lange, and Berenice Abbott, to name but a few, Ilse Bing was at the forefront of the photographic revival of the 1920s and 1930s. Not content with breaking the mold of society, these women opened up new paths in their art.

On a deeper and more personal level, the camera represented for Bing the magical key to the accomplishment of her most cherished wish: the dissolution of the border separating reality from dreams. To her, photography's unmatched ability to seize moments in time was ideally fit to convey what she saw as the evanescent nature of reality. In the ever-moving spectacle of existence, her eye, still affected by the visions of childhood, disclosed instants of pure fantasy. Thus, staring into the viewfinder of her toylike camera, she found not a mere mirror image but the very way to penetrate through the looking glass. There she disclosed a world of wonder that captures the imagination of the viewer to this day.

THERE WAS ONCE A KING'S DAUGHTER WITH A DEEP, DARK FIRE DID HER EYES GLOW. . . .

—Ilse Bing, *Märchen* (manuscript for an unpublished fairy tale), Frankfurt, October 26, 1919[1]

FRANKFURT

EARLY YEARS

AWAKENING

The green and quiet Westend section of Frankfurt is a lovely example of the type of oases the bourgeoisie created for itself in the booming cities of turn-of-the-century Europe. On the fringe of the town's bustling and crowded center, the streets of this neighborhood are lined with elegant town houses gracefully skirted with small gardens and decorative gates. It was in one of these comfortable nests that Ilse Bing was born on March 23, 1899.[2] Her father, who went by the stylish French name of Louis—worldlier than the German Ludwig—was a tradesman. The family belonged to Frankfurt's important Jewish community, a defining element of the city's history since the Middle Ages.

Reasonably wealthy, the Bings lived the typical life of their class with summer trips to the Tirol and winter evenings at the Frankfurt opera, whose façade seemed to the poetic imagination of the child Ilse to glow with "a silver gray shimmer."[3] Exquisitely receptive to sights, sounds, and smells, the little girl gained in her childhood a treasure trove of sensations that would permanently mold her worldview. Thus at the age of eighty-three Bing could still conjure up particular impressions of her father's study, "the smell of the ink and the rustle of the writing paper" while Louis Bing wrote "letters and numbers which [she] did not understand," and the vision of "the reflection of the light in [this] room," which "penetrated to [her]/through the translucent panels of the door."[4]

Both Ilse and her older sister, Alice (also called Liesl, born in 1896), received solid educations. From 1906 through 1916, Ilse was a student at the Elisabethenschule girl's school where she earned good grades in history, mathematics, physics, chemistry, gymnastics, and religion. Raised as a Jew, Ilse practiced her religion mainly as a social rite, as suited a daughter of Frankfurt's largely secularized Jewish middle and upper classes.[5] Eager for a higher education, she completed her training at the Schillerschule, which was then the only school in Frankfurt where girls could prepare the Abitur, the diploma necessary for enrollment at the university.[6] Displaying a definite taste for abstraction, at twenty-one Ilse went on to the University of Frankfurt to study mathematics and

science. In her textbooks, however, alongside dry geometrical problems she also scribbled poems and fairy tales full of a yearning, creative urge.

Ringing with impassioned and romantic tones, these texts tell the story of an awakening. In the *Märchen*, or fairy tales, which are a serious German literary genre, the recurring main character of a melancholy princess with dark eyes reads as the double of the author whose black, intense gaze always remained her most striking feature. In the poems, on the other hand, the young woman, giving way to a mood of introspection, often evokes the figure of Narcissus.

Self-representation interested Bing as early as her first recorded photograph. This self-portrait, dated 1913, when Bing was fourteen, is the first example of a theme she would return to repeatedly throughout the three decades of her professional career as a photographer. She shot this portrait with a Kodak box, which her uncle gave her as a birthday gift.[7] A basic roll-film camera, with a fixed focus and speed, the Kodak box was the first mass-produced amateur camera. Launched in 1888, it was marketed with the slogan: "You press the button, we do the rest." For the young Ilse Bing, as for other budding photographers, the childlike simplicity of the process, which did away with cumbersome technical problems, made it possible to concentrate on capturing candid moments of everyday life.

This spontaneity enlivens Bing's self-portrait, in which she wears a simple smock, her hair hanging loose as she poses casually in a bedroom, slouching over a dressing table with her feet carelessly resting on a chair. The décor, a quintessential bourgeois setting of the 1910s, is the interior of the apartment at 30 Cronbergerstrasse, where the Bing family moved in early March 1913,[8] a few weeks before Ilse's fourteenth birthday. Thus, this image commemorates not only the gift of a camera but also the dawn of a new life in what was to be the Bings' permanent home from then on. More specifically, the photograph reveals a careful composition that points to a precocious mastery of artistic expression.

Playing with the notions of reality and appearance, the photograph features the young girl's likeness captured indirectly through its reflection in a mirror. The picture is organized around the recurring figure of the frame. The panels of the closet on which the mirror is set frame the girl's image. Clearly designating the reflection as a mere image, this frame in turn beckons to the framed picture—perhaps a photograph—also appearing in the mirror, on the table, right next to the box camera. The latter memento, along with the framed paintings on the wall behind, completes the allusion to the fictitious nature of what we are seeing. The figure of the frame as a key element of composition also contributes to the distinctive two-dimensional aspect of the photograph, which calls to mind the shallow depth of field favored by the likes of James McNeill Whistler and the *Japonistes*.

Art was an early and important preoccupation for the young Ilse Bing. A text she wrote a few years later, in 1919, when she was twenty, throws some light onto the awakening artist's mind and soul. The manuscript, entitled *Art in Man's Life* (*Die Kunst im Menschlichen Leben*), finds the key to art in a harmonious fusion of the intellect and feeling, which in her conclusion Bing likens to a mystic experience. For Bing, the questioning of the nature of art was inseparable from a deeper

interrogation on the definition of the self. This existential quest, at the core of Bing's fairy tales and poems, gave rise in her early student years to several speculative texts, including an attempt at explaining the relationship between "I" and "Thou" (*Ich* and *Du*) on the model of the law of gravity.[9] In the young woman's own precarious equilibrium between her natural aptitude for science and her profound love of art, the balance was tipping in favor of the latter.

By 1922 Bing had permanently switched her studies from mathematics to art history. First at the University of Vienna, then at the University of Frankfurt, her curriculum included a classical survey of Western art from antiquity through the eighteenth century. The Italian art of the Renaissance was a fundamental chapter of the course, which Bing further explored during a trip to Florence and Rome in the spring of 1924. However most of the emphasis was put—significantly in these postwar years—on German art and civilization. The portion on the German Baroque inspired the topic of Bing's doctoral dissertation, which she began in 1926: a study of the work of the late eighteenth-century architect Friedrich Gilly.

Gilly's neoclassical style developed against the enduring background of the northern Baroque. The transitional nature of his oeuvre had a particular resonance for Bing. To her, indeed, he retained the Baroque "feeling for infinite space in all directions" while developing a new conception of space in which this movement was "frozen."[10] The tension between the dynamism of motion and the stillness of representation was to be a defining concern of the photographer. In the same way, Bing found in Gilly's designs an "abstract quality [that] brings him close to our time."[11] Inspired by Johann Joachim Winckelmann's pioneering studies of ancient Greek art, Gilly became the promoter of "an architecture of elemental geometric forms represented in an abstract, linear drawing technique."[12] This geometric sense of composition, which Bing also learned from her training in mathematics and science, would become a constant of the photographer's style. Like Gilly, who received the combined influences of Romanticism and Classicism, Bing as a photographer would strive to inscribe the *Sturm und Drang* of motion and feeling into a pattern of pure and noble lines.

The preparation for her dissertation was a turning point, coinciding with her first steps into an artistic career. To document her research on Gilly, she began to resort more and more to the camera.[13] She had already graduated sometime between 1924 and 1925 from the amateur box camera to a Voigtländer 9 x 12 cm plate camera, an apparatus renowned for its excellent lens. One of her first photographs with the new camera, as when she received the Kodak, was a self-portrait. This practice became a ritual with Bing, whose self-portraits over the years provide markers in the photographer's technical evolution. These images commemorate her transition to different types of cameras, from the Kodak box to the Rolleiflex, as well as her initial use of different photographic techniques and props such as studio lighting and the flash. Although somewhat less artistically mature than the 1913 self-portrait, the Voigtländer image attests to the seriousness with which the young woman engaged in the use of her newly acquired, professional-quality tool. Standing firmly in the center of the image, one hand resting authoritatively on her hip, Bing sternly scrutinizes her reflection in the mirror. Only the setting remains relatively unchanged from the 1913 portrait:

It is the same bedroom, probably Ilse's very own, with its somewhat constricting bourgeois décor from which photography was eventually to provide a window out onto the world.

For the time being, the art history student carried her Voigtländer through the galleries of German museums. Essentially documentary, her carefully crafted images of artifacts disclose at the same time a solid mastery of technique. More important, the meticulous presentation of the finished prints betrays the young woman's nascent artistic ambition. Usually mounted, the prints are dated, titled, and elaborately signed on the front. The conception of photography as an art form was then relatively unconventional in Bing's milieu. Based on a mechanical device, photography was considered—outside of avant-garde circles—a craft. At the turn of the century, however, a weakened form of Pictorialism had earned the new medium some level of general respectability by emulating painting. The more obvious mannerisms of the Pictorialist movement seduced the larger public and survived in the practice of professional photographers well into the 1930s. In the context of Bing's bourgeois upbringing this would have been the main point of reference as far as the art of photography was concerned.

Following this influence, Bing began producing atmospheric views of architecture and pensive portraits. Her melancholy view of the park at the Palace of Sans Souci, shot in 1927, is a typical attempt at picturesqueness. In the same way, the characteristic soft focus of her early portraits owes much to the Pictorialist-inspired style of contemporary studio photography. Moody and introspective, these images demonstrate Bing's newfound command of light. This is particularly apparent in a second *Self-Portrait with Voigtländer* in which Bing's slightly blurred profile softly glows against a background of heavy draping. The light here, warm and subdued, has a Rembrandtesque quality. A beautiful chiaroscuro also permeates the 1928 portrait of a weaver pictured at her loom, her profile cut out against the light of an open window.

A dreamy quality characterizes these early photographs. In a picture of the Frankfurt riverside promenade, known as the Schaumainquai, the photographer combines depth of field and soft focus to create a haunting dreamscape.[14] A 1929 image of a streetlight on an empty street against a backdrop of naked trees conveys the same atmosphere of reverie. Later Bing would relate these early photographic studies to the fantasy worlds of E. T. A. Hoffmann and German Romanticism, which nurtured her imagination as a child and a young woman, explaining that she "sought out what lies beneath in reality itself like the Romantics."[15] This is particularly apparent in a series of close-ups of objects that she photographed during the summer of 1929. These misty images of leaves, door handles, and a number on a gate[16] are not conceived as still lifes. Rather the caressing eye of the camera seeks, as in a fairy tale, to awaken a dormant life in these inanimate objects.

These photographs of humble details belong, in fact, to the dawn of a new existence. In May 1929 a visit to Switzerland broke the preordained pattern of Ilse Bing's academic career. The occasion was a seminar trip to the region of Lake Constance organized by the Art History department of Frankfurt University. At one point the group made a detour to Winterthur to visit the Oskar Reinhart Collection, where Bing discovered the work of Vincent van Gogh.[17] Mesmerized by the power emanating from these paintings, the young woman decided at once to abandon her studies

and follow her artistic calling: "In a split second, I knew. I decided that is Me."[18] In November 1929 she did not renew her enrollment at the university. By then she had both elected the instrument with which she would express herself for the next twenty years—the Leica camera—and taken her first steps in a new profession that would establish her in the field of photography: the fast-expanding trade of photojournalism. Leaving behind the melancholy Romantic figures of her youth, she resolutely leapt into the Modern Age.

A PIONEER OF PHOTOJOURNALISM

In the early spring of 1929, shortly before her decisive trip to Switzerland, Ilse Bing bought her first Leica. The camera, which was presented to the public in 1925 at the Leipzig Spring Fair, was still a novelty. Manufactured in the Leitz factory in Wetzlar, forty miles north of Frankfurt, it was originally conceived in 1913 to test motion-picture film. The *coup de génie* of its inventor, Oskar Barnack, was to apply this miniature camera to still photography, combining two frames of the motion-picture film to create the 24 x 36 mm format. Slowed down by the First World War, work on the camera resumed at a steady pace in 1923, when Leitz decided to launch it on the market. The name chosen for the new product was a contraction of "Leitz" and "camera." It was a short and effective name with a definite catch to it, in the same way "Kodak" was. In no way as basic as the Kodak box, the Leica did, however, seem a marvel of simplicity like the American invention. The ancestor of the 35mm cameras that became a fixture of family life by the 1950s, it heralded the mass consumption of photography.

Professional photographers, for their part, gave the new camera a cool reception. They were deterred by the small size of the negative, which they feared could not produce good quality enlargements. Used to the heavy paraphernalia of studio photography, they refused to view the tiny Leica seriously. As the photojournalist and photography historian Tim Gidal recalled, "from 1924 to 1930, [the small-format cameras] were chiefly regarded as little more than amusing playthings."[19] On the other hand, this product of high technology was expensive and out of reach for the average amateur. Despite these drawbacks, sales, which started on a modest scale in 1925, increased steadily over the next four years and doubled each year until 1929, when Bing purchased her model. That year saw only a modest increase in sales, followed by a jump in 1930.[20] A certain form of snobbery accompanied this expansion, as recorded in a contemporary deprecating reference to "well-to-do young ladies who want to kill the time on their hands with Kodaks and Leicas."[21] Taking a more detached view and studying the particular case of photography in France, the art historian Françoise Denoyelle reports that in the 1930s the Leica became the "fashionable camera whose use was reserved for the French elite."[22]

For the well-bred Ilse Bing, the Leica was much more than a social hobby. The immediate reasons for her purchase are not documented, and it is conceivable that the appeal of newness had a share in it. The fact that Wetzlar was near Frankfurt and that the Leitz product was well promoted in Bing's hometown may also have played a role.[23] The Leitz firm had an early publicist there in

the person of Dr. Paul Wolff, who operated a successful photography studio and permanently switched to the Leica in 1926. His photographs, which were praised and studied for their formal qualities, were often featured in the Frankfurt illustrated press, where they no doubt caught the attention of the young Bing.

As she later put it, photographing with the Leica represented a truly new experience. She "felt this small camera become a continuation of her eye which moved around with her; she could get things more lively with it."[24] Indeed, the 35mm camera employed a new mode of focusing that involved a direct connection between the vision of photographers and their subjects. Holding up the camera to his eye, the Leica photographer could, in the same gesture, point and shoot.[25] Although the Leica was not the first portable camera[26] to offer this particular feature, its diminutive size[27] and weight made it exceptionally easy to use. Camera and photographer, in effect, became one and the act of photographing was an almost unconscious extension of the act of seeing.

The thrill with which Ilse Bing adopted the camera is strongly reflected in her album of photographs commemorating the Frankfurt University seminar trip to Lake Constance, which followed shortly on her new acquisition. Testing the Leica's many possibilities, she tried unusual angles, tilting her camera up, down, and aslant. The resulting images combine an almost abstract sense of construction with snapshot spontaneity.

Immediacy was the Leica's first attribute. The second was the ability to construct an almost uninterrupted dialogue with reality. While the magazine of the portable plate cameras could only hold a limited number of glass plates, the Leica's three-meter long film—cut up into thirty-six frames—enabled the still photographer to shoot in a continuous flow and render an event in a process similar to that of the motion-picture cameraman. Beyond capturing a single instant of reality, photographs could be assembled to tell a story fluidly. Thus, the marketing of the Leica in the second half of the 1920s crossed paths with another important breakthrough in Germany: the advent of the modern illustrated press.

By the end of the 1920s the German illustrated press was setting the example worldwide for innovative photography and layout in ways that still affect photojournalism and magazine design today. Central to this evolution was the conception of the "photo-essay," in which pictures were combined to compose a self-contained narrative with minimal support from captions. Such photo-essays fed in turn on a new kind of photography, which was not just illustrative but truly eloquent and characterized by what Tim Gidal termed "strong human interest."[28] Whether the topic was a politician, a world-renowned scientist, or a simple citizen, the modern reportage focused on ordinary gestures of everyday life and tried to capture a sense of intimacy and naturalness. This novel approach was directly tied to the technical improvements of the portable and small-format cameras being produced in Germany. Along with the Leica, the greatest innovation in this respect was the Ermanox, manufactured by Ernemann in Dresden, whose fast lens made it possible for the first time to obtain candid images indoors with no additional lighting. In its design, however, the glass-plate Ermanox remained quite cumbersome when compared with the Leica. The major change in photojournalism came in effect from the "Leicaists," as the Leica photographers were known.

Between 1928 and 1929 a new wave of photojournalists thus emerged who broke the established patterns of the profession. For the most part, outsiders to the field of journalism and generally coming from the ranks of the bourgeoisie, these "born photo-reporters,"[29] as Gidal labeled them, were essentially amateurs. Trained in architecture, art, literature, or science, they were able to bring a strikingly fresh sensibility and creativity to their task. Contemporaries greeted the advent of "the intellectual photographer,"[30] superseding the traditional figure of the "artisan." They enjoyed accordingly a change of status. Whereas previously photo-reporters had been on staff and considered mainly as executors entrusted with illustrating a predefined subject, the newcomers were their own masters and as freelancers generally initiated their subjects. In fact, editors relied on them to submit original ideas and encouraged them to nurture their own style. The very best earned high wages and were even celebrated as "artists of the camera."[31]

The increasing financial appeal and prestige of photojournalism no doubt encouraged the proficient amateur Ilse Bing to present her own work to the local press. Her purchase of a Leica in 1929 coincided with the full expansion of the modern illustrated press as if she had consciously planned to make her way in that field. Her family's changed circumstances were probably an added incentive. Like so many members of the German bourgeoisie, the Bings had not survived the war and its chaotic aftermath unscathed. Although the family still lived comfortably, its economic situation was no longer stable.[32] It was conceivably made all the more fragile by the death of Louis Bing in the summer of 1926, an event recorded by Ilse in several photographs of her father on his deathbed. In her later years, Bing would present her first professional steps in the world of photography as a dramatic break with her conventional upbringing and her class. When she gave up her doctoral studies for photography, both her best friends and her family, she said, met her decision with shocked disapproval.[33] True, it did take daring for a young woman of her milieu to follow the reckless life of a photo-reporter, a field in which women were very few in number.[34] But here was at hand a relatively lucrative profession, which Bing, in the context of a diminished lifestyle, could practice without forsaking her education or her independence.

Her first contribution to the press was in the continuation of her academic background. This was a reproduction of a terracotta bust of the Madonna by the Renaissance artist Andrea Della Robbia. Its publication in the May 4, 1929, issue of *Das Illustrierte Blatt*—coinciding with her visit to Switzerland—provided a perfect transition between Bing's formative years and her new career. The newspaper itself was a familiar element in the Bing home.[35] Founded in 1924, it was the weekly illustrated supplement of *Die Frankfurter Zeitung*, the main Frankfurt daily. During the period of the Weimar Republic, the highbrow *Frankfurter Zeitung* was considered a herald of the liberal and intellectual bourgeoisie. Regular contributors included such luminaries as Walter Benjamin and Siegfried Kracauer—a friend and neighbor of the Bings who eventually became the paper's cultural affairs editor. Although it was in no way a religious paper, it was viewed as one of the main tribunes of the *Judenpresse*, so called because of its largely Jewish staff and readership.[36]

In keeping with the *Frankfurter Zeitung*'s high standards, the illustrated supplement boasted a distinguished roster of writers and photographers. Photographic contributors to *Das Illustrierte*

Blatt included, along with the already mentioned Paul Wolff, avant-garde photographers such as Herbert Bayer, Cami Stone, and the young Martin Munkacsi. The work of André Kertész appeared in the paper with text by Brassaï, then still an apprentice photographer. By publishing in the *Illustrierte Blatt*, Bing thus saw her name associated at once with some of the most exciting champions of the contemporary photography scene.

Bing's first published image was treated with care. It was the single illustration on the page, and the young photographer's name was clearly credited. Her second contribution, which appeared on June 8, 1929, was presented with similar attention. Its subtitle, "A photographic study by Ilse Bing," implied that the image was not a mere illustration but was, like an étude for the piano or a painter's sketch, to be considered from an aesthetic standpoint. At first sight this second photograph, which represents children in a playground, is a typical example of the candid form of reportage. A closer look, however, reveals in this spontaneous scene of everyday life a geometric sense of composition. In the same way, Bing's next "photographic study," published on August 3, 1929, transfigures the image of a towering telegraph pole, shot at a dramatic low angle, into an abstract pattern of powerful lines.

Soon after, in early October 1929, Ilse Bing produced her first full-fledged photo-essay. This reportage on a local Frankfurt custom—the tasting of the first crop of apple cider—was done on assignment, marking the true beginning of her career as a professional photo-reporter. From then on, she depicted for *Das Illustrierte Blatt* a number of themes that propelled her out of her sheltered life into the grim social realities of the times. Along with an essay on the Salvation Army, entitled "Fight Against Poverty" ("*Im Kampf Gegen das Elend*"),[37] they included a particularly successful presentation of the work done by the Frankfurt welfare office. The title of this photo-essay, "People Help Each Other" ("*Menschen Helfen Einander*"), was an appeal in itself. The picture story appeared at the end of 1929,[38] in the first stages of the economic collapse that hit Germany following the Wall Street Crash. It took the reader from the crowded waiting rooms of the welfare offices into the very homes of the destitute. The squalor of their cramped living quarters was plainly revealed as in the photograph of a baby propped up on a cupboard, trapped between a window and a stove. The assistance provided by the welfare organization was shown in simple, everyday gestures: a housekeeper sent by the office bending over a washtub in a cluttered kitchen or caring for a young mother and her newborn child. Although intimate, these images elicit neither voyeurism nor sentimentality. The lives of the poor are rendered in great detail but the photographer retains a distance when it comes to expressing their thoughts and feelings. Rigorous and sensitive at the same time, Bing's style is defined here as a potent combination of emotional restraint and bold objectivity.

At the same time that she was involved with presenting the cares of the poor, Bing was also interested in rendering the mysterious aura of humble, cast-off objects. This is particularly apparent in a photo-essay published in November 1929 on a Frankfurt floating bathhouse being dismantled for the winter.[39] Out of this item of local interest, Bing composed a richly atmospheric study in nostalgia rather than a factual reportage. She was attracted specifically to details that convey a mood of loss and emptiness. In a corner, she singled out the lonely presence of a now useless scale,

forlornly reflected in the empty pool. Her camera, roaming through the desolate décor, arranged abandoned furniture and utensils, scattered here and there, into evocative still lifes, as in the image of a metal folding chair, carelessly propped up against the wall of the former sundeck, a broom by its side and dead, crumpled leaves on the ground.

Bing's self-avowed attraction for what she termed "minor details in a banal conglomeration of things"[40]—or, more plainly said, dregs and refuse—was not unusual. At the end of the 1920s a certain aesthetic of "degradation and decay"[41] did indeed become so prominent amongst the avant-garde German photographers as to prompt a severe reaction from reviewers against this so-called "infatuation with garbage."[42] Bing's fascination for discarded odds and ends, however, attempted to sublimate the realism of her subject matter, filtering it through the recollection of childhood impressions. As a child, the photographer reminisced, she had discovered at her feet a wonderful fantasy world composed of "the pavement, the designs in the asphalt, the dead leaves."[43] In the spring of 1929, with her newly acquired Leica, she was able to materialize this particular vision in a photograph: a close-up shot of a dead leaf and a torn tram ticket lying on the sidewalk. Under the camera's almost microscopic lens, the usual sense of scale is distorted, and the leaf and the ticket thus blown out of proportion seem invested with a mysterious life of their own. This would not be the last time that Bing would train her lens on the neglected treasures of the sidewalk.

While still feeding on the child's imagination for whom "inanimate objects seemed to be alive,"[44] this particular image also reveals new, purely artistic influences. Within the frame of the photograph the objects form an abstract composition, evoking a Cubist collage. Other contemporary references come to mind, such as Kurt Schwitters's Merzbau compositions[45] or the still lifes of the Bauhaus photographer Walter Peterhans, pointing to a changing direction in the young photographer's work. The illustrated press had greeted this girl with a Leica as one of the members of the photojournalistic avant-garde. Yet her achievements in the pages of *Das Illustrierte Blatt* could not fully satisfy Bing's ambitions as an artist. All around her she could feel the bustling excitement of a thriving center of modern culture, of the "New Frankfurt" that had emerged during her student years and in which she was now impatient to take part.

THE NEW FRANKFURT

The city in which Ilse Bing started on her new life had itself undergone several radical changes, in particular in architecture. Following the war, under the energetic guidance of Ernst May, the architect in charge of all urban planning, the town of Frankfurt became a showcase of the *Neues Bauen*, the new architecture movement that flourished in Weimar Germany. The historical center of Frankfurt remained much as the photographer Gisèle Freund, Bing's contemporary, would later recall it: a labyrinth of narrow streets lined with low houses, dating back to the Middle Ages.[46] On the periphery, however, May, with the help of some of the modern movement's most radical architects, created entire new neighborhoods that carried out the most progressive ideas about social housing.

The inhabitants of Frankfurt greeted May's innovations with enthusiasm,[47] and throughout Germany the city was referred to as an example. May's ambitions, however, exceeded basic building and planning. Beyond improving the living conditions of his fellow citizens, he wished to help promote "the New Frankfurt" (*das neue Frankfurt*), a city that would be at the forefront of change not only in architecture but also in every artistic domain. This aspiration prompted him in 1926 to publish a monthly review dedicated to "issues surrounding the creation of modern forms,"[48] which he entitled, quite naturally, *Das Neue Frankfurt*.

It is against the background of this cultural renaissance that Bing developed her awareness of contemporary art. *Das Neue Frankfurt* certainly provided her with one of her first insights into the recent revolution in photography. In March 1929 the magazine released a special issue on "Experimental Photography."[49] It was a perfect summary of the avant-garde "New Photography" movement, whose groundbreaking conception of the art of photography was one of the most exceptional aspects of the intensely creative art scene in Weimar Germany. Also termed the "New Vision" (*Das Neue Sehen*), it was based on the idea that photography was an art form in its own right. Turning its back on Pictorialism, it proclaimed the break with painting as a model. There was, it decreed, no need to blur the sharp contours of reality with a soft dreamy focus, or to compensate for the mechanical nature of photography by complex retouching and printing techniques that tried to emulate the strokes of a paintbrush. The eye of the camera was believed to offer new ways of seeing and to be in itself endowed with a creative vision, which the New Photographers attempted to illustrate by exploring the camera's idiosyncrasies. Favoring extreme low- and high-angle shots, dramatic close-ups, and vantage points that upset the ordinary parameters of human vision, they carried their experimentations into the darkroom as well, working with superimpressions and montage and rediscovering the photogram.

Beyond simply transforming the art of photography, the New Vision also aimed to place photography at the vanguard of the art scene, as stated by the movement's main theoretician, the Bauhaus artist László Moholy-Nagy. In his seminal essay *Malerei Fotografie Film* ("Painting Photography Film"), published in 1925, Moholy-Nagy defended the idea that painting as it was known would be transformed by film and photography. Radical as it was, this concept had immense repercussions. Combined with the formidable expansion of the illustrated press, the spreading impact of the New Vision eventually established photography as a ubiquitous element of modern German society.

Important exhibitions helped promote the new art form throughout the country between 1928 and 1930, the most famous of which was *Film und Foto* (known as the "Fifo"), organized at Stuttgart in spring 1929. *Fotografie der Gegenwart* ("Photography of the Present Day"), a traveling manifesto of the New Photography, stopped at Frankfurt's Kunstverein in July 1929.[50] To Bing, this was again a major turning point.

She had already felt the influence of the New Photography, as revealed by the unusual angles she experimented with in several of the Lake Constance photographs. The university trip had followed shortly after the publication of *Das Neue Frankfurt*'s issue on "Experimental Photography."

Fotografie der Gegenwart, however, was the young woman's first direct contact with a large selection of works by the most influential practitioners of the new style. Seven names in particular captured her attention. These—which she studiously underlined on her copy of the show's announcement card—were Berenice Abbott, André Kertész, Eli Lotar, László Moholy-Nagy, Otto Umbehr (better known as Umbo), Sasha Stone, and, most important, Florence Henri.

Henri was no less than the New Photography's emblematic figure, and her self-portrait looking into a mirror was considered the movement's symbol. Thus, it had illustrated the introductory essay in the *Neue Frankfurt* issue on "Experimental Photography." Born in the United States, Henri had originally trained as a painter in Paris under Fernand Léger and André Lhote before joining the Bauhaus, where she first experimented with photography under the guidance of Moholy-Nagy. Her photographs reflected the purist, geometric principles of her artistic background. An essential component of this abstract style was the cool surface of mirrors, which Henri used to fragment the naturalistic space of the photograph. Her images were not meant as representations of reality but—as indicated by their generic titles—as "compositions," that is, pure works of art. In this she applied Moholy-Nagy's theory that photography as art needed to do away with the figural. Formalist in her approach to photographing, Henri, who lived and worked in Paris, relied exclusively on the view camera and stayed within the confines of the studio. In this, she was a world apart from Ilse Bing. Henri's lesson in geometry, however, found deep resonance with Bing. The abstraction of her mirror compositions would soon influence Bing's most celebrated photograph, the *Self-Portrait with Leica*. But most of all, it was to Henri's milieu that the young woman felt herself irresistibly drawn. Looming behind Henri's photographs was the magical allure of the City of Light. This, Bing knew, was where she would fulfill her artistic aspirations. Another year would go by before she finally made the jump and left for France. In the meantime, she turned all her attention to the "New Frankfurt."

One of her first discoveries was the newly opened Laban school of dance. Rudolf Laban was one of the founders of European modern dance. His efforts to bring dance back to the original purity of movement and do away with narration matched the modernist approach in the arts. Discarding all that was not the very essence of dance, Laban, at times, went so far as to renounce music. In her reportage on the Laban school, Bing tackled for the first time the difficult genre of dance photography, of which she was to become one of the most accomplished interpreters. These pictures already contain the fundamental principles of her approach. To translate Laban's melodies of movement, Bing relied on the silent music of composition. Rhythm and geometry inform her photographs of the dancers. Concentrating on pure forms, in one picture she focused tightly on the dancers' bare legs and feet, severing them from the rest of their bodies. This dramatic cropping is typical of the New Photography. Stylistically, however, the image is also grounded in Bing's fascination with the classical art of Greece and its avatar, neo-classicism. Organized in a perfect succession along a diagonal line, the legs seem to form a colonnade. The repetitive sequence of dancers evokes at the same time perpetual motion: the cropped ankle of the first dancer in the foreground suggesting the infinite repetition of the steps beyond the space of the picture. Bing achieves, in effect, a delicate balance

between the Grecian poise of Laban's choreography and the rendition of movement, creating an image that is at once dynamic and abstract.

Obviously, Bing still had very much in mind the model of the architect Gilly, whose art to her embodied the ability to "freeze" movement without stifling it. It was, in fact, architecture that opened the doors of Frankfurt's avant-garde to her during the eventful spring of 1929. Her introduction was the architect Mart Stam, a former student of the Bauhaus who had joined Ernst May's New Frankfurt team of architects. A proponent of Constructivism and a collaborator of El Lissitzky, the Dutch Stam is perhaps best remembered today for his novel tubular steel cantilevered chair, a precursor of Mies van der Rohe's now classic chair. Stam's approach to architecture and urban planning was expressed in two major constructions for the city of Frankfurt, the Hellerhof settlement and the Henry and Emma Budge retirement home (known as the BudgeHeim), which earned him an international reputation.

Of the same age (Stam, like Bing, was born in 1899), the photographer and the architect developed a close relationship based on a similar taste for abstraction. Soon Stam called on Bing to translate his architecture into photography. This type of collaboration was in line with Stam's experience at the Bauhaus, where the photography of architecture as a genre was reinvented concurrently with the emergence of the New Vision. Lucia Moholy, who tutored her husband László Moholy-Nagy in photography and was the main source of inspiration behind the development of *Das Neue Sehen*, began her career as a photographer by depicting the Bauhaus buildings at Weimar. Following her example, several students began exploring the school's novel architecture with a camera.

The relationship between the new architecture and the New Vision was theoretically grounded in Moholy-Nagy's principles, which stated that there was a natural equivalence between photography and the architectural revolution stemming from the Bauhaus. He contended that the unusual points of view afforded by the camera eye—low, high, and tilted angles, extreme close-ups, aerial views, and so on—transformed our way of experiencing space in a way that paralleled the experiments of the new schools of architecture. Photography and architecture were, in fact, both crucial elements in the realization of Moholy-Nagy's global artistic utopia: the advent of an age of Light. Just as the open and light-flooded Bauhaus architecture was meant to supersede the dark, closeted spaces of the past, so was photography, the art of light, meant to dethrone painting mired in pigment.

Echoes of these precepts run through Bing's pictures of Stam's buildings. Applying herself to her task with studious zeal, she made preparatory sketches of the architecture, taking particular note of the lighting conditions. In good Bauhaus fashion, Stam based his architecture on the idea that inner and outer space were not two distinct entities but were interconnected. Walls were no longer meant to hermetically divide rooms and could be broken up or made of glass. Light, of course, played an important role as the element that connected spaces that were separated. This is apparent in one of Bing's photographs of a stairway at the Henry and Emma Budge retirement home. The composition resembles a patchwork of flat planes. There is no single vanishing point as

in the linear perspective inherited from the Renaissance; instead, multiple lines and directions are united by the even sunlight that floods unhampered into the room.

At the same time, the quality of the light softens Stam's Constructivist architecture with a dreamy halo. Lingering on the handrail in the foreground, a ray of sun brings out its sensual curve. The plunging view of the stairway reads as an invitation to roam through the empty building as through a mysterious labyrinth. Although grounded in the abstract style of the New Photography, Bing's architectural views are singled out by a strong sense of atmosphere. While they perfectly render the sober aesthetic of the new buildings, they are nonetheless full of the photographer's sensitivity.

Bing's collaboration with Stam was crowned by the publication in July 1930 of a special issue of *Das Neue Frankfurt* entirely dedicated to the BudgeHeim, illustrated at length by the young photographer's pictures. Along with the images of the finished building, the review included several shots of the construction work. These documentary images, which relate to Bing's work for the general press, have strikingly geometric compositions. Their constructivist aspect was brought out vividly by the magazine's layout, in which the juxtaposed pictures seemed to be connected to one another by a pattern of diagonal lines running through them like a thread. This montage at the same time conveyed a dynamic sense of movement. The images were strung together like the frames in a filmstrip.

This cinematic effect points to the influence of another important member of the *Neue Frankfurt* circle, the artist, photographer, and filmmaker Ella Bergmann-Michel. Bing was introduced to her through Stam in the summer of 1930, and the two women struck up a strong friendship that lasted until Bergmann-Michel's death in 1971. Close to all the avant-garde movements of the 1920s, Bergmann-Michel had been a student of the Weimar art school and maintained ties with the faculty when it became the Bauhaus. Her house near Frankfurt—a mill on the River Taunus—was a stopping-off point for the members of Dada, in particular for Kurt Schwitters and Hannah Höch. Although Bing does not appear to have met any of these Dadaists[51] at the time, she would find in her frequent visits to the mill a rich source of inspiration.

In many respects, Bergmann-Michel was the epitome of the "woman artist," a revolutionary figure of Weimar Germany. The advent of women as key actors of the art scene was a specific phenomenon of the era and was perceived as such by public opinion. Its importance was confirmed by the publication in 1928 of *Die Frau als Künstlerin* ("Women-Artists"),[52] one of the first historical surveys of the life and work of women artists through the ages. Bergmann-Michel was among the contemporary artists singled out in the book and acknowledged as a pivotal figure in the breakthrough of women in art, a point highlighted in a review that appeared in the "Experimental Photography" issue of *Das Neue Frankfurt*. Bing, still in the first stages of her career as an artist, thus found in Bergmann-Michel an ideal model to follow.

As Bing herself described it, both she and Bergmann-Michel possessed the same fundamental approach to art. In a context of triumphant abstraction, their work, she explained, stood apart as "based on ongoing life in even the most abstract pictures."[53] This interest in representing life

through movement set Bing at odds with the emerging New Objectivity school of photography. The cool, clinical aesthetic of the *Neue Sachlichkeit*, which developed in photography about 1929, was a reaction to the experimental fever of the New Vision. Abundantly publicized by the press and by exhibitions, the photographic avant-garde of the New Vision had become omnipresent. Its audacity was now widely accepted and copied to the point that it was reduced to mere mannerisms. In contrast to this almost hackneyed style, photographers such as Albert Renger-Patzsch now called for a return to reality. Insisting on the purely mechanical objectivity of the lens, these proponents of the New Objectivity condemned all the more obvious stylistic devices in favor of straightforward close-ups of objects.

This direct approach, however, soon revealed its own limits. As pointed out by the art historian Olivier Lugon, hardly had the New Vision fallen out of favor than the New Objectivity itself came under attack.[54] Critics began to deprecate this movement, declaring its beautifully detailed photographs of ordinary objects not so much realistic as merely decorative.[55] More fundamentally, photography itself was rapidly falling out of favor. By 1929 critics, overwhelmed by the "uninterrupted and infinite chain of . . . exhibitions and publications"[56] presenting photography, started denouncing what came to be felt as a "photographic inflation" ("*Foto-Inflation*").[57] The "inflation" referred to both the excess of photographic images being produced and shown and the debauch of new styles and formal experiments. The tide that had carried the spectacular renaissance of photography in Germany was now turning. Voices from all sides called for a return to order. Progressive forces intended that the photograph be first and foremost a document invested with political or social meaning. Reactionaries, on the other hand, were already paving the way for the use of photography as propaganda. Neither direction suited Ilse Bing.

Barely had the young photographer started on her career when she found herself limited in her aspirations. There were other and more alarming signs. Following on the financial crash that darkened the last months of 1929, the year 1930 marked a political turning point in the history of the Weimar Republic. The spreading effects of the economic crisis disrupted the structure of the government. A strong presidential regime was established, which would eventually open an avenue for Hitler's rise to power. The legislative elections of September 1930 confirmed the formidable ascension of the Nazi party. This victory was due in large part to the decline of the liberal movement, which was shaken to its core by the economic instability. Reflecting this crisis, the liberal *Frankfurter Zeitung* changed some of its content and became more conservative. The illustrated supplement, which was Bing's main employer, began to resort increasingly to stock photographs rather than to the creative documents provided by talented photographers, thus reducing the young woman's publishing opportunities.

By the end of 1930 Germany had turned into a dead end for Ilse Bing. Professionally and economically, she appears to have come to a standstill. With her prospects diminished in the press, she applied in late September for a position as a photographer at the Institute for Legal Medicine of Heidelberg University.[58] A few years later, in France, her reportage work on clinics and surgical operations would find its way not only into magazines but also into art exhibitions. The Heidel-

berg application, however, was rejected. The New Frankfurt was also becoming a thing of the past. Ernst May, accepting an invitation from Soviet Russia to design towns in Siberia, was on his way to Moscow. It was time to move on. Just the year before, while perusing the announcement card of *Fotografie der Gegenwart*, Bing had made a note of the photographers living in Paris. In the last days of November 1930, telling her mother she would be gone for only a few weeks,[59] the young woman boarded the train to France, and to the city where, she knew, she was sure to come into her own as an artist. There she was to spend the ten most fruitful years of her career.

LIFE IN PARIS IS RIFE WITH SUBJECTS OF POETRY AND ENCHANTMENT.
ENCHANTMENT ENVELOPS US, WE DRINK IT IN LIKE THE ATMOSPHERE; BUT WE DO NOT SEE IT.

—Baudelaire, "De l'héroïsme de la vie moderne," *Salon de 1846*[1]

PARIS

ENCHANTMENT IN THE EYE OF THE CAMERA

PHOTOGRAPHY IN PARIS: A THIRD DIRECTION FOR MODERNISM

Bing's arrival in the City of Light coincided with the shift from Germany to Paris as the main platform of the photographic avant-garde. While the Germans were surfeited with the excesses of the "*Foto-Inflation*," the Parisians at the end of the 1920s took up the advent of this new art form with genuine excitement. Interestingly, a large part of the photographers who brought this evolution about were, like Bing, foreigners. Emigrating from the United States, Germany, and Eastern and Central Europe, they followed in the steps of the foreign painters and sculptors that had produced the *École de Paris*, a "school" that was not based on one artistic creed, but represented an international and eclectic group of artists held together by a shared love of Paris. At the time of Ilse Bing's move to the city the main representatives of the new "Paris School" of photography were the American Man Ray and the German-born Germaine Krull as well as Bing's role model, the German-American Florence Henri. The Hungarians, including Brassaï, Ergy Landau, Rogi André, and Eli Lotar, formed another important group. Chief among them was André Kertész, who had already built an important reputation in the German illustrated press.

As in Germany, the diffusion of photography was mainly ensured by the press. Directly inspired by the example of the Germans, in the late 1920s the French started to produce magazines in which the photographic image triumphed. Some of these were to have a lasting impact on the history of photojournalism. The most influential was *Vu*, which was launched in 1928 by Lucien Vogel, the founder of the *Gazette du Bon Ton* and the former artistic director of French *Vogue*. Specializing in international news, the weekly relied on reportage work by the best photographers of the day such as Germaine Krull, André Kertész, Brassaï, and, beginning in 1933, Robert Capa. Its radical new design, conceived by Alexander Liberman, was later copied by *Life*. It was the first of several illustrated news magazines in France, including *Voilà*, *Miroir du Monde*, *Marianne*, and *Regards*.

More elitist, but pivotal for the definition of photography as an art form, were the photographic albums published once a year by *Arts et métiers graphiques*. Created by Charles Peignot, the owner

of France's most important type foundry, in collaboration with Vogel, the review was meant to present the latest evolutions in printing techniques, typography, and the graphic arts. The recent developments in photographic illustration led in 1929 to the conception of a special annual issue on photography called, quite simply, *Photographie*. Art photography was also included in the magazine *Art et médecine*. Started in 1930, this luxurious publication, designed originally for the cultural leisure of medical doctors, granted a large section to the defense of the New Photography. In 1929 *L'Art vivant* became the main tribune of modern photographic criticism. All of these magazines contained reviews of the photography shows, which were just then beginning to multiply.

Since the turn of the century photography had been regularly exhibited in Paris at the annual *Salon international de photographie* ("International Photography Salon") organized by the Société française de photographie (SFP), the French equivalent of Britain's Royal Photographic Society. However, the champions of the New Photography soon set out to challenge the conservative aesthetic upheld by the *Salon*. The official break occurred in 1928 with the significantly titled *Salon indépendant de photographie* ("Independent Salon of Photography"), which featured work by Laure Albin-Guillot, Eugène Atget, Berenice Abbott, George Hoyningen Huene, André Kertész, Germaine Krull, Man Ray, Madame d'Ora, and Paul Outerbridge, consecrating the shift from pictorialism to modernism.

Soon after this event, the photography done in Paris found an international echo. The photographers working in France were given a place of choice in the landmark exhibitions of the New Vision organized in Germany: *Film und Foto, Fotografie der Gegenwart*, and *Das Lichtbild*. In Paris itself photography gained new visibility and became a dynamic feature of the general art scene, periodically shown in bookstores and art galleries. The most important of these venues were the Galerie La Plume d'or, the Galerie d'Art contemporain, and the Librairie Ouvert la nuit founded by the Surrealist artist and photographer Raoul Ubac.[2] The Galerie de la Pléiade, located in Montparnasse, stood out as a novel art space exclusively dedicated to photography, and its exhibitions enjoyed great prestige.[3] It was here that Ilse Bing presented her work to the public for the first time in the early months of 1931, making her Paris début with a splash. The importance of La Pléiade remained unchallenged until 1937, when the photographer François Tuefferd opened his own photography gallery, Chasseur d'images. Like the shows at La Pléiade, Tuefferd's group exhibitions federated a movement that was never formally united.

Impervious to dogma, the photography scene in Paris represented an informal mix of styles. Germaine Krull's bold paeans to the metallic splendors of modern constructions coexisted with André Kertész's poetic wanderings through Paris. The black magic of Brassaï's explorations of the city's hidden face answered, yet contrasted with, Man Ray's witty investigations of dreams. The Jansenist-like rigor of Emmanuel Sougez's still lifes was akin to the purism of Florence Henri's compositions, yet did not share their abstraction. Thus, there were passageways from one body of work to another, but each artist followed his or her own path, regardless of doctrine.

The discourse on photography reflected the loose organization of the modern photographic movement in Paris. Key notions of the German New Vision referring to the "productive" or creative nature of photography underpinned founding texts of the French photographic renaissance such

as Waldemar George's "*Photographie, vision du monde*" ("Photography, Vision of the World"), written in 1929 as the introduction to *Arts et métiers graphiques*'s first *Photographie* album.[4] But whereas the German theoreticians insisted on the mechanical and technical nature of the "photo-eye," George asserted the importance of "style"[5] and stressed the role of subjectivity. To him, the unique power of the camera's lens did not lie so much in its ability to penetrate the outside world and disclose unforeseen realities as in its capacity to forage inside the human psyche and "deliver the intimate key of dreams."[6] George's analysis of photography as an expression of the unconscious and dreams pointed clearly to Surrealism.

Arguably the most influential artistic current in France between the wars, Surrealism was to shape photography in a unique way. This particular "Surrealist revolution" was not so much aesthetic as semantic. It was founded on a reassessment of the photographic "document." Photography, declared the Surrealist poet Philippe Soupault[7] writing in 1931,[8] was "above all else a *document*."[9] The poet's meaning, however, was ambiguous. Praising photographs for their beauty, he clearly did not view the document as mere "documentation." On the other hand, his text was an appeal to abide by the photograph's outward realism. Indeed, at the core of the Surrealist fascination for photography lay the idea that a photograph was an actual piece of reality, a living proof not of a mere imaginary world but, to quote André Breton's first *Surrealist Manifesto*, of "the resolution . . . of dream and reality into a kind of absolute reality, of *overreality* [*surréalité*]."[10]

The ultimate reference in this respect was the work of Atget, whose photographs, which he himself designated as "documents," were rediscovered by Man Ray and his then-apprentice Berenice Abbott in 1925. While the experimental fever of the photographic avant-garde was dying out, the apparently artless yet strange beauty of Atget's images opened up a new direction. According to the critics of the period, the value of the old man's "documents" was to reveal reality as an enigma. This interpretation certainly explains why no true documentary style developed in France at the time, as it did in Germany and the United States. Significantly, Berenice Abbott, who dedicated herself throughout her career to making Atget's oeuvre known, left Paris for New York to produce her own documentary masterworks. Her methodical investigation of the streets of the American metropolis was indeed in absolute contrast to the somnambulistic wanderings of the photographers of Paris, who, beyond the founding figure of Atget, referred back to the Baudelairean *flâneur*.

The key element of the Parisian school of photography was "chance." Walking through the streets, the photographer would not set out with a predetermined subject in mind but with an eye on the alert for what the Surrealist poet Paul Éluard termed "accidental poetry." Not surprisingly, the flowering of this "wanderer's" approach to photography went hand in hand with the growing use of small-format cameras. Whereas the view camera became the indispensable tool of the objective and precise documentary style defined by the likes of August Sander and Walker Evans, the small-format cameras were ideally adapted to the spontaneity required of chance encounters. The Leica, in particular, was taken up by several representative Parisian photographers of the 1930s. André Kertész used both the 35mm camera and plate cameras. Yet the images he shot with the Leica remain the most emblematic of his poetic vision. For Henri Cartier-Bresson, as for Ilse Bing,

the Leica was fundamental to the practice of photography. Only with this tiny implement could they capture what Cartier-Bresson retrospectively described as "decisive moments." In this sense, the Leica, which originally had been taken up in the context of German photojournalism as the ideal tool for reportage, was redefined in Paris as a poetic instrument.

Following on the abstraction of the New Vision, and parallel to the austere purity of the emerging documentary style, the photography practiced in Paris represented a third direction, which attempted to reconcile poetry and realism, the enchantment of dreams and the sharpness of modernity. To contemporary critics this combination also explained a new and important phenomenon: the major breakthrough of women photographers. Revealing in this respect is an article from *La Revue de la photographie,* which singled out the work of women photographers at the 1936 International Exhibition of Contemporary Photography organized at the Pavillon de Marsan (in the buildings of the Louvre). The female reviewer, Hélène Gordon,[11] ascribed the new prevalence of women in photography to the happy association of instinctive feminine sensibility with the dry and sobering objectivity of the camera.[12] Beyond this conservative rhetoric, Gordon's article justly pointed to the essential fact that women, who had only played a minimal role in the traditional arts, such as painting and sculpture, had taken over front row in the advent of the New Photography. As Bing later explained, the main reason for this was the newness of the field itself: "Photography was not taken seriously and we [women] were so to speak admitted."[13] More specifically, there was a natural coincidence between the emancipation of the camera art from the fine arts and the first attempts at women's liberation, both striking features of modern times.

The importance of women in photography was first revealed in the context of the Weimar Republic. Yet it was in Paris that the phenomenon truly reached its peak. Leading the way were Germaine Krull and Florence Henri. Both were of German descent and had trained in photography in Germany. Paris, however, was where they chose to practice their art and where they rose to prominence among the photographers of the day. Several young German women followed their example, such as Marianne Breslauer. Hitler's rise to power led to the emigration of numerous artists, launching a new wave of photographers that included Gisèle Freund and Gerda Taro. Alongside this influx from Germany, Paris also attracted women photographers from the United States (Berenice Abbott, Lee Miller) and from Hungary and the former countries of the Austro-Hungarian Empire (Rogi André, Lisette Model, Nora Dumas, Ylla, Madame d'Ora, Ergy Landau). French talent was embodied in the versatile Laure Albin-Guillot and Dora Maar.

With the camera, women found a new and powerful mode of expression, unencumbered by the stifling weight of tradition. The special atmosphere of Paris enabled them to give full voice to this new instrument. The city's landscape opened itself to them as a vast space in which to experiment and create. Even more acutely than their male colleagues they felt the liberation of wandering through the Parisian streets and breathing in the intoxicating air of freedom that reigned in the capital. City of poetic wanderings and of chance discoveries, so eminently feminine in its seductive versatility, Paris was to these women, as it was to Ilse Bing, much more than its scenery, however exceptional. It was none other than the place where, in Bing's words, "they truly became themselves."[14]

Bing's first moments in Paris were like a homecoming. Although she had never visited the city before, as soon as she arrived she "sat down at a café terrace and felt as if roots were growing from [her] feet down into the Paris pavement."[15] Mart Stam had helped her prepare her trip. On his recommendation, she booked a room in the Hôtel de Londres at 3 Rue Bonaparte, in the neighborhood of Saint-Germain-des-Prés, which was, along with nearby Montparnasse, the center of Bohemian and intellectual Paris. The young woman, who had a good command of French, faced the metropolis with confidence. At thirty-one, she cut an attractive figure, "shaped cheeks, good lips, eternal dark eyes,"[16] alive with youthful energy and great determination.

A contributor to *Das Illustrierte Blatt*, the journalist Heinrich Guttmann immediately provided her with work. Doubling as an agent for photographers, Guttmann had André Kertész as his main client.[17] Bing had met him in Frankfurt, where she had helped him with the production of a photographic album released in November 1930, shortly before she left. Entitled *Aus der Frühzeit der Photographie 1840–1870. Ein Bildbuch nach 200 Originalen* ("The Early Days of Photography, 1840–1870; An album of 200 images reproduced from the original"), this book was a milestone in the study of nineteenth-century photography and was used as reference by Walter Benjamin for his seminal *A Short History of Photography*.

In Paris Guttmann's first assignment for Bing was a reportage on the wax figure cabinet at the Moulin-Rouge. Published in the January 8, 1931, issue of *Das Illustrierte Blatt*, the photographs illustrated an article deploring the demise of the Bohemian Paris that had flourished in Montmartre, and whose colorful characters—Toulouse-Lautrec, La Goulue, etc.—were now artificially embalmed in the wax museum of what had once been the temple of *La Bohème*. The fascination with wax figures was typical of the times. It had been a trait of German Expressionism[18] and was now taken up by Surrealism. Accordingly, Bing's images have an aura of strangeness that is reminiscent of Surrealist imagery.

Bing continued to cover social topics as well. One typical reportage, entitled *"Krisenwind über Frankreich"* ("Crisis Blowing over France"), illustrated the effects of the economic recession in Paris. It showed the darker sides of the glamorous city: the poor scraping a living by selling newspapers, the lines of the unemployed in front of the employment bureaus or the soup kitchens. Although the photographer was spared this kind of poverty, her own circumstances in Paris were precarious. "Food was often scarce," she revealed in an early interview for the American newspaper the *Springfield (Illinois) Republican*, which was interested in the romantic figure of this young German woman struggling in the City of Light.[19] She recalled that although "the third day [in Paris] she had work . . . , there were lean days ahead" when she had practically nothing to eat.[20] This description of the poor, hungry artist might ring somewhat as an empty stereotype. Yet a concerned letter from a friend, asking whether "Paris was being kinder to [her],"[21] confirms that times were indeed difficult during those first months. Bing could not rely on her collaboration with Guttmann to ensure a steady income. Their relationship was informal, and assignments were only paid upon

acceptance by a newspaper or magazine.[22] Working conditions were also less than satisfactory. The young woman's hotel room afforded no space to print her photographs, and she had to improvise a makeshift darkroom in Guttmann's Montparnasse garage. Guttmann's work opportunities were also limited as he apparently did not have contacts in the French press. In the spring of 1931 Bing decided to make her way on her own.

During this period Bing's career in photojournalism also took a new turn as she discovered the milieu of fashion, which was to play a significant role in her work in the next few years. In February 1931 she reported on the *Bal de la couture*, a society event organized by the couturiers at the Paris Opera. In her pictures Charles Garnier's architecture appears as an enchanted grotto, glittering with the diamondlike sparkle of myriad chandeliers, lamps, and strings of lights. Less glamorous were her images of Paul Poiret, whom she photographed at his home in January 1931. Clad in a dressing gown and slippers, the former arbiter of taste seems to have lost his panache. The angle chosen for this reportage faithfully applied the tenets of German photojournalism by disclosing the intimate life of a celebrity and debunking the myth of the great man. Both the Poiret piece and the images of the *Bal de la couture* were published in the German press (*Die Woche* and the *Münchner Illustrierte Presse*).

Bing's introduction into the Parisian world of fashion was probably provided by another Frankfurt contact established in Paris, Käthe von Porada. A well-known patron of the arts, Porada was one of Max Beckmann's muses and contributed largely to the introduction of German Expressionism to France. On the staff of the *Frankfurter Zeitung*, she covered Parisian fashion for the German paper, which must be how she came to be in touch with Ilse Bing. The photographer contributed several illustrations for Porada's book *Mode in Paris* ("Fashion in Paris"), released in 1932. Her photographs, which encompassed every aspect of fashion in the city, from haute couture to secondhand clothes, mingled pure reportage images with more enigmatic compositions such as a portrait of a blind woman hawking her meager goods to indifferent passersby. Standing at the entrance to one of the Parisian arcades that so captivated the imagination of Walter Benjamin, the woman seems to be an incarnation of Fate.

Destiny was also beckoning to Bing, whose work as an artist suddenly gained recognition in early 1931. Wandering through the Moulin-Rouge while completing her reportage for Guttmann on the wax museum, she came upon the cancan dancers and was enthralled by the spinning energy of their performance. The topic of the cancan was almost a cliché by then. With the Leica, however, Bing was able to transcend the anecdotal aspect of her subject into a pure representation of movement. The series was a stylistic breakthrough for her. She submitted it to the Galerie de la Pléiade, Boulevard Raspail, which was then presenting its annual photography group show, reuniting the best photographers working in Paris. The selection for the exhibition, or so the story goes, was already closed. Yet the quality and novelty of Bing's images were so obvious that they were added at the last minute to the gallery's storefront, where they attracted the attention of the critic Emmanuel Sougez. A few years later Sougez described the photographs with the literary verve of the opening scene of a short story:

"There was, in this window of the Boulevard Raspail, among other photographs, which lacked neither in importance nor merit, four or six images, tiny, brutal in their use of contrast, yet engaging somehow by a kind of twirling dynamism, a floating movement of unfurled dresses and scarves. These were dance movements. . . . There was mystery and reality here, but most of all something new. . . . At the bottom of the pictures, an illegible signature in a spidery handwriting. I had to go in and inquire. Ilse Bing, I was told, a young German girl, just arrived in Paris, who had asked for a corner in which to display these essays."[23]

Sougez was a pivotal figure in the photography movement in Paris. A photographer himself, he headed the photographic department of *L'Illustration*, which was the most important illustrated weekly, and played a major consulting role in the selection of photographers for the photographic albums of *Arts et métiers graphiques*. As a member of the organizing committee, he was also largely responsible for the choice of photographers represented in the landmark International Exhibition of Contemporary Photography (*Exposition internationale de la photographie contemporaine*) held in a wing of the Louvre in 1936. He was a champion of large-plate photography, and his images, mainly still lifes, were characterized by extreme definition and formal purity. Bing's Leica snapshots belonged to a radically different realm of photography, but her geometric sense of composition appealed to the French photographer's taste for classicism. Almost at once the young woman became Sougez's protégée.

In the wake of her meeting with Sougez, Bing participated in all the significant exhibitions of Parisian photography throughout the 1930s. On his recommendation, her work was included in the French section of *Das Lichtbild*; thus, in the summer of 1931, less than a year after leaving Frankfurt, Bing found her photographs presented in Germany in an international exhibition of the caliber of *Fotografie der Gegenwart*. In the course of just a few months, she had become an acknowledged member of the *Nouvelle photographie*, the French New Photography. As such, she took part regularly in La Pléiade's annual group shows, and in the Salons of the gallery Chasseur d'images. Her works appeared prominently in every important survey of the new movement such as *Photographes d'aujourd'hui* ("Photographers of Today") at the Galerie La Plume d'or, *Photographie moderne* ("Modern Photography") at the Galerie d'Art contemporain, *L'Image photographique en France de Daguerre à nos jours* ("The Photographic Image in France from Daguerre to the Present Day") at the Galerie Braun, and the previously mentioned 1936 International Exhibition at the Louvre. She participated as well in thematic exhibitions such as La Pléiade's homage to the bizarre entitled *Humour, fantastique, décoration* ("Humor, Fantasy, Decoration") and the presentations of photography in advertising at the Librairie Ouvert la nuit, and at the Studio Saint-Jacques (under the aegis of the Société des artistes photographes, headed by Laure Albin-Guillot).

Sougez also actively championed Bing's photography in the press. An image of a cancan dancer with a twirling skirt, from the series that had so vividly impressed him, was reproduced in the 1932 *Photographie* album, the prestigious supplement of *Arts et métiers graphiques*. That issue also contained a photograph by Florence Henri, *Composition à la fenêtre*; Bing's photography was now put on a par with that of her hero. Confirming Bing's new importance, Sougez gave her work central stage

in a review of the 1934 Salon of the Société française de photographie, where Bing exhibited every year starting in 1931. In his review for the *Bulletin de la Société française de photographie*, he singled out the "dynamism" of Bing's "twirling dancers" as one of the rare highlights of an overall mediocre display. It was then that in his enthusiasm for Bing's novel technique, he baptized her the "Queen of the Leica."[24]

The Frenchman's fascination with the young photographer's use of the small-format camera also was at the core of the portrait he published in the December 1934 issue of *L'Art vivant*, in which he described first discovering her images in the window of La Pléiade. The piece represented an important promotion for the photographer. While greatly regarded for its high artistic standards, *L'Art vivant* also benefited from a large audience, contrary to similar art publications such as *Verve* and *Minotaure*.[25] The critic's enthusiastic words were not, however, devoid of ambiguity. Oddly, Sougez posited the German woman against the "wave of foreign photographers . . . who, in the past ten years, have taken over Paris, flooding it with ghastly, worthless and carelessly produced images."[26] In Bing he praised on the contrary a sense of beauty and equilibrium that he defined as typically "French."[27]

These spurts of xenophobia revealed a distasteful side of Sougez that was to disclose itself fully at the end of the decade and poison the relationship with Bing. In 1937 Sougez initiated the creation of *Le Rectangle*, an association of exclusively French photographers avowedly meant to counter the influence of foreigners and to promote a national art of photography. This nationalist fervor fore-shadowed the photographer's warm allegiance to the Vichy government, whose propaganda he espoused at *L'Illustration*. Although he never openly broke with Bing, he clearly distanced himself from her in the years of political and social turmoil that marked the end of the 1930s. He would reveal his true face in the very first days of the war, declining to respond to his friend's appeals to use his influential position to protect her and her husband.[28]

Far more helpful was the patronage of Hendrik Willem Van Loon. The American writer was to be the photographer's main support throughout her time in Paris, providing her both with money and contacts. Of Dutch origin, Van Loon spent his time between Europe and the United States, where his writings on history and culture had made him a celebrity. Bing was introduced to him in May 1931 by the publicist at the House of Worth, the American René Scudamore who, sensitive to the young photographer's struggles, had directed her to her friend Van Loon, knowing his passion for philanthropy.[29]

A sanguine and exuberant character, Van Loon reacted with demonstrative enthusiasm to Bing's photography and on an impulse invited her, all expenses paid, to his home in Holland where she could work at leisure for a few weeks. The writer had a house in the picturesque town of Veere, in the Zeeland province. Preserved in time, Veere offered the perfect image of a Dutch town of the golden age. Bing delighted in its quaint atmosphere, and in the anachronistic vision of its tidy Dutch matrons in traditional gowns, their heads primly adorned with starched coifs. She captured them vigorously scrubbing the pavements or, more delicately, gliding through the streets, their long skirts merging with their shadows as in an Impressionist lithograph. She must have felt great emotion at discovering the sights of Van Gogh's home country almost exactly as he

had known them. During a stop in Amsterdam, Bing resumed contact with urban reality. Several of her photographs of the city reveal the definite imprint of Atget. Roaming in the poorer quarters, she focused on the odd, discarded wares hanging in secondhand stores: globular lamps and large, clownish long johns looking at once absurd and bizarre. Thinking perhaps of Atget's series on prostitutes, she portrayed two women on display at their window, waiting for the next client. Beside the squalor, there was also the magic of the canals in whose waters Bing could not resist snapping her shadow.

The trip had professional repercussions as well. Through Van Loon, the photographer started a collaboration with the *Algemeen Handelsblad*, the main Dutch newspaper. The writer also actively promoted Bing's work among his circle of friends, urging them to purchase prints from the photographer.[30] Bing would return to Holland twice in the 1930s on the writer's invitation. He introduced her in 1933 to the aircraft manufacturer A. H. G. Fokker, a meeting that resulted in a powerful low-angle close-up of a Fokker plane's propeller cut out against the sky. As thanks for the photograph, Fokker gallantly invited Bing for her first flight over Paris during his next trip to France. It is not known whether the invitation materialized, but it no doubt thrilled the energetic young woman so enamored with movement and speed.

With Van Loon acting as her patron, soon Bing was able to improve her living conditions. In June 1931, shortly after her return from Holland, Bing moved out of the Hôtel de Londres and took a lease on a furnished apartment at 146 Avenue du Maine, in Montparnasse. It was only a tiny studio, but it had a kitchen in which she could at last install her own darkroom. The place was so small that she had to pin her prints to dry over her bed. She slept under an umbrella to prevent the drops from wetting her sheets.[31] At about the same time, Van Loon returned to America. There, as in Holland, he actively set himself to making Bing's photography known.[32] It was his tireless promoting that brought about the early interview with the correspondent from the *Springfield Republican*, in which Bing candidly exposed her struggles as a newcomer in Paris. Van Loon also submitted her work to Frank Crowninshield, the editor in chief of *Vanity Fair*, who responded with interest.[33] All that was needed now was for Bing to make her way to the United States. There were several obstacles to this, however. The visa was not easy to obtain, and Van Loon's own finances for a while could not meet the expense. The plan was repeatedly discussed over the next five years, but it was only in 1936 that Bing traveled to America.

She was preceded there by two early exhibitions of her work in New York. In February 1932 she was included in the landmark show *Modern European Photography*: *Twenty Photographers* at the Julien Levy Gallery, thanks to Van Loon's introduction. A Harvard graduate, Levy was part of a set of young art historians who were promoting modern art in America. His gallery, which was a focal point of the New York avant-garde, was seminal in the diffusion of modern photography in the United States. However, Levy had a relatively conventional reaction to Bing's photographs, which he expressed in a letter to her. While demonstrating genuine admiration for her images, he could not refrain from commenting on her exclusive use of the small-format camera, which he considered a European exception. In America, he pointed out, "to use a small camera and then enlarge

was not considered good photography." Favoring an oddly conservative terminology, Levy went on to distinguish between the enlargement, which was suited as "reportage, anecdote, document," and the "beautiful image."[34] There is a certain irony to these commentaries when one considers that only a year later in 1933, Levy, organizing Henri Cartier-Bresson's first show, was to pose himself deliberately as the champion of the Frenchman's "bad photography."[35] It is not inconceivable that Bing's talent may have somehow prepared the way for the dealer's change of opinion.

Despite his reservations, Levy exhibited several of Bing's views of Paris and Holland. His choices, as can be judged by the donation he later made to the Art Institute of Chicago, included many of the photographer's best and most emblematic pictures.[36] One of these, the view of the Champ-de-Mars seen from the Eiffel Tower, was reproduced on a full page of the Paris edition of the *Chicago Daily Tribune* as an announcement for Levy's New York show.[37] Levy also loaned several of Bing's prints to the *International Photography* show held at the Brooklyn Museum of Art in March 1932, which duplicated the European model of the great avant-garde photography exhibitions.[38]

In September 1932 Bing had her first one-person show. The exhibition was held in Frankfurt at Galerie Trittler, on the Opera Square, which had fascinated Bing as a child. The *Frankfurter Zeitung* honored the occasion with a full review. This text presents a perfect summary of the state of photography in Germany in the early 1930s and the general feeling of satiety with the excesses of the New Vision. According to the critic, "modern" photography, in the form of the cult of "objectivity," was repeating the mistakes of "art photography" and losing all real sense of the object, whereas "abstract photography" remained at the experimental stage and could produce no complete work of art.[39] In contrast with the spent energies of the avant-garde, Bing's photography was applauded for its freshness. "What a relief, in this situation," exclaimed the reviewer, "to meet a photographer with the courage for reality, and also with the endurance to make it come true!"[40] Contrary to her predecessors, Bing, according to him, was able to inject meaning into her images—that is, not merely to reproduce reality but to make the "object say something."[41]

The Trittler show was to be the final episode of Bing's loosening professional ties with Germany. Since the end of 1931, her work had ceased appearing in the German press, at least under her name,[42] and the collaboration with Käthe von Porada in 1932 was her last contribution to a German book. After the split with Guttmann, she had successfully turned to the French magazines for work. The publication of her *Cancan Dancer* in the 1932 *Photographie* album provided excellent publicity. Throughout the following year, her photographs appeared in *Vu*, in the architectural monthly *Urbanisme*, in *Allo Paris* and *Le Sourire* (meant for light entertainment, these two magazines nonetheless employed some of the best photographers, for whom they represented a good source of income), and *Le Monde illustré*, a venerable illustrated weekly that was founded in the nineteenth century. Two of her photographs were singled out and reproduced on the cover of the latter magazine: again, the view of the Champ-de-Mars from the Eiffel Tower, and a dazzling image of a fountain at night at Place de la Concorde.[43]

For *Le Monde illustré* Bing also produced complete photo-essays in the same vein as what she had done in Germany. One was a long report on a popular Paris street fair, the *Foire au pain d'épices*

("Gingerbread fair"). The success of Robert Wiene's Expressionistic film masterpiece, *The Cabinet of Dr. Caligari*, had since the 1920s endowed the street fair with an aura of mystery. Following this influence, Bing lavished her attention on the fantastical elements of the fair, such as an enigmatic sculpture adorning an organ. But more important, she aimed at bringing out the intense animation and feverish atmosphere of the event. Her photographs seem to come alive: The blurred wheel of fortune is spinning under our very eyes; the hand of the street photographer, preparing to expose a picture, appears just about to lift the cap from the lens of his view camera; we feel the slight tilt upward of the swing before the weight of a pair of lovers carries it back down again.

In contrast with the excitement of the fair, reality was growing more threatening. In May 1933 *Le Monde illustré* featured a special story on the "Fate of German Jews" ("*Le Sort des Juifs d'Allemagne*"), which Bing illustrated with photographs of the Jewish quarter in Paris. The pictures in themselves, however, do not say much about contemporary events. They read mainly as documents of an unusual, and in a sense exotic, aspect of Paris. To Bing herself, the Eastern European Jews in traditional garb who peopled the neighborhood of the Rue des Rosiers were not a familiar sight. Her images, as a result, remain at a distance.

Like many German Jews of the bourgeoisie, Bing did not seem to have grasped the full meaning of Hitler's takeover. Her mother and sister remained in Frankfurt, and after a two-year absence between 1933 and 1935, she returned on a regular basis to her hometown. According to Gerard Willem Van Loon, Hendrik's son, in the first stages of the Nazi regime Bing considered applying for French citizenship.[44] In fact, the events of March 1933, by which Hitler was made Chancellor, only served to confirm Bing's already firm intention of establishing herself in Paris.[45] As if to make this resolution definitive, in April she moved out of her cramped furnished studio on Avenue du Maine into a more spacious pied à terre. The apartment was at 8 Rue de Varenne, on the border between Saint-Germain-des-Prés and Montparnasse. It was not luxurious but clean and functional, and it was located in a brand-new building in the modern style, which had the added prestige of housing Florence Henri's studio.

At that point, however, the young woman from Frankfurt had already emancipated herself from her role model's influence. Not much is known about the actual contacts between Bing and Henri in Paris.[46] It is almost certain that Bing visited Henri upon her arrival, but there is nothing to indicate that they developed a close relationship. Henri does not seem to have been interested in less experienced photographers, as judged by Gisèle Freund's own story. Like Bing, Freund—who came to Paris in 1933 as a refugee from Hitler's Germany—was a dedicated "Leicaist." Henri, who disdained the small-format camera, gave Freund only a few courses before unceremoniously declaring that she would never be a good photographer and showing her the door.[47] Nonetheless, she was fair enough to send Freund to see Bing, thus implicitly acknowledging her neighbor's *métier*. Throughout her time in Paris, Bing supplemented her income with teaching. However, although an interview from that time mentioned that she had a "school of photography in Paris,"[48] her teaching practice appears all in all to have remained limited and informal.[49]

A more lucrative activity was portrait photography, which Bing was able to practice on a regular

basis in her new studio. Her contacts with the American community secured her a number of portrait commissions. Sitters included expatriate figures of high society as well as less conventional celebrities, such as the writer and journalist Katherine Anne Porter. Bing also received major artists and performers of the day. She photographed Marianne Oswald, the German cabaret star and friend of Jean Cocteau, who introduced *The Threepenny Opera* to Paris after fleeing Nazi Germany. Tilly Losch, the Austrian ballerina and former protégée of Max Reinhardt, also sat for her, as did Léon Pierre-Quint, an expert in Marcel Proust's oeuvre and a collaborator of the writer Philippe Soupault. Bing took particular pride in her association with great musicians, namely the conductor Fritz Busch, the composer Arthur Honegger, and the concert pianist Artur Schnabel, a legendary interpreter of Beethoven.

The portraits, and specifically the studio portraits, convey Bing's mastery of revealing psychological insight. Her technique was described in emphatic terms by Van Loon:[50] "She has none of the pliable and amiable tricks of the successful portraitis [*sic*]. She will sit for hours around you and creep into you until at last she has got what she wants and then invariably it is perfect." This slow method contrasted with the snapshot function of the Leica. In general, Bing's use of the small-format camera for studio portraiture represented an innovative combination of the formalism expected from this type of exercise and the character of spontaneity and immediacy that was the Leica's main asset. Seeking to concentrate on the essential features of the personality in front of her, she achieved a degree of closeness, a precision, which one critic compared to that of a "scalpel."[51]

Just as she had successfully demonstrated that the Leica could be applied to studio portraiture—thereby defying the traditional use of large-plate cameras—Bing also endeavored to master the art of artificial lighting. Again, she was going against the accepted view, which associated the 35mm camera with candid imagery. She first experimented with lighting in self-portraits and later applied it to her portrait commissions. But it is in the context of her association with *Harper's Bazaar* that she truly learned, as she expressed it, to "model with light."[52] She first started working for *Bazaar* in November 1933 on the recommendation of a leading figure of Parisian high society, Daisy Fellowes. According to the great socialite and photographer Cecil Beaton, the American-born Fellowes "was much publicized as the best-dressed woman in the world,"[53] whereas Jean Cocteau said of her, "she has launched more fashions than any woman in the world."[54] Bing, who in her own way and with her limited means always displayed a great concern for her appearance,[55] developed a friendly relationship with her. Thus, when in September 1933 Fellowes was invited to head the Paris bureau of *Bazaar*, she quite naturally brought Bing's photographs to the attention of the magazine's new fashion editor, Carmel Snow.

Snow was busy making *Bazaar* into the most prestigious and innovative fashion publication of the period.[56] In contrast with the conservative aesthetic of *Vogue*, which favored the formal elegance of studio photography, she sought to create a natural and dynamic style, in tune with the energetic spirit of modernism, and applied the techniques of photojournalism to the world of high fashion. She was the first to employ practitioners of the small-format cameras in the context of a luxury fashion magazine and to use outdoor photography widely to present couture.[57] It was she who

turned Martin Munkacsi, a reporter who specialized in sports, into one of the greatest fashion photographers. His images of healthy young women, laughing and running on beaches or playing golf and tennis, embodied the magazine's new canons of graceful spontaneity.[58]

Bing's own assignments for *Bazaar* were carried out exclusively in the studio. In this artificial setting, however, she recreated an impression of life and naturalness. Her first contribution was a series of close-up shots of Daisy Fellowes's fashion accessories. Always striking and unusual, these were meant to contrast with the "studied simplicity"[59] of Fellowes's clothes and were a defining element of her chic. Most remarkable in this series was the photograph of Fellowes's gray felt hat by Caroline Reboux, which she flaunted rakishly tipped over her left eye. This androgynous hat had a stunning sex appeal that Bing brought out by the tight cropping of the image. The look was in the air. A month later, in the December 1933 issue of *Minotaure*, Tristan Tzara, in an article illustrated by Man Ray, would comment at length on the sexual character of the current vogue among women for masculine headwear.

From then on Bing regularly photographed shoes, jewelry, handbags, and belts for the magazine, revealing in these images a sensual appreciation of texture. Even and soft, her use of lighting molded rather than sculpted the objects at hand. She avoided the dramatic shadow effects employed by Edward Steichen and most of the big professional studios, which presented objects of luxury as unattainable objects of desire. It was important to her, on the contrary, that the photographs not look staged. In these pictures an exquisite pair of kid gloves with hand stitching seems to have just been carelessly tossed away by an insouciant belle, while the feet of a model in repose languidly demonstrate the grace of a pair of gold lamé evening shoes.

Through Fellowes, Bing was also introduced to the most exciting couturier of the day, Elsa Schiaparelli. A friend of the Surrealists, Schiaparelli conceived of clothes as embodiments of her imagination and true works of art. She had an aversion to utility, and it was her imaginative approach to accessories that gave them a new importance in the fashion of the period. Ordinary buttons were a particular object of her contempt, "symbolizing utter boredom" to her.[60] To redeem them from tedium, she made them an occasion for visual puns such as the padlock with which she attached a tweed coat, and which Bing photographed for *Bazaar*.[61] The two met in the fall of 1933, and their relationship, lasting through 1934, coincided with the heyday of the couturier.[62] There was an obvious connection between Bing's taste for fantastic beauty and the enchantment of Schiaparelli's Surrealist creations. This comes out particularly in Bing's publicity shot for *Salut*, an evening fragrance by Schiaparelli with white lily notes. Couched on a bed of lilies, and bathing in the faint, silvery glimmer of moonlight, the sleeping model appears as a fairy princess caught in a spell.

Advertisements were a desirable source of revenue for the New Photographers, who also considered publicity as a testing ground for their stylistic innovations and as a part of the photographic revolution then taking place. In the fall of 1933 Bing received a particularly important assignment on the wine cellars of Champagne and Burgundy, commissioned by George Putnam,[63] an American in charge of publicity for Pommery Champagne and for several major Burgundy

wines, to celebrate the end of the Prohibition in America. Images from the series were presented in an exhibition on photography in advertisement held at Ubac's gallery-bookstore Ouvert la nuit in July 1934. Among the works of Laure Albin-Guillot, René Zuber, Pierre Boucher, François Kollar, Emmanuel Sougez, Ylla, and others, the critic of *Photo-Illustration* distinguished Bing's "basket of champagne bottles," which was "so hard to resist."[64]

Bing's connections with expatriate Americans also resulted in her first one-person show in Paris, which was organized at the American Library in November 1933. That same year her photographs were exhibited in Philadelphia at the Second Philadelphia International Salon of Photography. Van Loon was again pressing for her to come to the United States, but his plans seem to have been hampered by problems with immigration services. He did not give up on publicizing her work, which continued to appear in the American press with his direct support. A group of Bing's Holland photographs illustrated a 1935 article by Van Loon in *Town and Country*. That same year a full-page reproduction of her picture of the Temple d'Amour—a monument in a park outside Paris—was published in a New York magazine with the flattering caption "Ilse Bing, that exciting young photographer, the Margaret Bourke White [*sic*] of Paris."[65]

Bing and her mentor caught up with each other during Van Loon's visits to Europe. The young woman also developed a close relationship with the writer's son, Gerard Willem Van Loon, a dancer who was established in Paris. With Willem, as he was known, Bing perfected her representation of movement. She pictured the dancer[66] as Mercury,[67] an aerial figure cut out against the sky, leaping and bounding as if suspended in the atmosphere. The raw energy of these photographs translates the infectious power of dancing, its "contagiousness," as expressed by an article in *Art et médecine*, in which an image from the series appeared in February 1934.[68] Another picture from this successful ensemble was picked to represent Bing's art in the 1933–1934 *Photographie* album,[69] where it was praised for its "dynamic" quality.[70]

Bing's talent for capturing the spirit and movement of dance attracted the notice of George Balanchine, who asked her to photograph the dress rehearsal of his ballet *Errante*, which premiered at the Théâtre des Champs-Elysées in June 1933, starring Tilly Losch. Pavel Tchelitchew, who had previously designed sets for Diaghilev's Ballets Russes, created a surreal, dreamlike mood for the occasion, largely through innovative lighting effects. To enhance the feeling of unreality, Tchelitchew replaced the usual painted backdrops with plain white curtains on which shadow images were projected. Bing's photographs, which constitute an exceptional document on a now legendary dance production,[71] convey the expressionistic quality of this lighting as well as the evanescent beauty of the choreography. The blurred effects of her images bring out the ethereal grace of the corps de ballet dancers whose light, fluid steps and frothy tunics made them look like nymphs in a painting by Botticelli. At the same time, the photographer boldly shot into the light emanating from the projectors so as to transform the ballerinas, surrounded by the halo of the back lighting, into immaterial visions. An early attempt at documenting a ballet as a continuous whole during an actual performance with no additional lighting, the *Errante* series represented a tour de force of delicacy and vivacity.

The technical superiority of Bing's photography was due in part to her contacts in Germany, which she had maintained despite the political situation and which enabled her to keep abreast of the Leica's latest improvements. In 1935 she took advantage of a trip to Frankfurt to visit the Leitz factory in nearby Wetzlar, at the invitation of the company's publicity representative in Paris.[72] This was her first time in Germany since the rise of Hitler. Curiously, the letters she sent from this trip do not betray any feeling of danger or estrangement. On the contrary, Bing affectionately described her reunion with her hometown and gaily recounted her pleasure at exploring the romantic streets of Wetzlar, the setting of Goethe's *Sorrows of Young Werther*. At the Leitz factory she was received as an honored guest, shown the most recent novelties, and presented with the gift of a "special instrument for close-ups."[73] Plans were also made to associate Bing more directly with the promotion of the Leica, but this proposition was never fully carried out.[74] The photographer nonetheless kept up a privileged relationship with Leitz, often purchasing new equipment from the company before it was put on the market.[75]

Throughout 1934 and 1935 Bing's work continued to appear regularly in the press, and in particular in *Harper's Bazaar*. At the same time, images from her Burgundy reportage were featured in *Le Document*, a new monthly magazine, launched in 1935. Bing also sold this magazine pictures from her reportage on the *Foire au pain d'épices*, some of which had already been published in *Le Monde illustré*. This was a common practice for photographers at the time. In the same way, Bing reused her photographs of a Salvation Army rally, which she had done on assignment for *Das Illustrierte Blatt*, to illustrate an article in *Vu*.[76] However, the work situation for independent photographers such as her was becoming more difficult. The influx of German immigrants to Paris after 1933 was partly responsible for this. Denied working papers by the French government, several turned to photography as one of the rare self-employed occupations that were open to them, and their arrival further restrained the already limited work opportunities in the press and advertising. Another important group of exiles took over the field as photography agents. Some of the newly founded agencies would become well known, such as Rapho, which was created in 1933 and united the talents of the agent Charles Rado[77] and the photographers Brassaï and Ergy Landau. Alliance Photo, founded in 1933 by the refugee Maria Eisner and the French photographer René Zuber, operated, like Rapho, in close collaboration with photographers. Most times, though, the freelance photographers, whose creativity had fostered the golden age of photojournalism, resented having to forfeit their independence and perceived the agent as an unnecessary and unproductive middleman.

Bing at first resisted the agency system. She trusted in her personal contacts with editors and her network of friends and patrons. In the spring of 1936 Van Loon was at last able to bring her over to the United States. She remained there for two months—April 13 to June 16—staying alternately at Van Loon's home in Connecticut and at the Algonquin Hotel in Manhattan. As if in response to Julien Levy's comments four years earlier, she set out, in her own words, to do "Leica-propaganda"[78] in America. It is surprising that she does not seem to have met with the dealer, but she did enjoy a one-person show at the Velvet Guild Salon, organized by June Hamilton Rhodes.

In an interview that accompanied the opening of the exhibition, Bing described her first impressions of New York. She was fascinated by the "wild" and "unnatural" quality of the cityscape and architecture.[79] In her letters she expatiated as well on the dizzying movement of the American metropolis that made her feel like "an atom wandering in the universe."[80] She experienced New York at first not as an actual city but as a fascinating confusion of sounds and fleeting visions, and she was not so much touched by the architecture as by the peculiar quality of the light, which she defined as "phosphorescent."[81] Although she produced masterful photographs of the most famous skyscrapers and monuments (the Chrysler Building, the Empire State Building, the Brooklyn Bridge) that brought out the boldness of their streamlined silhouettes, she was not attracted to the heroic aspect of the buildings. Rather, she sought, as in her moody panoramic views of the city and the skyline, to convey a rich sense of atmosphere. Inspired by the lonely poetry of empty subway platforms and deserted areas, she felt magic as well in the alleys of Central Park, which she represented as an enchanted garden, and in the artificial moonlight recreated by projectors inside a circus tent.

There were also gloomier aspects of New York. Exploring the city in depth, Bing captured the image of hobos gathering by the East River, at the Queensborough Bridge. She walked through the poor areas of the Lower East Side and was deeply affected by her discovery of Harlem. There are no photographs of this particular visit, but an image shot in another neighborhood aptly translates her sympathy for the plight of African-Americans, which she also expressed in a letter.[82] This photograph, whose undercurrent of social criticism stands out for its time, represents a black shoeshine and his white customer. The contrasting poses of the two men clearly express the inequality of their relationship. At the same time Bing's rapid eye brings out the details—the newspapers and the hats—which the two men share and which ironically establish a form of identity between them.

Despite her clear awareness of the city's sadder realities, Bing's experience of New York was undeniably exciting and filled with promise. A highlight of her stay was her meeting with the legendary father of modern photography, Alfred Stieglitz, who showed her images from his *Equivalents* series.[83] Van Loon eased her way into New York society, and she made fruitful contacts with the press. She visited the offices of *Fortune* and was put in touch with Kurt Korff, a key photography adviser at Time Inc., the magazine's publisher. The former editor-in-chief of the illustrious *Berliner Illustrierte Zeitung*—the leading illustrated paper of Weimar Germany—Korff was at that point busy with the creation of a new Time publication, *Life* magazine. The doors of the American photography milieu were opening up for Bing, and she was clearly tempted to stay on. By this time, however, she was no longer on her own.

Konrad Wolff, her fiancé, was waiting for her in Paris. A German Jewish refugee, Wolff was the son of Dr. Martin Wolff, a famous legal scholar. Following in his father's footsteps, Konrad held a doctoral degree in law, yet his true love was the piano, and after immigrating to Paris—where, as a foreigner, he could no longer practice law—he decided to dedicate all his time to music and later became a well-known musicologist. He and Ilse met in February 1935. They were neighbors at 8 Rue de Varenne, and Bing was first made aware of the young man by the sound of piano music

drifting through her window from his studio. The two were married in November 1937 and remained together for fifty-two years, until Konrad's death.

Despite this new turn in Bing's life, her return to Paris in spring 1936 was strenuous after the exhilaration of New York. In her last days in America she expressed her worries at going back with no definite job prospects ahead. Money was a great concern.[84] She was not alone in this situation. In September Florence Henri planned to move out of the Rue de Varenne building because, it was said, she could no longer afford the rent.[85] At this point Bing was willing to collaborate with an agent, at least for the American market. Favorably impressed by the professional attitude of the agencies[86] she had seen in the United States, she settled on Black Star. An offspring of the Weimar press, the agency was founded in New York by two emigrants from Berlin, the photo agent Ernest Mayer and the publisher Kurt S. Kornfeld, joined shortly after by Kurt Szafranski, the former publishing director of *Die Berliner Illustrierte Zeitung*, who also was involved with Korff in the launching of *Life*.

Alas, the association with Black Star was to prove unsatisfactory from the beginning. The number of actual sales of Bing's work was disappointing, and the agency's policy might actually have damaged her career in the United States. Choosing to bypass Bing in their contacts with the editors of *Time* and *Fortune*, the Black Star agents possibly severed the relationship she had already built with these magazines. Another source of misunderstanding was the use of the photographer's views of New York. Bing strongly wished to have these published in book form. The agency did nothing to support this project. Quite to the contrary, the agents seem to have opposed it as incompatible with their purposes because magazines, they contended, wanted only unpublished material.

As in Germany almost a decade before, photography was now suffering a conservative backlash both in the United States and in France. The beginnings of this "return to order" could be felt already in 1935. It was reflected in the selection of photographs published in that year's issue of *Photographie*. Idyllic landscapes, pictures of farmers and peasant women extolling the virtues of rural life and traditional values took over the pages of the album, which originally had been conceived as the luxurious showcase of the avant-garde. The quality of *Photo-Illustration* similarly faded as of 1936, and in 1937 the magazine stopped appearing on a regular basis. The change was also obvious in the reactionary stand adopted by Sougez with the foundation of the group *Le Rectangle*. In New York Bing's visit coincided with a growing disaffection with photography. There were fewer photography exhibitions and even the great discoverers of modern photography, Stieglitz and Levy, now favored showing paintings over photographs.[87]

The end of the decade was marked nonetheless by a number of important international photography shows. Along with the 1936 exhibition held at the Louvre, there was the landmark *Photography 1839–1937* retrospective organized by Beaumont Newhall at the Museum of Modern Art in New York, which was a milestone in the recognition of photography as an art form in the United States.[88] Newhall included four of Bing's photographs in the retrospective, which was a good average. A staunch supporter of the documentary style, however, he did not choose Bing's more abstract photographs. More representative of Bing's style was the selection she sent in 1939 to the

International Exhibition of the French School of Photography in Copenhagen, which constituted a summary of her work since her arrival in Paris: richly evocative Paris cityscapes, images of New York, and portraits. The exhibition itself represented the concluding act of the Paris School of Photography. It was also the last big international photography show in the line of *Film und Foto*.

That same year Bing was given an important one-person show at Chasseur d'images. The openings and parties held at François Tuefferd's gallery rallied the entire photography milieu. At one such event—a Mardi Gras costume party—Bing appeared in a striking Dada-like outfit, clad as an "image" with a belt of flashes around her waist.[89] The costume alluded to her perfect command of artificial lighting, which she was then putting to use in her portraits. Her 1939 solo show at Chasseur d'images featured some of these along with "impressions of New York," which elicited the compliments of a reviewer from the *New York Herald Tribune*, who compared Bing's art to that of a "born musician [reacting] to a musical instrument."[90]

After 1937, however, Bing's production slowed down considerably. She kept up with technical developments and experimented with color film as soon as it was put on the market,[91] but her inspiration was drying up. Her marriage to Konrad and the ensuing move absorbed much of her attention. She was also touched by current events. The tragedy of Kristallnacht, a night of violence in which hundreds of Jews in Germany were killed or injured and thousands of Jewish businesses and synagogues were destroyed, deeply affected her.[92] Shortly after this her sister, Liesl, left Germany for the United States. Van Loon had been urging her for some time to do the same and "get on the quota."[93] Transcending her fear of the future, Bing produced two last views of the Parisian landscape. Showing the panorama from her apartment on the edge of the city, both photographs were shot on the last Bastille Day before the war, on July 14, 1939. In the hazy distance, the Eiffel Tower in one picture and the Sacré-Cœur in the other appear as mirages, while the darkening clouds read as a foreboding of the coming catastrophe. Less than two months later, war was declared between France and Germany, and Bing and her husband were forced into permanent exile. Soon the Paris that had been the photographer's home would vanish. Yet the enchantment of the city would endure for Bing forever in the poetic documents captured by her Leica.

ONEIRIC DOCUMENTS: PHOTOGRAPHS FROM THE PARIS PERIOD

Urban Realities

In Paris Bing experienced for the first time the revelation of the magical spectacle of urban life. To depict the city's particular appeal, she did not have to roam very far. Her neighborhood of Montparnasse, then a modest area where the struggling artist mingled with the working poor, was rife with sources of inspiration. Thus, leaning out the window of her first studio on Avenue du Maine, the young woman captured the intriguing patchwork of ads lighting up the gloomy wall on the other side of the street. A fascination with posters and signs, both as graphic elements and as cryptic sources of meaning, was a recurring feature among Parisian artists and writers of the period. The Leica photographers, in particular, made abundant use of the involuntary poetry contained in

ads. Classic examples are Kertész's photograph of a woman sitting on a bench with a Dubonnet ad behind her, and Cartier-Bresson's *Behind the Gare Saint-Lazare*, in which a man jumping over a puddle seems to imitate the figure on a poster nearby. Bing's wall of placards was a Surrealist's dream come true, featuring such mysteriously alluring inscriptions as "*au rêve*" ("under the sign of dreams"), "*c'est encore moi, toujours moi, vous m'attendez*" ("me again, always me, I am the one you are waiting for") and "*regardez-moi, désirez-moi, dégustez-moi*" ("look at me, desire me, savor me").

A similar inspiration guided Bing to a torn poster of a film starring Greta Garbo found in the old, time-worn streets of the Jewish Ghetto, in the neighborhood of the Marais. The "Greta Garbo" photograph was probably Bing's most celebrated work in the 1930s. Critics waxed lyrical when evoking it: "If only you could see this forlorn bit of wall with its sad vestige of Greta Garbo, a shred of a poster hanging on the scabby façade of a building, between a seedy street lamp and a toothless shutter!"[94] exclaimed Sougez in *L'Art vivant*. To the journalist of the *Frankfurter Zeitung* reviewing Bing's 1932 show at the Galerie Trittler, this image masterfully debunked the myth of the movie star: "... just by the lapse of time did the persistent misery of this wall destroy the false, glued-on, glamour of that dear name and face, even better: made it crumble."[95]

The setting of the photograph is distinctly that of the *Vieux Paris,* the old, squalid Paris whose seedy streets triggered the imagination of Balzac and inspired the wanderings of Atget. As Sougez aptly pointed out, the décor is filled with emblematic details: a corner streetlight such as those under which crimes are committed and prostitutes linger, the faded sign of a cheap hotel, closed shutters on a derelict building. Bing makes the particular atmosphere of decrepitude almost tangible, showing the textures of plaster and stone, the coats of grime rubbed onto the buildings by time, and the rough surface of the unfinished side of a house, which looks like an open wound. This is the wall on which the Garbo poster hangs. Under Bing's lens, this tormented assemblage of rubble and peeling paper appears, however, as more than an anecdotal illustration of poverty and ruin. As an abstract composition it predates the *décollage* art of Raymond Hains, Jacques de la Villeglé, and Mimmo Rotella, whose lacerated and torn posters ripped off the walls of buildings opened a new chapter in the history of non-figurative painting in the 1950s.

Looming behind this image is also the memory of *The Joyless Street*, the German film directed by G. W. Pabst that launched Garbo as an international star. Indeed, the cluttered space of Bing's composition strongly conveys a sense of "joylessness" and lack of hope. It is not precisely a feeling of dramatic despair but of being trapped in a dead end. The largest portion of the image is blocked up by the crumbling wall on which the shredding poster is pasted. The narrow street or alleyway on the left side does not seem to lead anywhere. There is no true opening in the picture save for a small piece of sky, tightly wedged into the upper part of the composition.

Underpinning the documentary representation of an old section of the city is the metaphor of blindness. With its closed shutters, the building on the left of the picture offers but a blind façade. The empty upper section of the hotel sign blinds the view of the sky. Peeling off the blind wall on the right, Garbo's effigy has lost its eyes. The shred of paper curling over the star's nose resembles a blindfold, with the poster now evoking the classic image of Fate with her eyes covered. Significantly,

all that is left of Garbo is her enigmatic half-smile. The passage of time has, in effect, pared down the image of the star to her essential feature: an aura of melancholy and mystery.

Bing's vision of the streets of Paris was eminently symbolic. In the worn façades of the city she disclosed the invisible presence of chance and sought out the odd contrasts and juxtapositions, which, as she later explained, transformed the banal reality of everyday life into an "idea."[96] She was referring in particular to the photograph *Midi…*, one of her more complex symbolic compositions. The image presents the decrepit face of a building which has been abandoned for some time. The plaster of the façade is cracked, and the windows are broken. The lower part of the house is covered with a placard. Bing has cropped the image in such a way that only the upper section of the poster appears, thus isolating the mysterious inscription "*Midi…*" ("Noon"). The word "noon," which to one critic evoked the comforting break in a hectic workday,[97] reads in this context as the hour of Fate. It is the crucial moment par excellence, a turning point frozen on the brink of the unknown intimated by the ominous suspension dots. The enigma contained in these punctuation marks is symbolically repeated in the figure of the broken windowpanes, which open onto utter darkness.

Abandoned buildings and lonely streets in deserted neighborhoods were not Bing's only source of inspiration. In Paris she also fully approached the subject of animated street life for the first time. Previously in Germany, she had pictured people in their homes, or in public offices, but only rarely in the street. The free and casual pace of everyday life in Paris, in particular in the city's poorer areas, inspired her in a new way. Her style gained in fluidity and liveliness, as witnessed by the aforementioned series on the *Foire au pain d'épices*, the popular street fair held in a working-class neighborhood. The dynamic quality of the photographs is almost cinematic. Indeed this reportage shares many thematic and stylistic characteristics with the "poetic realist" school of filmmaking, which was then just beginning to bloom in France. The carefree workers pictured by Bing out on a spree at the fair could easily have appeared in a film by Jean Renoir or Marcel Carné, as could the debonair street photographer or the more exotic carnie coifed with a fez. As in these movies, Bing juxtaposed the realistic representation of a social milieu with the rendition of a strange atmosphere. Exemplary in this respect is the image of tree shadows projected onto one of the tents in the fair. These ghostly shadows evoke the drama of mysterious crimes taking place behind the scenes at the fair, as they so often do in the films of the period. More than a mere popular scene of entertainment, the fair is viewed as the abode of destiny, as suggested in Bing's repeated pictures of wheels of fortune. Not all is mystery and potential tragedy, however. In this series Bing, as if swept up by the general good humor of the event, reveals as well a touch of light irony. Some of her images border on caricature, such as the profile portrait of a woman whose glasses resemble the fish bowls behind her, or the candid shot of a couple eating ice cream.

The mood of freedom experienced in the streets of Paris also affected Bing's approach to other cities. She applied a direct humanistic touch to views of New York street life, such as her images of men playing cards on a sidewalk. This greater ease is similarly obvious in her photographs of Amsterdam. The previously discussed image of the two prostitutes in a window is a striking example of this. The general composition of the photograph is cubistic, yet geometry does not take

precedence over emotion. The key element is the rectangle. The repeated rectangular shapes—the door, the window sash, the opening in which the prostitutes appear, the grill under the window—form a grid pattern in which the women seem trapped. The prevailing feeling is one of enclosure. However, the structural complexity of this picture does not engulf its main human feature: the dark, bold gaze of the prostitute looking out, which, echoing Walter Benjamin's definition of photography as a direct imprint of reality, seems to have "seared" the image.[98]

A children's scene produced two years later in Amsterdam further reveals Bing's looser manner. The photograph represents groups of little girls dancing in the street to the sound of a barrel organ. The angle is level, the space unstructured by any obvious geometric patterning. It is the open space of the street, a setting rich in picturesque details, that provides a strong sense of atmosphere. The center of the image is occupied by the baroque figure of the organ, a massive piece of *art naïf* in harmony with the imaginations of childhood. Of note as well is the painted sign on the right, an example of folk art created by a childlike hand. At the core of the scene is a mood of artless spontaneity, vividly embodied in the blurred vision of the little girls spinning. The entire photograph seems caught up in a twirling, waltzlike rhythm. To enhance this impression, Bing has organized her composition along a curved line, which runs from one group of little girls to the other. Renouncing the rectilinear dynamism of her more constructivist images for the fluid representation of pure movement, the photographer attains here her ideal of "active geometry."[99]

Active Geometry

The precoccupation with geometry was common to the period and may be found in the work of several photographers from the 1930s. To Ilse Bing, however, geometry had to be combined with the rendering of time and movement. She herself described her method in an analysis of the photograph *Three Men Sitting on Steps at the Seine*, shot in 1931. The picture presents a view of steps leading down to the Seine and of the quay below. It is taken from a high angle, looking down on a sequence of three men each sitting on one of these steps. On the edge of the quay, a fourth man sits pensively glancing up. A fifth man, strolling along the quay, has just entered the photograph from the left. This man is a pivotal element of the composition as Bing later recalled in her description: "In the background, a man comes walking forward. I saw him before he was in the plane, but I waited until he had reached a specific point. . . . Without consciously thinking about it, I wanted him in the picture, because his incidental passing-by demonstrated that the whole situation was part of the movement of time. I wanted him at that point, because this way the composition was harmoniously closed, and it expressed peaceful rest. . . . If I had snapped the picture before the man was in it, I could only have produced a fixed composition—which might have looked quite nice—in which this situation would have been isolated from the constant vibration of life."[100]

The geometric structure of the photograph is quite apparent. A line runs through the five men composing the outline of a triangle, while the oblique angle chosen by the photographer brings out as well the triangular cut of the side of the steps. The space appears divided into five segments, which are clearly distinguished from one another by pattern or texture: the band of steps in the

foreground; the sawlike row of larger steps on which the men are seated; the cobbled stretch of quay; the border of the quay; and the wedge of water. The three men of the title are seated in mathematical succession at regular intervals: three steps from the first man at the top to the second, then two steps, then one. The coincidental perfection of this alignment, which first attracted the photographer's notice, is enhanced by the viewpoint. Seen from the back, the men appear almost as interchangeable figures or pawns. In a sense, they might be doubles. Indeed, there is a mirror effect in their almost identical position. Each concentrated on the object of interest directly in front of him—the newspaper, the man painting in front, the canvas—they are the very image of repose.

Yet at the same time this tranquil scene of perfect immobility relies on a precarious balance. The depth of field combined with the tilted point of view creates a slight impression of distortion, as if the whole space of the photograph were leaning to one side. Thus, the figure of the man seen entering from the left almost appears as an acrobat doing a balancing act. The composition's point of stability is the man seated on the border of the quay, with his feet firmly planted on the ground. He is situated at almost the exact center of the picture's horizontal border. His presence, however, does not arrest the implied movement of the composition. On the contrary, his upward glance enlivens the scene perhaps even more potently than the man walking along the river. It reads as a candid moment of life caught on the spot, introducing a vivid impression of here and now. Significant as well is the direction of the man's gaze, pointing outside the space of the picture toward the photographer. Thus, the image is open both to the next moment—with the implication of movement—and to the space beyond—with the allusion to the presence of the photographer.

Bing similarly strove to open the photograph beyond the closed space of the composition in the iconic *Self-Portrait with Leica*, also executed in 1931. It is interesting that this image, which has become emblematic of Bing's art, does not appear to have been exhibited before the rediscovery of her work in the 1970s. Perhaps Bing avoided showing it because it was too closely related to Florence Henri's own self-portrait, which contemporary opinion acknowledged not only as the photographer's masterpiece but also as a symbol of the New Vision.[101] Bing created her own image in the first stages of her arrival in Paris as if, in the same gesture, to both pay homage to and defy the genius of the woman who drew her to the city. The photograph must also be understood in the continuity of Bing's fascination with self-portraiture, which she expressed at each momentous period of her life and evolution as an artist. It reflects as well the particular predilection of the new wave of women photographers for the genre. Thus, the mise en scène of the artist with her camera—absent from Henri's photograph—calls to mind Germaine Krull's *Self-Portrait with Ikarette*, shot in 1925.

The photograph was taken in Bing's room at the Hôtel de Londres. It shows the young woman, "brown eyes as quick and candid as the shutter of her camera,"[102] peering intently at her image in a mirror and focusing her Leica at the same time on her reflection. A second mirror on the side throws back her profile. The photograph's complex interaction between the two reflections in the mirror and the reflection in the camera's eye blurs the simple notion of the image as an objective duplication of reality and alludes to the illusory nature of all representation. Indeed, Bing's play with mirrors has a certain theatrical quality to it. The picture is artfully staged. The young woman

is wearing a dress of heavy cloth, which somehow resembles a costume. The curtain in the background completes the metaphor of the stage or theater. There is as well a certain dramatic quality in the photograph's tonal range. The choice of orthochromatic film[103]—a film only moderately sensitive to red rays—accentuates the dense, velvety aspect of the sleeve's cloth and brings out the dark, burning presence of the lips and eyes.

Because the Leica's viewfinder was not directly coupled with the lens, the eye with which Bing is focusing appears slightly above the camera. This produces an important distinction from the New Vision paradigm of the "camera eye," which for instance inspired Germaine Krull's self-portrait. Whereas Krull all but disappeared behind her Ikarette, forming with it some strange and powerful woman-machine, Bing reasserts the subjective presence of the artist. The questioning gaze with which she confronts both her own image and the spectator endows her photograph with a psychological aspect that is foreign to the objectivist tenets of modernism. It also introduces the element of time as the sense of duration. What is represented is not a fixed image but a photograph in the very process of being shot.

Time here appears at once as ongoing and suspended. Although the actual photograph is evidence that Bing has indeed released the Leica's shutter, it seems paradoxically as is if the "decisive moment" of the snapping of the picture is forever suspended. In that sense, the photograph remains perpetually open to completion. The mirror on the side adds to the representation of the creative process as uninterrupted. This second reflection constitutes a notable difference from both Krull's self-portrait and the more direct example of Henri's own mirror composition, which presents the spectator with a single image closed on itself—an icon, in that respect. With her arms crossed and an enigmatic expression floating about her face, Henri's double seems to have surfaced in the mirror as through a conjuring trick. Bing was quite struck by the bewitching power of this apparition, which she likened to that of a "spider in her web."[104]

Contrary to Henri, Bing deliberately fragments the composition of the photograph and diffracts the attention of the spectator. Her conception of the picture's space is strikingly cubistic. It is a flattened, two-dimensional space in which face and profile, as in a painting by Picasso, are disjointed from one another and put on the same plane. This geometric aspect of the photograph is accentuated by the detail of the pulled curtain in the background, which precludes any opening. The second mirror, which reflects the profile of the artist, does not provide any more sense of depth. Quite the opposite, rather than lead the gaze of the onlooker into the picture's space, it projects the image back toward this same onlooker. Yet, in one version of this image, a certain sense of perspective is procured by the apparently incongruous detail of a matchbox lying diagonally in the foreground (a detail itself reminiscent of Cubism). However, the composition most often reproduced today leaves out the matchbox. The tight cropping of the latter version brings out all the more the cubistic abstraction of the photograph.

Just as the photographer unveils the process by which she produces her portrait, so is the viewer compelled to reconstruct the photograph while looking at it. This active vision is the very opposite of contemplation, which the photographer's gaze—insistently soliciting the attention

of the spectator—renders impossible. Whereas the remote elegance of Henri's composition was an appeal to a meditative approach, Bing's Leica portrait is animated by the immediacy of the instant. Exploring the ideas of instantaneity and simultaneity, the *Self-Portrait with Leica* is not so much a self-representation as a concentrated expression of Bing's obsession with the moment. The moment, that is, not as a fixed point in time but as the conjunction of multiple directions and occurrences suspended in fugitive harmony.

Bing's conception of time was not linear but owed much to the relativistic theories, which marked her period. This revolutionary approach informs, in particular, the photograph *"It Was So Windy in the Eiffel Tower,"* in which visitors are seen walking up and down the steps leading to the tower's platform. The subject of people on stairways has a definite cachet of modernism as exemplified by Marcel Duchamp's seminal *Nude Descending a Staircase* of 1912 and, closer to Bing, Oskar Schlemmer's *Stairs of the Bauhaus* of 1932. In her photograph Bing adopts a high angle, typical of the New Vision, with the result that the portion of the spiral staircase depicted seems abstracted from the rest of the construction and almost suspended in mid-air. The most remarkable effect, however, is an impression of confusion as to the actual direction of the people mounting and descending the stairs. Indeed, although the logic of the scene makes it clear that the man and woman on the right are on their way up, they appear to be moving down. The group of visitors actually seems not to be going up or down but round and round as on a merry-go-round. This circular motion visually translates the gust of wind of the title, to which the detail of the man holding on to his hat also clearly alludes. It is as if the scene were caught in a spinning vortex. A feeling of dizziness arises, which is conveyed as well by the dappled light. Up and down, before and after, are fused in the rhythm of perpetual motion, and the ordinary parameters of time and space are swept up in the vertigo of movement.

Vertiginous as well is the twirling movement of the cancan dancer who adorns one of Bing's most famous photographs. Resting on one leg as on a point, with her skirt blown out, the figure of the dancer evokes that of a top. Her arms, still caught in the spin, have all but disappeared. The image was shot using a long exposure so that the successive positions of the arms are compounded into one single blurred image. The Leica has, in fact, snapped the movement of the dancer just as it was dying out. Thus, the leg is already in focus, as is part of the head. This combination of movement and repose calls to mind the Surrealist definition of the *explosante-fixe*—the fixed or still explosion, which André Breton designated as an essential attribute of the "convulsive beauty" he aspired to. Breton wrote in *Minotaure* that the word "convulsive" "would lose all meaning in my eyes if it were conceived in movement and not at the exact moment when this movement expires. There can be, according to me, no beauty—convulsive beauty—unless it be through the affirmation of the reciprocal relation, which unites the object considered both in movement and in repose."[105]

Paradoxes such as this were at the heart of the Surrealist aesthetic, the most important being the movement's fundamental creed advocating the juxtaposition of dreams and reality. Similarly, Bing's "explosive" vision of the cancan dancer is, in a sense, a photographic oxymoron: Aglow with the warm trepidation of life, it is also an image of immaterial grace, which reveals ultimately the

young woman's obsession with the oneiric dimension of reality. As Bing described it to her friend Ella Bergmann-Michel, photography's unmatched capacity to seize fleeting instants of reality opened up for her the possibility of capturing the wondrous world of dreams: "What interests me fundamentally," she wrote, "is the 'apparition' [*Erscheinung*] of people and things. By 'apparition' I mean that they are here but at the same time elusive, part of the unreal. They can in the next second be gone like a dream. And yet at the same time they are still here, so incredibly real."[106]

Dream Visions

Even when depicting the most ordinary environment, Bing's photographs have a dreamlike aura. The rendering of air and atmosphere was a key aspect of this style. It is indeed the ability to render the "air between the things"[107] that in large part justified the young woman's choice of the Leica. By enlarging the small-format negative she could achieve "a certain softness and atmosphere"[108] as opposed to the dry sharpness and mass of details that distinguished contact prints made from large-plate negatives.

Such "softness," however, was rejected by most professional photographers as mere "graininess" and was perceived originally as the Leica's main drawback. In Bing's expert hands, though, it became a desirable effect. She was not the only one to be seduced by the artistic possibilities involved in the production of a grainy print. Pierre Gassmann, then still a young photographer who had just fled to France from Germany, peremptorily contradicted Brassaï on the question of graininess, asserting that it was "photographic."[109] Gassmann later went on to become one of the most famous photographic printers of his day.

Night photography in particular was an important domain in which Bing could express her oneiric vision of reality. In all likelihood it was in Paris that she started photographing at night, the earliest examples of night photography in her work being dated 1932. Brassaï published *Paris de nuit* (Paris by Night), his masterful homage to the beauty of the city at night, at the end of that same year. In January 1933 he also published an essay on his technique in *Arts et métiers graphiques*.[110] Whether Bing knew of Brassaï's night photography prior to taking her own photographs cannot be ascertained.[111] An early view by her of the Avenue du Maine at night demonstrates that she had not totally mastered some of the problems Brassaï successfully tackled, namely the representation of a lit lamppost, which in Bing's image burns with a naked light that contrasts sharply with the rest of the décor. Brassaï's answer to this kind of unbalance was to mask light sources and let the excess of lighting be absorbed by the atmosphere. Bing's own atmospheric night scenes were achieved by quite a different route and with a distinctly different result.

Whereas her colleagues relied on the more sensitive plate cameras for night photography, Bing again stretched the technical possibilities of the Leica. Because she could not find in Paris 35mm film that was sensitive enough for night photographs, she had a special film imported from Frankfurt.[112] This had to be processed within two weeks with a special developer, which Bing prepared herself. But however superior the sensitivity of this film, it could not compete with the larger format negatives. Rather than try to emulate their greater definition, Bing played with the softer rendition

of the Leica and turned apparent flaws into expressive details. Thus, in the photograph *Loterie Louis Lam…* she transfigures the image of a lottery stand in a street fair at night into a dreamlike vision. The people, leisurely strolling in search of easy entertainment, are depicted as ghostly and fantastic silhouettes. Their features are completely erased and their contours blurred so that they seem like the figures in a strange shadow play. The surrounding night is represented as a dense, black band of absolute darkness out of which only the vividly lit stand emerges. The lights of the stand are overexposed, but what might elsewhere be considered a defect here becomes an important element of an enchanting vision. So bright that they seem to be detached from their background and to be floating in the night, these incandescent lights have a hallucinatory presence.

The magic of artificial lighting was an obvious source of inspiration for Bing. It is a central element of her effervescent visions of cancan dancers and of her dreamy New York circus series. In the iconic photograph of the single twirling cancan dancer, the long exposure transforms the stage lights into pure white spots dotting the dark background like specks of paint. At the same time, there is a clear simile between these spots and the dots on the dancer's costume, which enhances the general impression of enchanted lightness and movement. It is as if the intense spinning movement of the skirts had projected the dots to the ceiling, like balls thrown up in the air by a juggler and now hanging in levitation. In the same way, in the group photographs of the Moulin-Rouge chorus girls, the tremulous lights in the background—the illuminations on stage were a replica of the sails of the Moulin-Rouge windmill spinning—duplicate the blurred, frothy skirts of the dancers caught in movement. The soft, dreamy lines of the image seem to be quivering as if seen through a haze.

In the New York circus pictures Bing utilized the even lighting of the floodlights to compose a softer and more ethereal atmosphere. As distinct from the feverish, almost boisterous animation of the dance hall, in the circus all is delicate grace and aerial movement. Not that Bing underplays the excitement of the circus performances. For example, the photographs of acrobats on horses going around the ring have some of the trepidation and flamboyance of Toulouse-Lautrec's celebrated images of the circus. Partially blurred, however, Bing's visions of the acrobats divest them of their corporeal density. This immaterial representation of the circus is also very much at the core of Bing's spectacular photograph of horses leaping through flames. The long exposure makes the figure of the horses take on a ghostly aspect: The silhouette of the first horse has almost completely vanished as if swallowed up by the flames. The most emblematic photographs of the circus series are perhaps those entitled *Circus Acrobat with Ball*, and in particular the picture in which the ball is adorned with stars. Surrounded by darkness, the acrobat appears weightless. The base of the platform on which he rests is invisible. The only apparent support seems to be the crossing floods of light emanating from the projectors, in which he seems to be suspended. Gently shimmering, the figure of the acrobat becomes a projection of the imagination, a fleeting illusion bound to disappear when the lights go out.

The balance between the aura of the acrobat, the soft light of the projectors, and the deep surrounding darkness demonstrates Bing's exceptional command of the art of photographic printing.

A virtuoso of darkroom techniques, the photographer would melodiously blend luminous bright whites and charcoal blacks in a single print while avoiding the brutal dissonances of sharp contrasts. The result is an impression of soft unreality. Thus in the photograph *Orchestra Pit, Théâtre des Champs-Elysées*—shot prior to the performance of the ballet *Errante*—the music stands appear to be floating in a dark void. This effect is partially obtained by the choice of an oblique angle. The music scores are organized along a diagonal line running from the lower right corner to the upper left, evoking leaves blown up in one direction by the wind. The key stylistic component, however, is the printing, in which the glimmer of the scores very fluidly fades into the dense, velvety obscurity of the pit.

In a contemporary photograph, *Boucherie Chevaline* ("Horsemeat Butcher"), Bing again played with dense blacks with a result that was less dreamlike than *Orchestra Pit* yet equally surreal. The photograph represents the gilt horses' heads adorning the front of a butcher shop specializing in horse's meat.[113] The overall texture of the print is grainy. The larger part of the shop is enveloped in darkness. Emerging from this thick black mass, the heads of the horses have a strange and ominous presence enhanced by the bright shine of their paint. Resplendent with a metallic sheen, they rise out from the obscure background with the disquieting force of pagan idols.

The silvery, metallic highlights of this photograph read retrospectively as the prelude to Bing's experiments with solarization. This technique, favored by the Surrealists, involves exposing a partially developed negative a second time so that in the final print the positive and negative values are partially reversed. In a solarized photograph objects seem to glow with a supernatural aura, and the borders between dream and reality appear to have dissolved. Discovered in the nineteenth century, the process was reinvented by Man Ray in 1929 and was henceforth associated with him. By 1933, however, several other photographers had started to adopt it for themselves. Man Ray's apprentice, Maurice Tabard, published "Notes on Solarization" in the November 1933 issue of *Arts et métiers graphiques*, in which he explained the technical aspects of the process in detail. A few months later, in the spring of 1934, Ilse Bing began making her first solarized images. She practiced this avant-garde process for a very short time, using it only once after 1934.[114] During this interlude, however, she manipulated it with such skill and originality that she may be said to have recreated it in her own right.

The solarized photographs represent the most radical expression of Bing's imaginary world. It is significant that their creation coincided with the acme of Bing's production and official recognition as an artist. She adopted this new process at first as an ideal mode to convey the magnificence of the great Parisian monuments. Her first solarized images depicted the florid turn-of-the-century splendors of the Pont Alexandre-III and the flamboyant effluence of the fountains at the Place de la Concorde. She had pictured these fountains at night before, dazzling with the light emanating from the square's many lampposts. With solarization, however, she was able to intensify the magic of this vision so that these same lampposts now seemed to float in a silvery haze, circled with a phosphorescent outline—"a magic halo, an enchantment surrounding reality," in the words of Sougez.[115] In one image the water splashes from the fountain as an explosion of light ending in long

metallic trails. In another image a fountain at the Rond-Point des Champs-Elysées bursts out like a firework. In this last photograph the water seems somehow incandescent, while the lights around the square of the Rond-Point appear like dots of fire directly burnt into the print. Although Bing never distressed the negative, the effect here is similar to that obtained by Bing's friend and colleague Raoul Ubac in his *brûlages*, a process in which parts of the negative's emulsion were melted.

Bing's solarized images portray also more banal subjects, such as the anonymous façades of the photographer's neighborhood. In one image she immortalized the lamppost and number adorning her own building, at 8 Rue de Varenne. Again, the elements in the picture seem to be floating in a dreamlike atmosphere. The lamppost appears to be melting while the plaque bearing the name of the street, "Rue de Varenne," blazes like a hallucination. Bing's Parisian home of the "Rue de Varenne," like Dora Maar's own "Rue d'Astorg" (celebrated by the latter in her Surrealist photomontage, entitled *29, Rue d'Astorg*), is clearly not meant to be perceived as a place existing in reality. Yet to the photographer the enchantment conveyed by this image had more truth than any straight document.

In moving to Paris, Bing had sought to fulfill her career as an artist. It was the lure of the art scene that had prompted her to emigrate, and she did indeed find much support and nourishment in the thriving life of the artistic, in particular the photographic, community. But once she actually set foot in the capital, the animation of the artistic milieu faded behind the attraction of the city itself: its monuments and its ordinary houses, its splendor and its squalor, its light and its very atmosphere. Here for the first time she was able to completely achieve the ideal fusion of dream and reality that she had yearned for since she was a child. Her photographs of the Paris period visually translate the emotions expressed by her friend Siegfried Kracauer as he wandered through the streets of the city: "At the same time as one is walking through lively streets, they have already become as distant as memories, in which reality is fused with the dream that is its fluctuating image and in which refuse is mixed with stars."[116]

With the outbreak of war, however, reality harshly reclaimed its rights. For a time all the stars seemed to have been extinguished and only the refuse remained, raw and brutal. Although she continued to cling to her precious vision, Bing could not blind herself to events. When the deluge would finally pass over, she would find that she could not look at the world with the same eye, nor in the same delicate light.

THE PAST LIES / BEHIND A LOCKED DOOR / . . . / THE DOOR TO THE FUTURE / REMAINS AJAR /
AND LETS ME PENETRATE / INTO . . . / THE FUTURE PAST / OF WHICH I MYSELF SHALL BE PART . . .

—Ilse Bing, "Future Past," 1979[1]

NEW YORK
ART AFTER THE DELUGE

A NEW LIFE IN A NEW WORLD

The events of the Second World War dramatically altered both Bing's life and art, which were overtaken for a long period of time by a deep sense of alienation. Forced to abandon Europe for America, she had to painfully rebuild a career at age forty-two in a country that despite her previous visit appeared strange and disconcerting. This feeling of estrangement was reflected in a gradual change in style. A sharper light took over her photographs, which became more detailed and abstract. In later notes and interviews she claimed this evolution was due to one single dramatic event, the dropping of the atomic bomb in 1945, of which she wrote: "Mankind's perception of the world was drastically affected . . . the moment was torn out of the continuous course. The world was no longer given whole and our daily thinking became impregnated with traces of silence."[2]

The reference to the atomic bomb obscures Bing's personal experience of the war and the private tragedies to which she only partially alluded to in later life. The catastrophe began a few days after war broke out between France and Germany. Her husband, Konrad, was immediately interned following passage of a measure by the French government that required that all male refugees from Germany be rounded up by the police as potentially dangerous aliens. It is at this time that Bing in her anguish turned to Sougez for help, only to be met with silence. A few months later, on May 15, 1940, Bing was in turn confined to the Vélodrome d'hiver, the infamous sports stadium from where Jews would be sent to the death camps during the summer of 1942. From there she was deported to the internment camp of Gurs in the Pyrenees, near the Spanish border.

Conditions in the camp of Gurs were harsh. Later Bing would insist that this was not a simple internment camp but truly a concentration camp.[3] Its official designation was indeed *camp de concentration*. Founded in 1936 to take in refugees from the Spanish Civil War, it was used at the outbreak of the war with the Reich to hold German women exiles. They were lodged in spartan barracks on muddy soil and given little food; by the time Bing was released she was severely undernourished.[4] Contrasting with this grim reality, the beauty of the natural surroundings provided some form of

escape. Bing later recalled her pleasure at watching the sun setting on the Pyrenees. Friendships were also formed, which alleviated some of the pain. Bing was particularly happy to share barracks with the political philosopher Hannah Arendt. But nothing could blot out the burning feeling of shame and degradation, and the absolute loss of freedom. All throughout her stay in the camp, Bing kept a razor blade ready to cut her wrists.[5]

In the meantime, Konrad and many other German exiles were able to ease their plight by joining the *prestataires*, a corps of foreign internees who worked in the fields to replace the farmers drafted in the army; in exchange, they were given military status. Konrad and his group were taken to a camp in the center of France,[6] then followed the army in its flight south as the German troops advanced. While in Gurs, Bing had no news of her husband for nearly a month. Her anxiety reached a climax when on June 17, 1940, France capitulated. Three weeks of terrible confusion followed before contact was finally resumed with Konrad, who had taken refuge in Périgueux. After much difficulty he managed to intervene with the camp's authorities and arrange for Ilse's release, and the two were reunited on July 11. Carrying with him an official letter of discharge from the French army, Konrad was able to acquire legal papers for himself and his wife. This protection lasted throughout the time that the couple remained in France. Although it did not shield them from all danger, it helped them avoid the terrible fate of the stateless Jews, who were the first victims of persecution.

From Périgueux the couple made their way to Marseille, where they hoped to board a ship to the United States. Despite Van Loon's active help and the additional intercession of Carmel Snow, it took them nearly a year to obtain the necessary visas. It was a long and arduous process, bordering at times on the Kafkaesque. The usual route to America went through Spain and Portugal. In order to validate the precious American visa, the candidate for emigration had first to present identity papers or, in their absence, a French affidavit, then purchase a boat ticket, and then again apply both for an exit visa from the French government and for transit visas delivered by the Spaniards and the Portuguese. The exit visa was difficult to obtain and the transit visas almost always delivered late, so that by the time they were issued the exit visa and the affidavit often were no longer valid, and the entire process had to be started all over from the beginning. Bing and her husband obtained a U.S. immigration visa in January 1941 and shortly after the French *visa de sortie*. The transit visas, however, were not only delivered late but contained errors. The delay obliged the couple to book passage on another boat, and the American visa had to be renewed.[7] At last on May 6, 1941, they departed aboard the S.S. *Winnipeg*. A new passage to the United States had opened up temporarily through the French Antilles and the ship was bound for the French colony of Martinique. From there the refugees were to board another boat to an American port. For Ilse and her husband it was a narrow escape. A few days after they set sail the French secret police, the *Sûreté*, was at their hotel in Marseille looking for Konrad.[8]

The voyage aboard the *Winnipeg* offered a welcome respite from the continual anguish and danger of wartime. In the crowd of refugees were seven photographers who along with Bing soon formed a small fraternity. These were the Germans Josef Breitenbach, Yolla Niclas, Fred Stein and

Monie Tannen, the Hungarian Ylla, the French Lipnitzki, and the Belgian Charles Leirens.[9] But the group had not yet seen the end to their trials. Three hours before landing in Martinique, the *Winnipeg* was accosted by a British ship and directed to Port-of-Spain, Trinidad, which was still ruled by Great Britain. The refugees of German origin and from countries allied with the Reich were once more transferred to an internment camp as enemy aliens. After a week's internment, however, the British released them and allowed them to travel to the United States. On June 13, 1941, Ilse Bing and Konrad Wolff arrived in New York in pouring rain.[10] Liesl, Bing's sister, was there to greet them at the pier along with the Kracauers.[11]

The first few months were relatively easy. Gerard Willem Van Loon lent them his Washington Heights apartment, and although Hendrik was now sick, the Van Loon network was still active. Bing resumed contact with June Rhodes, and it is probably her recommendation that prompted the *New York World-Telegram*[12] to publish an interview with Bing,[13] which brought the name of the photographer back into the press as early as August 1941. Yet there were grave troubles with which to contend. In November Bing received an alarming letter from her mother. Johanna Bing's frail health had deterred her from leaving Germany when it was still possible. Following Kristallnacht, Ilse had come up with several unlikely plans to bring her mother out of the country, including a scheme in which an American friend would smuggle Mrs. Bing in her car over the border into France.[14] Now Johanna sent word that many of her friends were deported and that the Nazi stranglehold was closing in on her. Clinging to one last desperate hope, Bing and her husband frantically tried to borrow the money that would buy her mother a visa to Cuba. It was too late. In the beginning of July 1942 Johanna was still at home in Frankfurt. This was the last that was known of her. It was not until September 1945 that Ilse and Konrad found out her fate. She had been deported to Theresienstadt and died on her arrival on August 20, 1942, "from a heart attack, caused by the strain and excitement of the transport."[15] There is no direct report of the manner in which Bing received the news. Whether in letters, notes, or interviews, she never mentioned her mother's death. Her silence alone bears testimony to her grief.[16]

In later years Bing looked back on her arrival in America with bitterness. Some of the people who had fêted her during her first visit to New York in 1936 as an important photographer from Paris now turned their back on the refugee.[17] The context, however, was very different. The interest in photography had subsided, and museums and galleries were no longer actively promoting the new art. In the press, on the other hand, the use of photography was more commonplace and the former stylistic innovations had settled into accepted forms. To survive in this new and unwelcoming environment, Bing and her husband were obliged for a period to rely on menial work. While Konrad gave piano lessons, Ilse eked out a living by producing identity pictures for German exiles.

Undeterred by these difficult times, Bing set out to rebuild a career with what she had been able to save from the disaster of war. She had managed to bring with her all of her negatives and most of her photographic equipment,[18] and was eventually busy again with advertising and portrait work. Soon she was able to reconstruct a network of prestigious clients such as Mrs. Nelson Rockefeller and her children and the Baron Robert de Rothschild. In 1950 she was honored with an assignment

to portray the war hero and future president General Dwight D. Eisenhower and his wife, Mamie, for *Life*. Seeking to widen her clientele, Bing also invented for herself the position of an "itinerant photographer." She would travel to big cities across the country and organize portrait sittings in people's interiors. St. Louis, Missouri, in particular became a second home to her, and her sessions there provided her with a regular source of income throughout the 1940s and 1950s. During these trips she developed a special skill for photographing children and came to be known as an expert in child portraiture. Bing's travels provided her as well with the opportunity to discover her new country, of which she became a citizen in 1946. The tie was now irretrievably broken with the Old World; as Konrad noted, Bing felt "exiled, permanently . . . from France."[19]

In the context of the New York art world, however, Bing still defined and introduced herself as a French artist. Her first official reappearance on the art scene occurred in late 1942 in a benefit group show held for the war effort at the prestigious Wildenstein Gallery. A few weeks later, in the winter of 1943, she was invited to represent French photography in the important exhibition *Art in Exile*, organized by the New York Public Library. As indicated by the subtitle, "an exhibition of banned European art," the show was meant as a reply to the infamous *Entartete Kunst* ("Degenerate Art") exhibition produced by the Nazis in Germany in 1937. The artists selected represented nearly every major artistic movement of the last thirty years. Thus, Bing's photographs appeared alongside the works of Marc Chagall, Max Ernst, George Grosz, John Heartfield, Wassily Kandinsky, Paul Klee, Oskar Kokoschka, Fernand Léger, Tamara de Lempicka, Franz Marc, André Masson, and her mentor Van Loon.

Such reunions were particularly welcome to Bing, who despite her friends and her work could not erase the past from her mind. Overcome by grief for their lost relatives, and for a lost world, neither she nor her husband was able to fully rejoice at the end of the war. Sad news mingled with good tidings. One such good message was that the majority of Bing's prints had survived the war intact in the storage where they were left in Marseille. Yet many of them absurdly had to be destroyed after being shipped to New York. The duties claimed by the U.S. customs officials were too high for Bing's meager means. In haste, she selected a small number of the best photographs and threw the larger part away.

It was not until 1947 that Bing "found herself again."[20] That year she traveled back to the old continent. For the first time in nearly ten years, she visited Frankfurt. The experience was traumatic.[21] The spectacle of the city in ruins was devastating, as can be judged by the photographs produced that very same year by her old acquaintance Pierre Gassmann. Unlike other exiled German photographers, Bing could not muster the courage to document the disastrous state of her home country. In Paris, on the other hand, where she now returned for a three-month stay, she felt her inspiration come to life again, and she took up her camera with new vigor.

Her approach to the city at that time appears grounded in her past experience yet devoid of nostalgia. She explored her old neighborhoods: the area near the Porte d'Orléans, where she and Konrad had last lived, and the portion of the Boulevard Raspail close to her studio on Rue de Varenne. She also revisited some of her favorite themes, such as the timeworn façades of old

buildings in the poorer areas, and the signs and posters adorning shops and streets. Gone, however, was the dreamy quality that characterized her earlier work. An even light illuminated these new images in which the elements of Parisian scenery appeared in crisp detail. Bing's vision was now less subjective and more matter of fact. Although she was as enamored as ever with the city, she was no longer part of its life and her photographs bear a sense of distance. In the pictures from this period, objects dart out toward the onlooker unmediated by personal impressions or atmosphere. The difference between the prewar photographs and the series from 1947 is further manifest in Bing's later representations of placards and signs. Previously she had interpreted these as poetic enigmas, whose mysterious meanings added a surreal dimension to the urban landscape. Now they were to be appreciated either for their purely graphic attributes or as sources of visual puns. Thus, in the image entitled *Scandale*, the striking, almost garish poster, which occupies most of the image, does not elicit any reverie. With its aggressive typography—enhanced by the bold exclamation points—and loud imagery, this ad for teasingly "scandalous" lingerie points to the dawn of the age of fast and easy consumerism. At the center of the composition a woman, dwarfed by the triumphant placard, advances slowly. Head bent, shoulders slightly hunched over, she seems wrapped in her thoughts and despite her elegant attire, introduces a note of melancholy. Bing, however, does not linger on this figure, who appears here mainly as a foil for the buoyant lingerie ad and for the brisk pace of the people rushing by. One of these, a man, quickly turns his head toward the woman. His stare stands in for the gaze of the photographer who, shooting the scene from a distance, assumes an almost voyeuristic stance.

This distant attitude went hand in hand with a growing taste for abstraction that was not tempered by the representation of movement. Exemplary of this is the photograph of a Paris street cleaner with two passersby. The image is shot at a very high angle, bringing out the fundamental geometric elements of the composition as described by Bing: "The triangle of the three men's position, the cracks in the pavement combined with the straight lines of the street markers and the outstanding circle of the sidewalk produce an abstract composition, independent from the surroundings."[22] As opposed to Bing's earlier photographs, such as *Three Men Sitting on Steps at the Seine*, the actions of the three men represented here appear to be frozen. The temporal element is not completely absent from the image—it is evoked metaphorically by the conelike pattern created by the position of the three men, which combined with the curve of the sidewalk brings to mind the face and hands of a clock. But the course of time is arrested. The key to the photograph is the silhouette of the man stopped at the edge of the sidewalk. Staring into the distance, he accentuates the impression of emptiness and loneliness that pervades the picture. His figure sums up the fundamentally existentialist dimension of the scene.

Even in approaching Parisian subjects, Bing's new style was deeply affected by her experience of isolation in New York. Contrary to her time in Paris, where she had been immediately enveloped by life around her, in the American metropolis she felt cut off not only from her surroundings but, in a sense, from reality itself: "[In New York] the streets in which I walk," she wrote, "do not 'integrate' me like the Paris streets; the architecture with its inhuman proportions makes me feel

isolated and, as it were, living in a vacuum. Here I see the wonders of the world as if from inside a space capsule."[23]

There is indeed a quality of science fiction to Bing's later views of New York. She was particularly mesmerized by the maze of antennas adorning the roofs of the buildings like strange forests from outer space. In one picture the metallic structure of the George Washington Bridge appears through the barbed spikes of antennas as the gate to some unknown and threatening world. In the 1950s grids, fences, and bars became recurring figures in Bing's photographs of both America and Paris. A literal example of this is a 1952 view of the Eiffel Tower seen through a fence. In earlier years the photographer had chosen to shoot from within the tower, bringing out the structure's elegant geometry and contrasting it with its surroundings. Now the tower itself was framed and entrapped by the rigorous pattern of the fence and all evocation of context obliterated. The notion of imprisonment also appears figuratively in a Paris view shot from the window of the apartment where Bing was staying on Rue de Vaugirard, in which a net curtain covers half of the image. Shades and curtains were conceived by Bing in this period not as indications of an opening but signs of being shut in. In a photograph of a flower in a vase, the shadow of the window shades on the wall is likened to bars. Symbolic as well is the spidery silhouette of the flower, which is akin to the antennas of the New York rooftops. Standing forlornly in a crystal vase, the flower appears almost as lifeless as the dark shadow that faces it on the wall.

A striking aspect shared by all these images is the use of stark contrasts. The tonal range is much less modulated than in the photographs of the 1930s. Shadows are depicted in opaque blacks, and the objects have solid contours. As noted before, already in the 1930s Bing had demonstrated a great fondness for dense blacks. But in the earlier photographs, these zones of obscurity were always tinged with a silvery or metallic sheen. Rich and textured, they were eminently sensual. In the photographs of the 1950s, on the other hand, the black tones are fundamentally mute. They are an essential component of the new graphic quality of Bing's style, which also was marked by a different conception of lighting. This particular stylistic evolution was again tied to Bing's experience of life in New York. The enchantment of the city's "phosphorescent" light, which she had discovered on her first trip, had faded. The photographer now was struck by New York's "clear and differentiating light, which [made her] see things in sharp detail."[24] She applied this perception indifferently to all her subjects—New York cityscapes, views of Paris, still lifes, and portraits.

Her interior shots, in particular, were marked by a greater definition bordering at times on actual coldness. For these she resorted to a technical novelty, the strobe light, with which she deliberately eliminated all blurring, favoring now instead of the "everlasting value of the passing moment" the representation of the "frozen moment."[25] Most times she would mix artificial and natural lighting in order to soften the more strident effect of the flash. The result, however, clearly conveyed an impression of stillness and arrested movement. Objects and people in these photographs have a mineral aspect, their shapes delineated with the cool crispness of crystals. As Bing's new style evolved throughout the 1950s, she also came to change her instrument. The magical spontaneity of the Leica did not apply to the photographer's increasingly sharp vision. Starting in 1950 she

began working with the Rolleiflex. For a brief period she switched back and forth between the two cameras, but in 1952 she definitively renounced the Leica for the Rollei. The larger negative of the Rolleiflex provided her with "greater depth of field and clearer details than ever before with the Leica."[26] This, combined with the greater sensitivity of available film, made the objects in her photographs seem now to be seen through an instrument of precision, or as Bing herself described it, through a "separating glass shield."[27]

On a few occasions, however, Bing still allowed herself to be swept over by the mysterious presence of poetry. This occurred during her regular visits back to Paris. In two Parisian images she returned to her fascination with the unexpected magic of the most humble elements of the urban landscape. Both photographs depict a gutter: One shows a street sweeper's broom, and the other a puddle in the Rue de Vaugirard. The broom image is a dazzling study in light and reflections. It shimmers with a subtle, silvery shine that brings out the various textures of the glistening cobblestones, the oily puddles of water, and the sparkling pebbles. Sublimating its prosaic subject matter, the photograph reveals an enchanted vision of reality, which borders on the non-figurative. The same holds true of the puddle on Rue de Vaugirard. Here the softly contoured puddle has taken over almost all the space of the photograph, while the outline of the street has melted into a curve. The reflection, visible yet evanescent, brings to mind ancient legends of cities submerged by water and whose ghostly visions are said to rise to the surface from time to time.

The floating nature of reality was an important concern for Bing following the shock of the war. In the past she often had liked to question appearances and play with illusion, as in the *Self-Portrait with Leica*. Such questioning, however, implied the possibility of constructing some form of interpretation of reality. Now mirrors threw back an image in which reality itself seemed to have been completely dissolved. In the 1952 *Self-Portrait in Paris Antique Shop Window*, the store window reflecting the photographer resembles some strange aquarium in which objects and images are afloat. In a sense, it is as if the surface of the looking glass had melted, and Bing were no longer staring into the mirror but had found her way through it. This voyage through the looking glass may also be interpreted as a personal voyage back in time. The delicate nineteenth-century coffee and tea sets on display in the antique store might have evoked in the photographer's mind the bourgeois rituals of her younger years in Frankfurt. It is possible as well that this image contains a discreet homage to Atget, who in a similar picture portrayed his own enigmatic reflection in the window of an antique shop on Rue du Faubourg Saint-Honoré.

Despite the treasures of Parisian antique stores and the enduring beauty of the city's streets, the photographer's vision could not help but be marked by a growing feeling of disenchantment. Paris, she bitterly complained in a letter to Konrad, had become a "giant museum."[28] Its entire splendor now could be contained "in a box," as she ironically demonstrated in a photograph of cheap souvenirs on display in a cardboard suitcase, titled *All Paris in a Box*. The epitome of Bing's detachment from the city of her dreams was the photograph *Sans Illusion* ("Disillusioned"). Significantly, this image, which was meant to evoke the Paris flea market, was not shot on location but reconstructed in the photographer's New York studio.[29] It shows two bald porcelain doll's heads and a pair of glass

eyes posed against a crumpled piece of newspaper on whose headline appear the words *"sans illusion."* These elements express Bing's continued fascination for used and discarded objects, but their surreal poetry is tinged with an unusually sinister edge. They appear in a hard light, their lifeless contours sharply outlined by strong contrasts. The glass eyes, faceless, eerily stare at the onlooker. This fixed gaze reads ultimately as the symbol of the photographer's own frozen vision. Shot in 1957, *Sans Illusion* is indeed one of the last examples of Bing's photography and is the artist's swan song.

As Bing herself said, by 1957 she was feeling more and more "the tangible . . . escaping our grasp."[30] To overcome this gnawing feeling of separation from reality she gave up black-and-white film and switched to color. It was not the apparent realism of color imagery that attracted her but, on the contrary, its surreal potential. In several of the photographs from this period, she went further than ever before into dreamlike abstraction. Typical of this new style is the composition *My Hand with Broken Watches*, a close-up view of the artist's hand surrounded by the dials and the mechanisms of dismantled watches. The broken watches seem to float in space, dematerialized symbols of an oneiric conception of time in which the usual parameters of past and present have melted away. As before, Bing mastered all the technical aspects of her new medium. She did all of the developing and printing herself, relying primarily on her instinct and ceaselessly experimenting. Soon she had successfully triumphed over all the technical difficulties. Yet at the same time she felt increasingly that her inspiration was running out. Afraid of repeating herself, the now sixty-year-old artist gave up still photography permanently in 1959. For a while, she tried her hand at motion film and acquired a Bolex super-8 camera. Discontent with the still image, she hoped to convey with film yet again the "permanently changing movement of life."[31] Work in this new medium, however, was costly, and the expense exceeded her limited funds. In 1962 she abandoned this last mode of expression, finally renouncing all photographic activity.

TWILIGHT AND REDISCOVERY

Throughout the 1940s and 1950s Bing's photographs were exhibited and published regularly both in France and in the United States. More and more, however, Bing felt the need to think and write about photography take precedence over the urge to submit her work to the public eye. In 1951 she provided a first retrospective view of the period in which her art had bloomed. This manuscript, entitled *The Place of Photography in Modern Art*, was the basis for a lecture held in St. Louis that same year. Throughout the decade she continued to explore the nature and history of photography in an attempt to assess her own evolution as an artist. She wrote a second essay, *Photography as a Fine Art*, which she presented in 1961 at a lecture at Bennett College in North Carolina. In these texts the speculative rigor of the German doctoral student again comes to the fore. These lectures were to be the first of many that Bing would tirelessly hold at museums and institutions throughout the United States and Europe following the rediscovery of her œuvre in the 1970s.

The 1960s were for Bing a period of retreat. Her work was no longer visible, and very soon it went into complete eclipse. In this Bing followed the fate of most of her colleagues from the New

Photography. The reassessment of this movement had only begun, and aside from exceptional figures such as Brassaï and Man Ray, many of the great masters of the period were yet to be recognized. As if to mark her complete severance from the past, Bing became an expert in a completely unexpected field of activity. To support herself she trained as a dog groomer. As she plainly put it, she "needed to make money and . . . didn't want to involve herself with art."[32] Eventually, this occupation brought her a new kind of fame. Her clientele included the ballet dancer Mikhail Baryshnikov, who later purchased a complete collection of dance photography from her. She became a familiar New York figure, zipping on her way to the homes of her clients on a bicycle through the city's heavy traffic, her own dog, Staccato, placidly seated in the front basket. Later, at age sixty-seven, she could be seen, as intrepid and active as ever, storming about on a motorcycle. A bad accident on the motorcycle in 1968 interrupted this phase of her life. Hospitalized in a state of shock, she began to translate her pain and anguish into poems. She was soon absorbed by this new form of expression. In 1974 she independently published a first collection of her poems, entitled *Words as Visions*. This was followed in 1976 by *Numbers in Images*, a book that combined drawings and poetry inspired by the mathematical forms that had fascinated her as a child.

This renaissance in a new medium coincided with the exhumation of her photographic work. Aware of the Museum of Modern Art's pioneering interest in the photography of the 1920s and 1930s, Bing contacted the director of the Department of Photographs, John Szarkowski, who purchased several of her prints for the museum's permanent collections. They figured prominently in a show of recent acquisitions held at MoMA in 1976, where they garnered much attention from the press. In turn this led a few months later to Bing's first one-person show since 1959, at the Witkin Gallery in New York. At the same time, David Travis, the curator of photography at the Art Institute of Chicago, was preparing an exhibition highlighting the photographs from the Julien Levy donation to the museum. More than forty years after Levy's seminal *Modern European Photography* show, Bing found her work reunited with that of the best photographers of her generation.

From then on her images were included in most major retrospectives of the New Photography and in many publications on the topic. She also benefited from the growing interest in women photographers and was singled out as an emblematic figure of the movement. She responded to this interest in 1982 with her very first book of photographs, published in France and entitled *Femmes de l'enfance à la vieillesse* ("Women from Childhood Through Old Age"). Introduced by Bing's longtime friend and colleague Gisèle Freund, this publication presented the various facets of womanhood from childhood through old age. Assembling images from different periods of Bing's œuvre, it read as well as an autobiography of the photographer. Very soon her work was presented in museum solo shows, of which the most important were the 1985 retrospective at the New Orleans Museum of Art, which traveled to the International Center of Photography in New York the following year, the 1987 exhibition at the Musée Carnavalet in Paris, and the 1996 presentation at the Suermondt-Ludwig-Museum in Aachen, Germany.

Not content solely with the rediscovery of her photography, Bing decided to explore yet another form of expression. Assembling her photographs with shells, twigs, and bits of strings found on

walks or during her snorkeling expeditions—at eighty-nine she was still diving—Bing produced collages, which, bringing together several of her childhood obsessions, "spoke to her as Fairy Tales."[33] But tragedy entered her life again on October 24, 1989, when Konrad died suddenly in Cologne. The couple was touring Germany on their way to the opening of one of the photographer's shows at a gallery in Hamburg. Bing's loss was immense. Yet driven ahead by her indomitable energy, she survived her husband for nine years. While her fame kept on spreading, she was distinguished with prestigious awards, including the first Gold Medal ever awarded for photography by the National Arts Club of New York, and the pace of her exhibitions never slackened. In March 1998 the Edwynn Houk Gallery of New York was planning an important retrospective to commemorate the photographer's ninety-ninth birthday. In the middle of these preparations, on March 10, 1998, Ilse Bing died in New York, two weeks shy of the show's opening.

In a conversation with a friend, Bing once confided: "There is always somewhere a door. One must keep on looking for doors and trying to open them."[34] To the young doctoral student of 1929, the revelation of modern photography had been the first of those "doors."[35] From that moment on, Bing chose to build her life and work as a search for openings onto the other side of reality. Her lens focused on the unknown, and her eye arched over her viewfinder like a question mark, she never ceased to probe the depths of human vision. Pushing back the threshold that divides waking life from dreams, she created her photographs as talismans for a journey of enchanting beauty.

NOTES

INTRODUCTION

1. Emmanuel Sougez, "Le XXIXe Salon international d'art photographique 1934," *Bulletin de la Société française de Photographie*, 1934, no. 9 (September), p. 182.

2. According to Nancy Barrett, Ilse Bing was "the only professional photographer in Paris to use the 35mm Leica camera exclusively" Nancy Barrett, *Ilse Bing: Three Decades of Photography*, New Orleans Museum of Art, 1985, p. 9. This assertion, though largely true, doesn't take into account the Hungarian-born André Steiner, an early practitioner of the Leica, active in Paris as of 1927 (cf. Christian Bouqueret, *Des Années folles aux années noires: la Nouvelle Vision photographique en France, 1920-1940*, Paris: Marval, 1997, p. 158); and Gisèle Freund, who moved to Paris in 1933, taking her precious Leica with her. The case of Henri Cartier-Bresson must be considered separately. Although he was already at the time selling his work to the press, in particular to the magazine *Vu*, Cartier-Bresson was still hesitant at that point to call himself a "professional" photographer.

3. Cf. the numerous recent publications and exhibitions on the subject: Constance Sullivan, Eugenia Parry Janis, *Women Photographers*, London: Virago Press, 1990; Naomi Rosenblum, *A History of Women Photographers*, New York, London, Paris: Abbeville Press, 1994; Christian Bouqueret, *Les Femmes photographes de la Nouvelle Vision en France, 1920-1940*, Paris: Marval, 1998, and accompanying exhibition; Unda Hörner, *Madame Man Ray. Fotografinnen der Avantgarde in Paris*, Berlin: Edition Ebersbach, 2002; Ute Eskildsen, ed., *Fotografieren hieß teilnehmen. Fotografinnen der Weimarer Republik*, Essen: Museum Folkwang and Düsseldorf: Richter, c. 1994, and accompanying exhibition (traveled to the Jewish Museum, New York, as *Women Photographers of the Weimar Republic*).

FRANKFURT: EARLY YEARS

1. "Es war einmal ein Königstochter Dunkeltief leuchtern ihre Augen . . . ," Ilse Bing, *Märchen*, unpublished manuscript. (Ilse Bing Archive/Estate of Ilse Bing; hereafter referred to as IBA/EIB).

2. At 55 Unterlindau.

3. Bing referred to "ein gräulich Silberschimmer," in the documentary *Frankfurt, Paris, New York, Die Drei Leben der Ilse Bing*, by Crissy Hemming, Wiesbaden: ZDF, April 1986.

4. Ilse Bing, "Doors Doors Doors," September 8, 1982, in Ilse Bing, *Snapshots Without a Camera*, Ramsey, New Jersey: Laurence and Kathryn Libin (publishers), 1989, n.p.

5. Herlinde Koelbl, *Jüdische Portraits. Photographien und Interviews von Herlinde Koelbl*, Frankfurt: S. Fischer, 1989, p. 25.

6. Gabriele Metzler, "Die Königin der Leica: Von Frankfurt nach New York – Die Fotografin Ilse Bing – Austellung am 16. Juni," *Jüdische Gemeindezeitung Frankfurt*, no. 5/6, 1987, p. 29.

7. Michael Solomon, "The Eyes of Ilse Bing," *Avenue*, November 1990, p. 48.

8. Frankfurt City register, Frankfurt Institut für Stadtgeschichte (city archive).

9. Ilse Bing, unpublished manuscript, untitled, n.d. (circa 1919). (IBA/EIB).

10. Ilse Bing, *Epilogue to My Dissertation on Friedrich Gilly of 1926–1929*, unpublished manuscript, February 1985, n.p. (IBA/EIB).

11. Ibid.

12. David Watkin, Tilman Mellinghoff, *German Architecture and the Classical Ideal 1740–1840*, London: Thames & Hudson, 1987, p. 66.

13. Crissy Hemming, *Frankfurt, Paris, New York, Die Drei Leben der Ilse Bing*.

14. The Schaumainquai (literally, "quay with a view of the Main River") was where Frankfurt University's art history institute was located.

15. "Das Forschen nach dem Untergründigen in der Realität, wie bei den Romantikern," Ilse Bing, letter to Konrad Wolff, Saint-Louis, April 15, 1951. (IBA/EIB).

16. Bearing the number 30, this is the plate of the Bing home at 30 Cronbergerstrasse.

17. The particular painting that struck Bing has not been identified. *The Night Café*, to which she later referred, was never part of the Reinhart Collection.

18. Nancy Barrett, *Ilse Bing: Three Decades of Photography*, New Orleans Museum of Art, 1985, p. 13.

19. Tim Gidal, *Modern Photojournalism, Origin and Evolution, 1910–1933*, New York: Collier Books, 1973, p. 15.

20. Gianni Rogliatti, *Leica: The First 70 years*, Hove: Hove Collectors Books, p. 17.

21. Karel Teige, "The Tasks of Modern Photography, 1931," in Christopher Phillips, ed., *Photography in the Modern Era: European Documents and Critical Writings, 1913–1940*, New York: The Metropolitan Museum of Art/Aperture, 1989, p. 319.

22. "Le Leica devient l'appareil à la mode réservé à l'élite française," Françoise Denoyelle, *La Lumière de Paris: le marché de la photographie 1919–1939*, volume I, Paris: L'Harmattan, 1997, p. 31.

23. Judging from a family photo album, which includes views of Wetzlar, it seems that Ilse Bing visited Wetzlar shortly before the purchase of her first Leica. (IBA/EIB).

24. Ilse Bing, interview with Nancy Barrett, September 26 and 27, 1985, quoted in Barrett, p. 11.

25. On the original Leica, which was a non-reflex camera, the viewfinder was located above the lens. The slight discrepancy is easily corrected through practice.

26. Several portable hand-held plate cameras had offered this feature since the end of the nineteenth century.

27. The first Leica marketed measured 29mm in depth, 55mm in height, and 133 mm in length, Rogliatti, p. 34.

28. Gidal, p. 14.

29. Ibid., p. 15.

30. Herbert Starke, "Der neue Pressephotograph," *Photographische Rundschau und Mitteilungen*, Halle, vol. 67, no. 8, 1930, French translation in Olivier Lugon, ed., *La Photographie en Allemagne, Anthologie de textes (1919–1939)*, Nîmes: Editions Jacqueline Chambon, p. 257.

31. Ibid.

32. Annemarie Tröger, "Zwischen Kunst und Zeitungsmarkt: Ein Ausschnitt aus dem Leben der Fotografin Ilse Bing," in Diethart Krebs, ed., *Die Gleichschaltung der Bilder: Zur Geschichte der Pressefotografie 1930–1936*, Galerie 70, Berlin, Berlin: Frölich & Kaufmann, 1983, p. 91.

33. Ilse Bing, quoted in Alan G. Artner, "At 80, Still in Focus: A Long Reign for the 'Queen of the Leica,'" *Chicago Tribune*, April 1, 1979, from clipping in IBA/EIB. See as well the documentary *Frankfurt, Paris, New York, Die Drei Leben der Ilse Bing*.

34. Naomi Rosenblum mentions "the relatively minor role of women in the expanding era of photojournalism in Weimar Germany . . . ," Naomi Rosenblum, *A History of Women Photographers*, New York, London, Paris: Abbeville Press, 1994, p. 141.

35. A photograph in one of Bing's early family albums shows Ilse, her sister, Liesl, and an unidentified man posing around the breakfast table. The man holds in front of him the daily edition of the *Frankfurter Zeitung*. (IBA/EIB).

36. Enzo Traverso, *Siegfried Kracauer, itinéraire d'un intellectuel nomade*, Paris: Editions La Découverte, 1994, pp. 105–106.

37. Published on November, 27, 1930.

38. On December 21, 1929.

39. "Bade-Anstalt Schwimmt Heim," *Das Illustrierte Blatt*, November 2, 1929, p. 1260.

40. Barrett, p. 13.

41. Olivier Lugon, *Le Style documentaire, d'August Sander à Walker Evans 1920–1945*, Paris: Macula, 2001, p. 344.

42. Ibid., p. 345.

43. "Ich schaute unter mich und da war eine ganz wunderbare Welt: das Pflaster, die Zeichnungen im Asphalt, die toten Blätter und dies nur ein kleines Beispiel," Ilse Bing, *Improvisation einer Biographie*, unpublished preparatory script for the documentary by Crissy Hemming. (IBA/EIB).

44. Ilse Bing, childhood recollections, untitled manuscript, December 1978, n.p. (IBA/EIB).

45. Barrett, p. 13.

46. Gisèle Freund, *Mémoires de l'oeil*, Paris: Seuil, 1977, n.p.

47. On Ernst May, see Barbara Miller Lane, *Architecture and Politics in Germany, 1918–1945*, Cambridge, Mass.: Harvard University Press, 1968, pp. 90–103.

48. "Monatschrift für die Probleme moderner Gestaltung."

49. "Experimentelle Fotografie."

50. This information is based on an original announcement card found in Ilse Bing's personal papers (IBA/EIB). According to this document, the show *Fotografie der Gegenwart* stopped at the Frankfurt Kunstverein from July 7 to August 8, 1929.

51. In a letter to Ella Bergmann-Michel dated April 30, 1953, Bing describes her pleasure at discovering the work of Kurt Schwitters for the first time in an exhibition. Ella Bergmann Archive, Sprengel Museum, Hannover.

52. Written by Hans Hildebrandt.

53. Ilse Bing, unpublished manuscript on the Bauhaus, July 6, 1985, n.p. (IBA/EIB).

54. Lugon, p. 52.

55. Ibid.

56. (Attributed to) Ernst Kállai, "Nachträgliches zur Foto-Inflation," *Bauhaus*, Dessau, vol. 3, no. 4, October–December 1929, p. 20. French translation in Lugon, p. 197.

57. The term "Foto-Inflation," coined by Ernst Kállai in 1929, was commonly used by other critics, Lugon, pp. 195–96.

58. Letter to Ilse Bing from the Institut für gerichtliche Medizin an der Universität Heidelberg, September 30, 1930. (IBA/EIB).

59. Artner, passim.

PARIS: ENCHANTMENT IN THE EYE OF THE CAMERA

1. "La vie parisienne est féconde en sujets poétiques et merveilleux. Le merveilleux nous enveloppe et nous abreuve comme l'atmosphère; mais nous ne le voyons pas." Charles Baudelaire, "De l'héroïsme de la vie moderne," *Salon de 1846*, in *Curiosités esthétiques*, Genève, Paris, Montréal: Editions du Milieu du monde, p. 208.

2. The name of the space translates as "open at night." It opened in 1933, near the Place de Clichy.

3. Christian Bouqueret writes, "To have an exhibition at the Galerie de la Pléiade in the thirties is the confirmation of one's talent." ("Avoir une exposition à la galerie de la Pléiade dans les années trente est la confirmation d'un talent."), Christian Bouqueret, *Les Femmes photographes de la Nouvelle Vision en France, 1920-1940*, Paris: Marval, Collection Années 30, 1998, p. 18.

4. *Arts et métiers graphiques*, no. 16, "Photographie," 1929–30, pp. 5–20 and 131–61.

5. Ibid., passim.

6. "Livre la clef intime des songes," ibid., p. 7.

7. Philippe Soupault was excluded from the Surrealist group in 1926 but continued to define himself as a Surrealist.

8. Philippe Soupault, "Etat de la photographie," *Arts et métiers graphiques*, "Photographie," 1931, n.p.

9. Soupault, "une photographie est avant tout un document," ibid.

10. "Résolution de ces deux états...que sont le rêve et la réalité, en une sorte de réalité absolue, de *surréalité*." André Breton, "Manifeste du surréalisme (1924)," in André Breton, *Manifestes du surréalisme*, Paris: Gallimard, Collection Folio Essais, 1995, p. 24.

11. After the war, Hélène Gordon became the editor in chief of *Elle* magazine under her married name, Hélène Lazareff, see Christian Bouqueret, *Les Femmes photographes de la Nouvelle Vision en France, 1920-1940*, Paris: Marval, Collection Années 30, 1998, p. 37.

12. Hélène Gordon, "Les Femmes photographes au Pavillon de Marsan," *La Revue de la photographie*, 2, 1936, quoted in Bouqueret, p. 37.

13. Unpublished preparatory script for the documentary *Frankfurt, Paris, New York, Die Drei Leben der Ilse Bing* by Crissy Hemming, ZDF, Wiesbaden, April 1986, English version, p. 7. (IBA/EIB).

14. "In Paris, I became truly myself." ("A Paris, je suis vraiment devenue moi-même.") Ilse Bing, quoted in Françoise Reynaud, "Ilse Bing et Paris," in *Ilse Bing Paris 1931–1952*, Musée Carnavalet, Paris: Paris-Musées, 1987, p. 7.

15. "...setzte ich mich in ein Café auf der Straße und spürte, wie sich von meinen Füßen Wurzeln in das Pariser Pflaster zogen." Ilse Bing, unpublished preparatory script for the documentary *Frankfurt, Paris, New York, Die Drei Leben der Ilse Bing*, p. 4. (IBA/EIB).

16. Letter from Jerome Mellquist to Ilse Bing, New York, May 13, 1932. (IBA/EIB). A young American aspiring to be a writer, Mellquist was Bing's neighbor at the Hôtel de Londres. He later was known as an art critic.

17. Tim Gidal, *Modern Photojournalism, Origin and Evolution, 1910–1933*, New York: Collier Books, p. 18.

18. Paul Leni's masterpiece of Expressionist film, *Das Wachsfiguren Kabinett* ("The Wax Figure Cabinet"), produced in 1924.

19. Anonymous, "She Compares Her Camera to Musical Instruments," *Springfield (Illinois) Republican*, October 2, 1932, clipping in IBA/EIB.

20. Ibid.

21. Letter from Jerome Mellquist to Ilse Bing, Florence, May 14, 1931. (IBA/EIB).

22. Annemarie Tröger, "Zwischen Kunst und Zeitungsmarkt: Ein Ausschnitt aus dem Leben der Fotografin Ilse Bing," in Diethart Krebs, ed., *Die Gleichschaltung der Bilder: Zur Geschichte der Pressefotografie 1930–36*, Galerie 70, Berlin, Berlin: Frölich & Kaufmann, 1983, p. 92.

23. "Il y avait, dans cette vitrine du boulevard Raspail, parmi d'autres photographies non sans importance ni sans mérite, quatre ou six images, petites, brutales par leurs contrastes et attachantes par on ne sait quel dynamisme tournoyant, quel flottement de robes et d'écharpes développées. C'étaient des mouvements de danse. . . . Du mystère et du réel, du nouveau, surtout. . . . Là-dessous, une illisible signature en pattes de mouche. Je dus entrer, m'enquérir. Ilse Bing, me dit-on, une jeune Allemande qui abordait Paris, avait demandé un coin pour montrer ces essais." Emmanuel Sougez, "Ilse Bing," *L'Art vivant*, December 1934, p. 488.

24. "Ilse Bing innovated in Paris with her dynamic photographs of twirling dancers. And if you saw the rest of her work, you would say she is the Queen of the Leica." ("Ilse Bing a innové, à Paris, le dynamisme photographique avec ses danseuses tournoyantes. Et si vous voyiez l'ensemble de son oeuvre, vous diriez qu'elle est la Reine du Leica.") Emmanuel Sougez, "Le XXIXᵉ Salon international d'art photographique 1934," *Bulletin de la Société française de photographie*, 1934, no. 9 (September), p. 182.

25. Françoise Denoyelle, *La Lumière de Paris: le marché de la photographie 1919-1939*, volume I, Paris: L'Harmattan, 1997, p. 128.

26. "Cette vague de photographes étrangers et souvent improvisés qui, depuis dix ans déferle sur Paris lui imposant d'infâmes images sans valeur ni soin." Sougez, "Ilse Bing," p. 488.

27. "Here one finds only quality, sensibility, and a sense of measure . . . the photographs are beautiful, and say

only what they have to say, but say it well, and, yes, say it in the French taste." ("Il ne s'agit ici que de qualité, de sensibilité et de mesure . . . les photographies sont belles, disent seulement ce qu'il faut dire, mais le disent bien et, mon Dieu! oui, à la française."), ibid.

28. Letter from Ilse Bing to Konrad Wolff, October 26, 1939. (IBA/EIB).

29. Alan Cohen, Victoria Benham, interview with Ilse Bing, *The Arts Club of Chicago,* September 13, 1985, p. 9. (IBA/EIB).

30. Hendrik Willem Van Loon correspondence with Ilse Bing, May 1931, passim. (IBA/EIB).

31. Ilse Bing, quoted in Hervé Guibert, "Ilse Bing, une vie," *Le Monde,* Thursday, June 4, 1981, clipping in IBA/EIB.

32. In a letter from July 29, 1931, Van Loon mentions in particular showing Bing's prints to Arnold Genthe "who is our best photographer." Letter to Ilse Bing from Hendrik Willem Van Loon, New York, July 29, 1931. (IBA/EIB).

33. Letter from Frank Crowninshield to Ilse Bing, April 7, 1932. (IBA/EIB).

34. Letter from Julien Levy to Ilse Bing, New York, n.d. (IBA/EIB).

35. Introduction to the catalogue of the exhibition "Photographs by Henri Cartier-Bresson and an Exhibition of Anti-Graphic Photography," written by Julien Levy under the name of Peter Lloyd. Quoted in Ingrid Schaffner and Lisa Jacobs, ed., *Julien Levy: Portrait of an Art Gallery,* Cambridge, Mass. and London: The MIT Press, 1998, p. 128.

36. Julien Levy Collection, Special Photography Acquisition Fund, The Art Institute of Chicago.

37. The laudatory caption read: "This artistic photo of one of the beauty spots of Paris, the Champ-de-Mars, as seen from the Eiffel Tower, was taken by Ilse Bing, a young German girl who has already established a reputation as a camera genius. She has held several exhibitions of her work here and is planning another for the near future. At the present moment her work is on view at the Julien Levy Galleries, New York." *Chicago Daily Tribune, Daily News and The New York, Europe's American Newspaper,* Paris, Wednesday, March 16, 1932, clipping in IBA/EIB.

38. A list of works consigned by Julien Levy is in the Brooklyn Museum Archives, File 1220 (1913–33). This information was kindly provided to me by Lisa Jacobs.

39. J. Bl., "Photo-Austellung Ilse Bing," *Frankfurter Zeitung,* Sunday, September 18, 1932, clipping in IBA/EIB.

40. "Wie erlösend ist es in dieser Tage, einen Photographen zu treffen, der den Mut zur Wirklichkeit hat und dazu noch die Stetigkeit, ihn wahr zu machen," Ibid.

41. "Daß die 'Sache' etwas aussagt," Ibid.

42. Bing claimed that her work was still being published under the Nazis. This is probable as press prints generally remained the property of the newspapers, which would often use them several times. See Tröger, p. 97.

43. *Le Monde illustré,* no. 3931, April 22, 1933, cover page, and no. 3934, May 13, 1933, cover page.

44. Gerard Willem Van Loon, *The Story of Hendrik Willem Van Loon,* Philadelphia, New York: J. B. Lippincott Company, 1972, p. 281.

45. A certificate of good conduct delivered in Frankfurt on October 21, 1938, indicates that Ilse Bing was registered as a resident of the city from the time of her birth until August 10, 1931, implying that after that date she was officially a resident of Paris. (IBA/EIB).

46. Ilse Bing, interview with Alain Beaufils and Dominique Gaessler, "Une Pionnière de la photographie des années 30," *Photographiques,* April 1983, p. 29.

47. Gisèle Freund, *Mémoires de l'œil,* Paris: Seuil, 1977, n.p.

48. Gertrude Bailey, "Famous German Woman Sees Life in New York as Transitory and Wild," *New York World Telegram,* Monday, June 8, 1936, clipping in IBA/EIB.

49. Late in life, Bing mentioned that she might also have taught Lisette Model, but she was not sure of the fact and we have found nothing to support this information.

NOTES

50. Letter of introduction from Hendrik Willem Van Loon, February 12, 1932. (IBA/EIB).

51. "Une exposition de photos chez Tiranty," *La Revue française de photographie et cinématographie*, no. 319, April 1, 1933, p. 108. The article is not signed but may be attributed to Claude de Santeul.

52. Ilse Bing, untitled manuscript presenting a summary of the photographer's career, 1978. (IBA/EIB).

53. Cecil Beaton, *The Glass of Fashion*, London: Weidenfeld and Nicholson, 1954, p. 138.

54. Quoted in Carmel Snow, with Mary Louise Aswell, *The World of Carmel Snow*, design by Alexey Brodovitch, New York, Toronto, and London: McGraw-Hill Book Company, 1962, p. 86.

55. Ilse Bing on her time in Paris, as stated in the documentary by Crissy Hemming, *Frankfurt, Paris, New York, Die Drei Leben der Ilse Bing*: "Ich hungerte manchmal, das Geld, das ich hatte, ging in erster Linie für Fotomaterial, in zweiter Linie, daß ich anständig angezogen war. Erst in dritter Linie kam das Essen." ("I was often hungry. The money I had I spent first on photo equipment. Then I made sure I was decently dressed. Food was only third in line.")

56. According to the photography historian Françoise Denoyelle, "*Harper's Bazaar* c'est un peu le *Arts et métiers graphiques* de la mode." ("*Harper's Bazaar* is a bit like the *Arts et métiers graphiques* of fashion.") Denoyelle, p. 274.

57. Beginning at the turn of the century, newspapers and magazines started sending photo-reporters out to the races and similar social events to photograph fashionable women, reproducing these images in lieu of fashion plates. Such reportage work remained, however, strictly documentary.

58. On Carmel Snow's revolution at *Harper's Bazaar*, see Nancy Hall-Duncan, *The History of Fashion Photography*, New York: Alpine Book Co., 1979, chapter 4.

59. Beaton, p. 138.

60. Palmer White, *Elsa Schiaparelli, Empress of Paris Fashion*, with a foreword by Yves Saint Laurent, London: Aurum Press, 1995, p. 140.

61. "Button, Button," *Harper's Bazaar*, October 1935, p. 115.

62. White, p. 80.

63. Putnam was the husband of Amelia Earhart.

64. "Qu'il est alors difficile de résister au panier de champagne offert par Mlle Ilse Bing . . . ," C. S. (Claude de Santeul), "Les Expositions," *Photo-Illustration*, no. 1, January 1934, p. 10.

65. *So You're Going to Be Married*, no. 11, Winter 1935, clipping in IBA/EIB. The Temple d'amour ("Temple of Love") stands on the Ile de la Jatte, in Neuilly.

66. In Paris, in 1932.

67. Tobi Tobias, "Subtler and More Lasting Shapes," *Dance Ink*, vol. 3, no. 2, Summer 1992, p. 32.

68. Fernand Rivoire, "Contagion de la danse," *Art et médecine*, February 15, 1934. The photograph was reproduced on page 22.

69. *Photographie 1933–1934*, illustration 23.

70. "…le rendu en quelque sorte dynamique de l'athlète vu par Mme Ilse Bing," C. S. (Claude de Santeul), "L'Album Photographie 1933–34," *La Revue française de photographie et cinématographie*, no. 333, November 1, 1933, p. 347.

71. In 1935, George Platt Lynes documented the revival of the ballet in the United States. Bing's images are the only visual testimony of the first production.

72. Letter from Ilse Bing to Konrad Wolff, Frankfurt, September 1, 1935. (IBA/EIB).

73. "Instrument für Nahaufnahmen," letter from Ilse Bing to Konrad Wolff, Frankfurt, September 6, 1935. (IBA/EIB).

74. Letter from Leitz to Ilse Bing, Wetzlar, November 5, 1936. (IBA/EIB).

75. Letter from Leitz to Ilse Bing, Wetzlar, March 23, 1937 (IBA/EIB), mentioning the photographer's acquisition of a new lens, the Leitz Xenon 1:1,5 that was not yet marketed.

76. "Vie des Salutistes," *Vu*, no. 339, September 12, 1934, p. 1150.

77. Previous to seeking refuge in Paris, the Hungarian Charles Rado had settled in Weimar Germany to escape his home country's repressive regime.

78. Letter from Ilse Bing to Konrad Wolff, Riverside, Connecticut, May 5, 1936. (IBA/EIB).

79. Bailey, passim.

80. "Ein im Weltall irrendes Atom," letter to Konrad Wolff, New York, April 26, 1936. (IBA/EIB).

81. Letter from Ilse Bing to Konrad Wolff, Riverside, Connecticut, May 5, 1936. (IBA/EIB).

82. Letter from Ilse Bing to Konrad Wolff, New York, April 26, 1936. (IBA/EIB).

83. Nancy Barrett, *Ilse Bing: Three Decades of Photography*, New Orleans Museum of Art, 1985, note 42, pp. 29–30.

84. Letter from Ilse Bing to Konrad Wolff, New York, June 12, 1936. (IBA/EIB).

85. Postcard from Ilse Bing to Konrad Wolff, Paris, September 21, 1936. (IBA/EIB).

86. Letter from Ilse Bing to Konrad Wolff, Frankfurt, September 8, 1936. (IBA/EIB).

87. Maria Morris Hambourg, "From 291 to the Museum of Modern Art: Photography in New York, 1910–1937," in Maria Morris Hambourg, Christopher Phillips, *The New Vision: Photography Between the World Wars: Ford Motor Company Collection at the Metropolitan Museum of Art*, New York: Metropolitan Museum of Art, 1989, p. 60.

88. Ibid., p. 62.

89. Thomas Michael Gunther, *François Tuefferd: Chasseur d'images*, Paris: Bibliothèque historique de la Ville de Paris, 1993, p. 110.

90. Anonymous, "Ilse Bing, Photographer, to Display Her Works," *New York Herald Tribune*, March 21, 1939, clipping in IBA/EIB.

91. Letter from Ilse Bing to Ella Bergmann-Michel, Paris, January 21, 1939. (IBA/EIB).

92. Letter from Hendrik Willem Van Loon to Ilse Bing, Old Greenwich, Connecticut, December 14, 1938, which mentions Bing's feeling of "groveling misery and despondence" following Kristallnacht. (IBA/EIB).

93. Letter from Hendrik Willem Van Loon to Ilse Bing, Old Greenwich, Connecticut, May 21, 1937. (IBA/EIB).

94. "Que ne pouvez-vous voir ce pan de mur désespéré où se lamente un vestige de Greta Garbo, lambeau d'affiche sur un immeuble croûteux, entre un bec de gaz de mauvais coin et une persienne édenté!" Emmanuel Sougez, "Ilse Bing," p. 488.

95. "Das beharrliche Elend dieser Brandmauer hat langsam . . . nur mit etwas Zeit, den falschen aufgelebten Schein dieses teuren Namens und Gesichts zerstört, besser: zerfallen machen." In J. Bl., "Photo-Austellung Ilse Bing."

96. As per Françoise Reynaud's recorded interview with Ilse Bing, June 1987, Wiesbaden.

97. "Un morceau d'affiche en caractères gras porte ces quatre lettres: MIDI… Midi, le retour chez soi dans l'intimité quiète et discrète après le labeur morne et décevant d'une matinée pareille à toutes les autres." ("A piece of a poster displaying these four letters printed in large characters: MIDI… Noon, the return to the quiet, discreet intimacy of home after the dreary and frustrating labors of a morning like every other.") In C. de Santeul, "Les Artistes photographes d'aujourd'hui," *Photo-Illustration*, no. 9, January 1, 1935, p. 3.

98. "No matter how artful the photographer, no matter how carefully posed his subject, the beholder feels an irresistible urge to search such a picture for the tiny spark of contingency, of the here and now, with which reality has (so to speak) seared the subject (…).", Walter Benjamin, "Little History of Photography," p. 510, in Walter Benjamin, *Selected Writings, Volume 2, 1927–1934*, translated by Rodney Livingstone and others, Michael W. Jennings, Howard Giland and Gary Smith, eds., Cambridge, Mass. and London: The Belknap Press of Harvard University Press, 1999.

99. Cf. the title of a poem by Ilse Bing, "Active Geometry," August 25, 1985, in Ilse Bing, *Snapshots Without a Camera*, Ramsey, New Jersey: Laurence and Kathryn Libin, 1989, n.p.

100. Ilse Bing, "The Camera as My Artistic Tool," unpublished manuscript, n.d. (circa 1980), p. 3. (IBA/EIB).

101. Another source of inspiration would have been a portrait by Florence Henri reproduced in the "Experimental Photography" issue of *Das Neue Frankfurt* in March 1929. Although not a self-portrait, it displays a similar composition with two mirrors, one of which reflects the sitter's profile.

102. Bailey, passim.

103. Ibid.

104. Ilse Bing, unpublished comparative notes on *Self-Portrait with Leica* and Florence Henri's *Self-Portrait in Mirror*, post 1976, p. 2. (IBA/EIB).

105. "[le mot "convulsive'] perdrait à mes yeux tout sens s'il était conçu dans le mouvement et non à l'expiration exacte de ce mouvement même. Il ne peut, selon moi, y avoir beauté – beauté convulsive – qu'au prix de l'affirmation du rapport réciproque qui lie l'objet considéré dans son mouvement et dans son repos." André Breton, "La Beauté sera convulsive," *Minotaure*, no. 5, May 1934, p. 12.

106. "Was mich eben im Grunder interessiert, ist die 'Erscheinung' der Menschen und Dinge, mit Erscheinung meine ich, dass sie da sind aber doch irgendwie unfassbar, aus dem irreellen heraus. Sie könnten in der nächsten Sekunde weg sein so wie ein Traum. Und doch sind sie eben da, so furchtbar reell." Ilse Bing, letter to Ella Bergmann-Michel, New York, July 17, 1949, Ella Bergmann Archive, Sprengel Museum, Hannover.

107. Ilse Bing, quoted in Alan G. Artner, "At 80, Still in Focus: A Long Reign for the 'Queen of the Leica,'" *Chicago Tribune*, April 1, 1979, clipping in IBA/EIB.

108. Ilse Bing, quoted in Mildred Stagg, "Ilse Bing 35-mm. Specialist," *U.S. Camera*, August 1949, p. 51.

109. "Le grain est photographique," quoted in Hervé Le Goff, *Pierre Gassmann, La Photographie à l'épreuve*, Paris: Editions France Delory/Picto, 2000, p. 51.

110. Brassaï, "Technique de la photographie de nuit," *Arts et métiers graphiques*, no. 33, January 15, 1933.

111. Cf. letter from Ilse Bing to Ella Bergmann-Michel, Paris, January 21, 1939: "I know Brassaï's photos, I hold him for one of the greatest photographers. Do you know his book 'Paris dans [sic] la nuit?'" ("Die Photos von Brassaï kenne ich, ich halte ihn fuer einen der groessten Photgraphen [sic]. Kennst Du nicht sein Buch: 'Paris dans [sic] la nuit?'"). Note Bing's mistake in quoting the title of *Paris de nuit*, which implies that she was not altogether familiar with Brassaï's work. Ella Bergmann-Michel Archive, Sprengel Museum, Hannover.

112. Françoise Denoyelle's study on photography in France between the wars confirms that the French were late in producing highly sensitive film for small-format cameras, see Denoyelle, p. 71.

113. According to the handwritten list included in Bing's original negative binders, this photograph was shot in Auxerre, Burgundy, and not in Paris as was indicated until now. (IBA/EIB).

114. For a portrait of Baroness Van Zuylen shot in New York in 1941.

115. ". . . ces halos magiques, cette féerie autour du réel," Sougez, "Ilse Bing," p. 488.

116. From the French translation, "Alors que l'on chemine encore à travers des rues bien vivantes, elles sont déjà aussi lointaines que des souvenirs, dans lesquels la réalité se mêle avec le rêve qui en est l'image ondoyante et où se croisent des ordures et des constellations." Siegfried Kracauer, "Souvenir d'une rue de Paris," in Siegfried Kracauer, *Rues de Berlin et d'ailleurs* ("Strassen in Berlin und anderswo"), translated from the German by Jean-François Boutout, Paris: Le Promeneur, 1995, p. 19.

NEW YORK: ART AFTER THE DELUGE

1. From Ilse Bing, *Snapshots Without a Camera*, Ramsey, New Jersey: Laurence and Kathryn Libin, 1989, n.p.

2. Quoted in Nancy Barrett, *Ilse Bing: Three Decades of Photography*, New Orleans Museum of Art, 1985, p. 27.

3. Ilse Bing interview with Herlinde Koelbl, in Herlinde Koelbl, *Jüdische Portraits, Photographien und Interviews von Herlinde Koelbl*, Frankfurt: S. Fischer, 1989, p. 26.

4. Letter from Konrad Wolff to his parents, New York, July 11, 1941. (IBA/EIB).

5. Koelbl, p. 26. Also in the documentary *Frankfurt, Paris, New York, Die Drei Leben der Ilse Bing*, by Crissy Hemming.

6. One of Konrad's companions there was the photographer and printer Pierre Gassmann, cf. Hervé Le Goff, *Pierre Gassmann, La Photographie à l'épreuve*, Paris: Editions France Delory/Picto, 2000, p. 75.

7. Letter from Konrad Wolff to "Paul," New York, November 10, 1941. (IBA/EIB).

8. Letter from Konrad Wolff to his parents, New York, September 30, 1941. (IBA/EIB).

9. The story of these photographers is recounted in an article by Fritz Neugass, "The Saga of the S.S. *Winnipeg*," *Modern Photography*, 1951, pp. 72–87.

10. Letter from Konrad Wolff to "Paul," New York, November 10, 1941. (IBA/EIB).

11. Letter from Konrad Wolff to his parents, New York, June 15, 1941. (IBA/EIB).

12. Helen Stephenson, "Freed from French Camp, Ilse Bing Carries on Here," *New York World-Telegram*, August 13, 1941, clipping in IBA/EIB.

13. Letter from Konrad Wolff to his parents, New York, August 8, 1941. (IBA/EIB).

14. Letter from Ilse Bing to Konrad Wolff, Paris, December 29, 1938. (IBA/EIB).

15. Letter from Konrad Wolff to his mother, New York, September 28, 1945. (IBA/EIB).

16. The only direct mention of her mother's deportation can be found in one of the very first letters from Ilse Bing to Ella Bergmann-Michel after the war. Letter to Ella Bergmann-Michel, New York, April 29, 1948, Ella Bergmann-Michel Archive, Sprengel Museum, Hannover.

17. Cf. documentary *Frankfurt, Paris, New York, Die Drei Leben der Ilse Bing*.

18. Letter from Konrad Wolff to his parents, New York, July 21, 1941. (IBA/EIB).

19. Letter from Konrad Wolff to his parents, New York, January 2, 1945. (IBA/EIB).

20. Barrett, p. 26.

21. Cf. documentary *Frankfurt, Paris, New York, Die Drei Leben der Ilse Bing*.

22. Ilse Bing, "The Camera as My Artistic Tool," unpublished manuscript, n.d. (circa 1980), p. 30. (IBA/EIB).

23. Ibid., p. 36.

24. Ibid., p. 35.

25. Ilse Bing, untitled manuscript, September 6, 1984. (IBA/EIB).

26. Ilse Bing, "About the Change in My Style," unpublished manuscript, March 1979. (IBA/EIB).

27. Cf. Ilse Bing, "The Camera as My Artistic Tool," p. 14.

28. "Paris zeigt sich als Riesenmuseum," Ilse Bing, letter to Konrad Wolff, Paris, June 11, 1950. (IBA/EIB).

29. As per Françoise Reynaud's recorded interview with Ilse Bing, June 1987, Wiesbaden.

30. Ilse Bing, "The Three Phases of My Work," unpublished notes for a lecture at the International Center of Photography, January 1991, n.p. (IBA/EIB).

31. Ilse Bing, unpublished manuscript, September 6, 1984. (IBA/EIB).

32. Ilse Bing, interview with Susan Charlotte, New York, 1992, preparatory manuscript to *Facets of Creativity*, p. 9. (IBA/EIB).

33. Ilse Bing, "The Three Phases of My Work," unpublished manuscript, March 1987, p. 2. (IBA/EIB).

34. Françoise Friedrich, interview with the author, Paris, December 2001.

35. As per Françoise Reynaud's recorded interview with Ilse Bing, June 1987, Wiesbaden: "With modern photography, all of a sudden a door opens up." ("Dans la photographie moderne tout d'un coup il y a une porte qui s'ouvre.")

PLATES

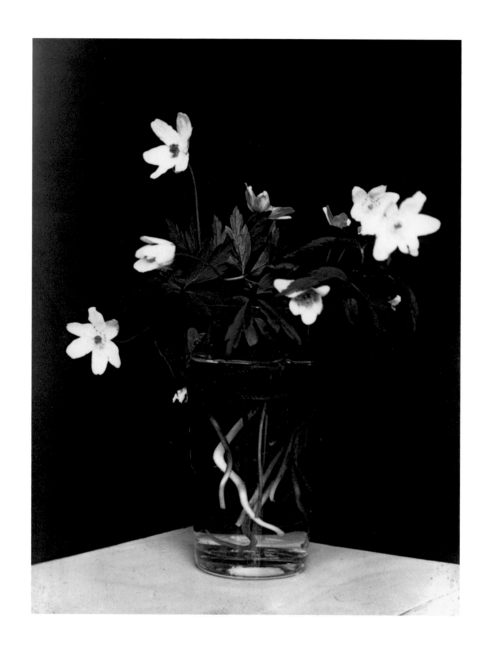

Still Life, Frankfurt, 1928

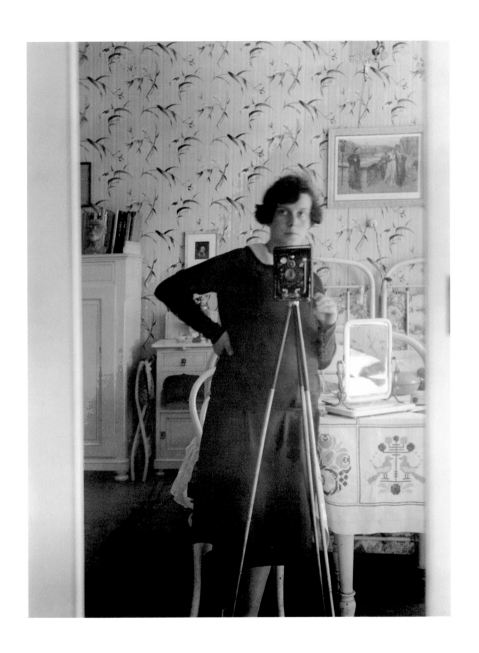

Self-Portrait, Frankfurt, 1925

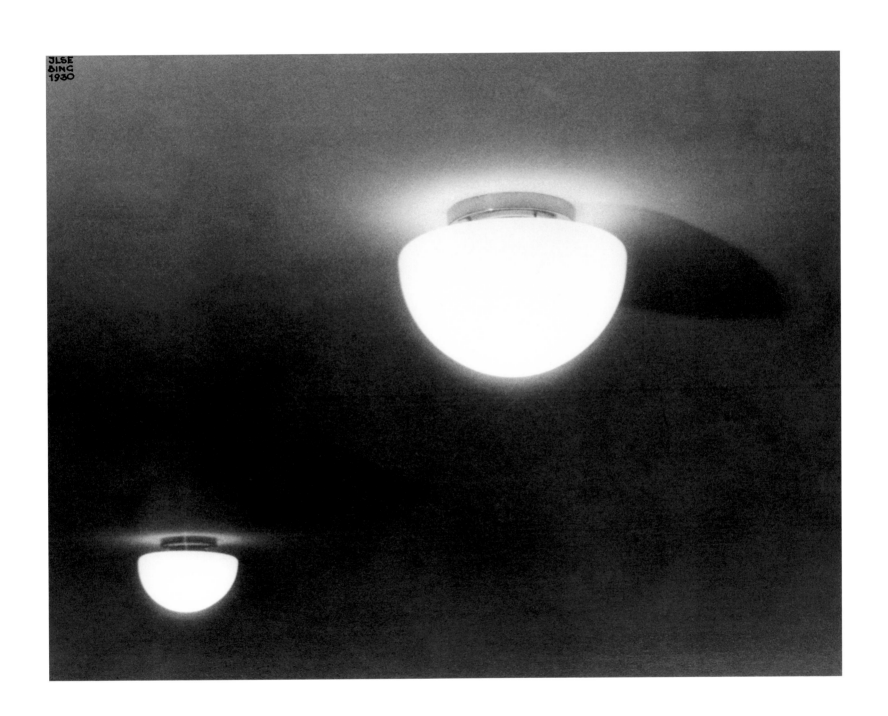

Lamps in BudgeHeim, Frankfurt, 1930

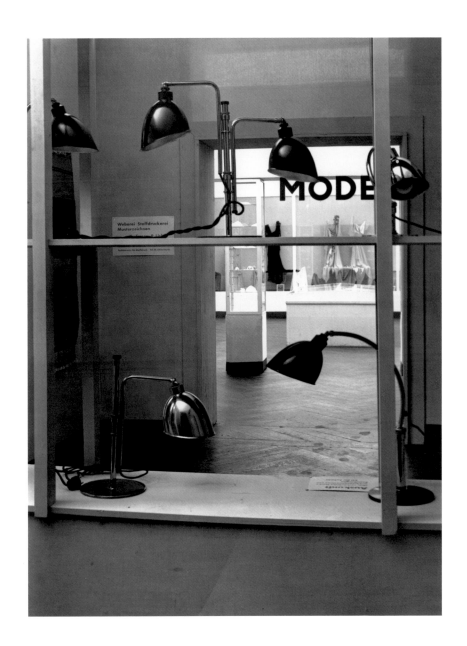

School of Design Exhibition, Frankfurt, 1929

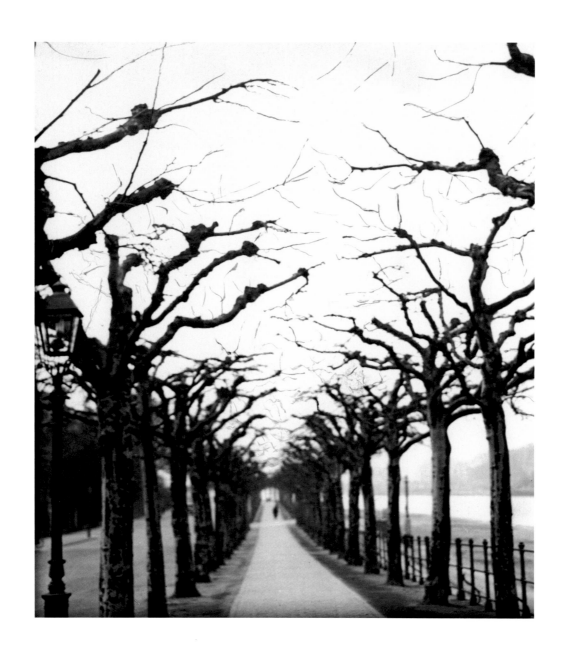

Frankfurt, 1929

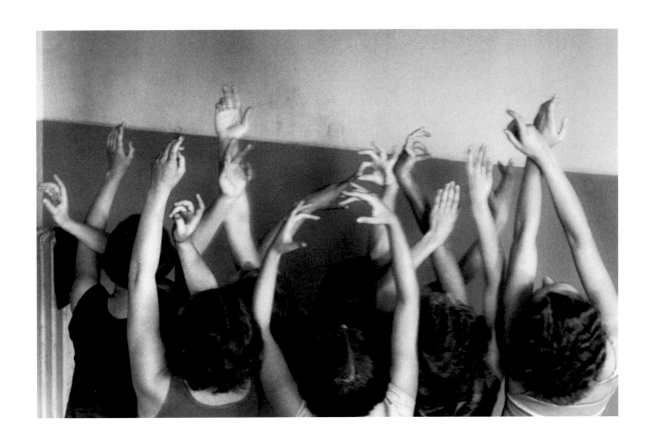

Laban Dance School, Frankfurt, 1929

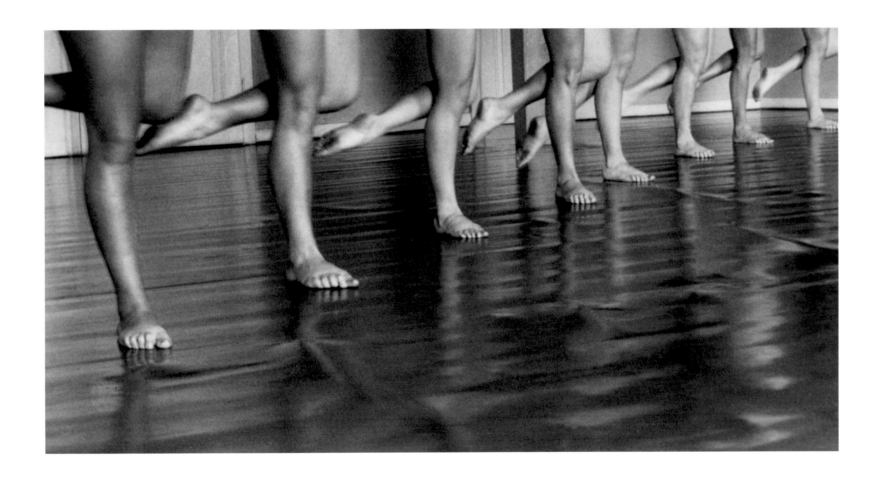

Laban Dance School, Frankfurt, 1929

Railroad Cars, Switzerland, 1929

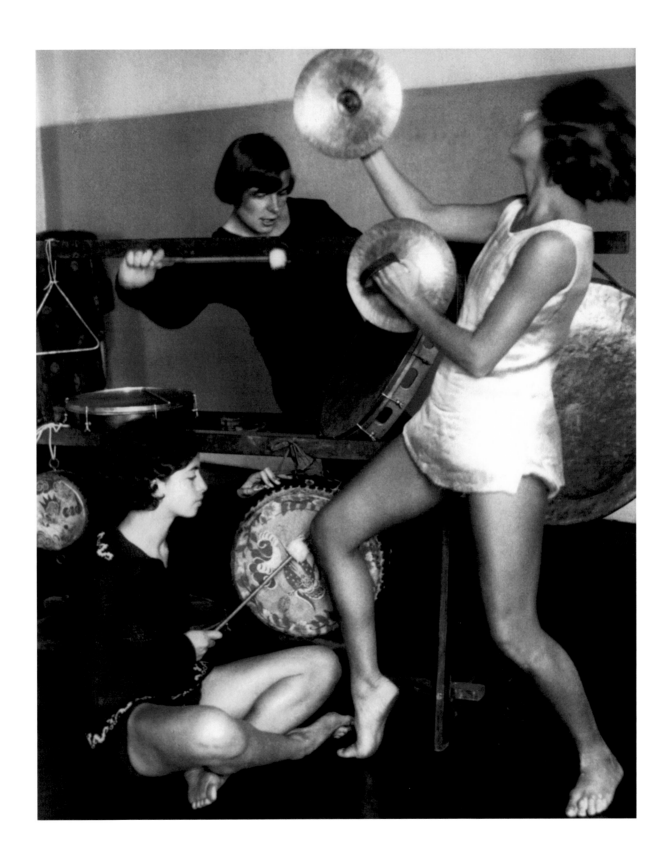

Laban Dance School, Frankfurt, 1929

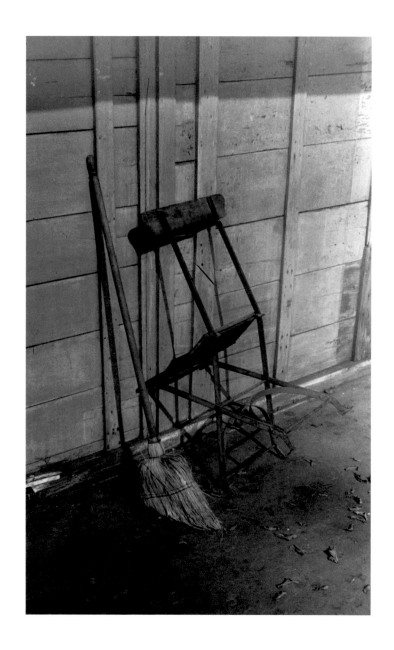

Frankfurt, 1929

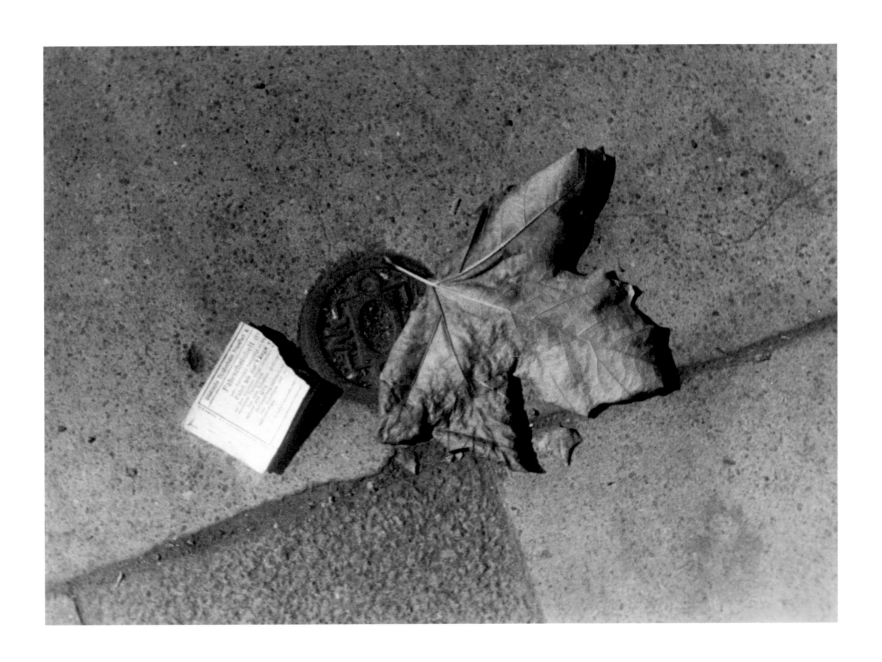

Dead Leaf and Tramway Ticket on Sidewalk, Frankfurt, 1929

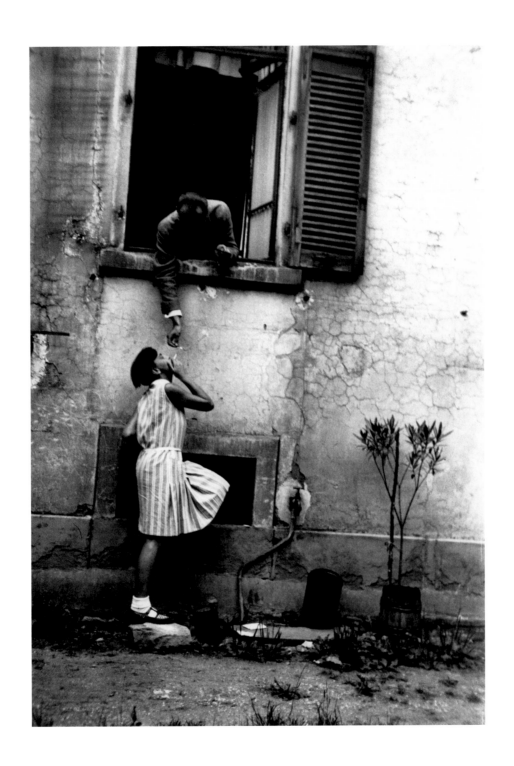

Frankfurt, 1929

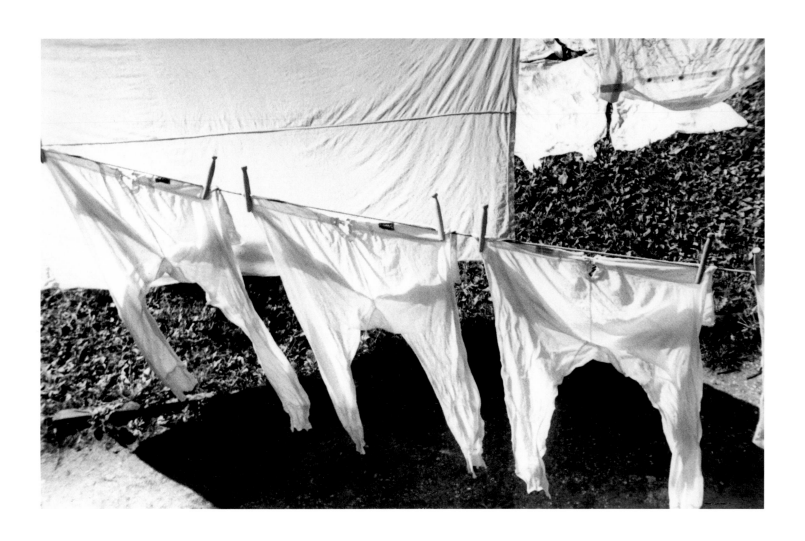

Laundry, Frankfurt, 1929

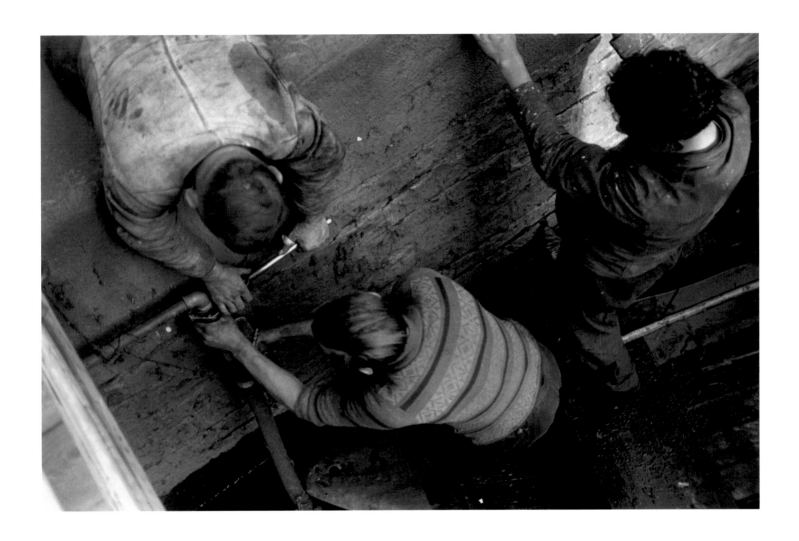

Three Men Dismantling Swimming Pool, Frankfurt, 1929

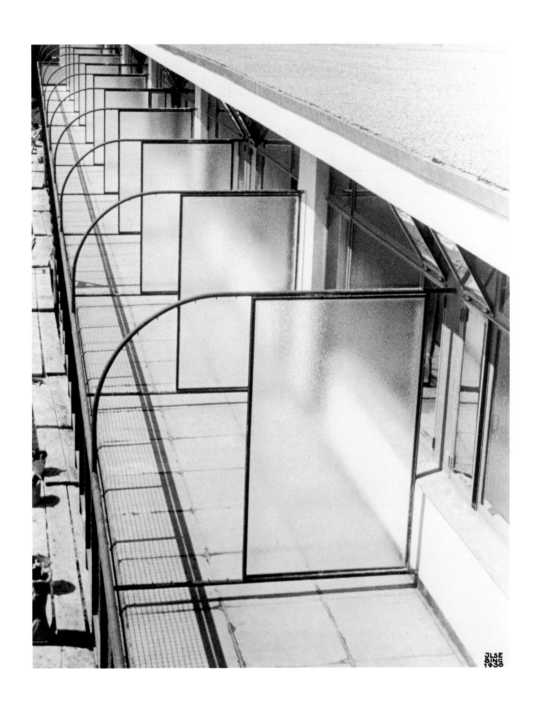

BudgeHeim, Frankfurt, 1930

Railroad Cars, Switzerland, 1929

Railroad, Switzerland, 1929

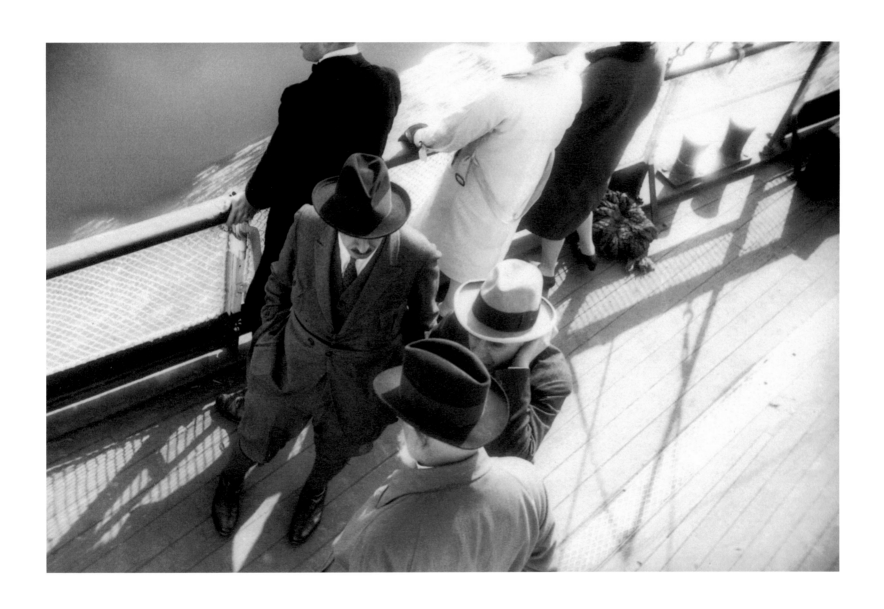

Lake Constance, Switzerland, 1929

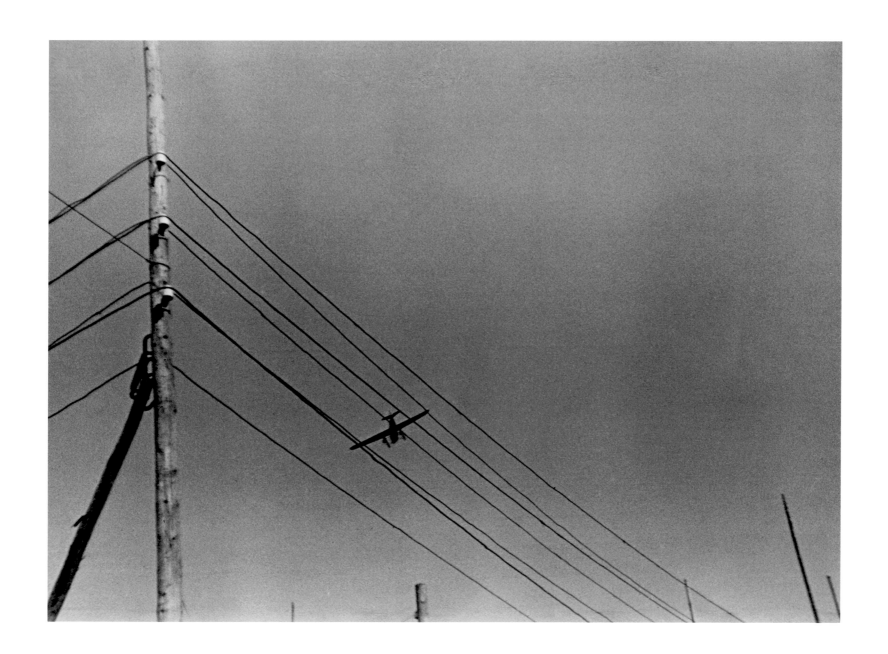

Frankfurt, 1929

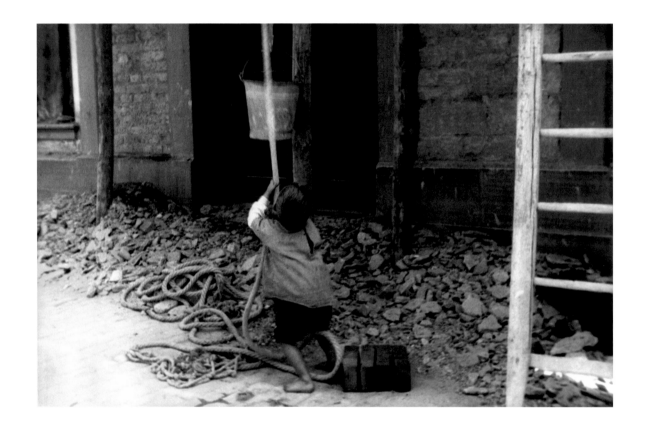

Construction, Frankfurt, 1929

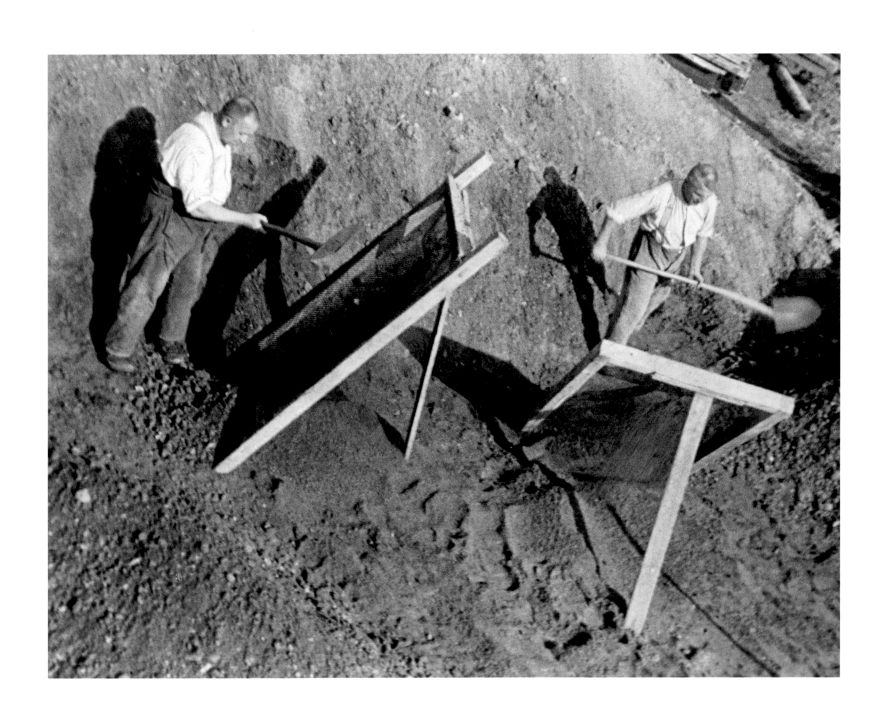

Construction, BudgeHeim, Frankfurt, 1929

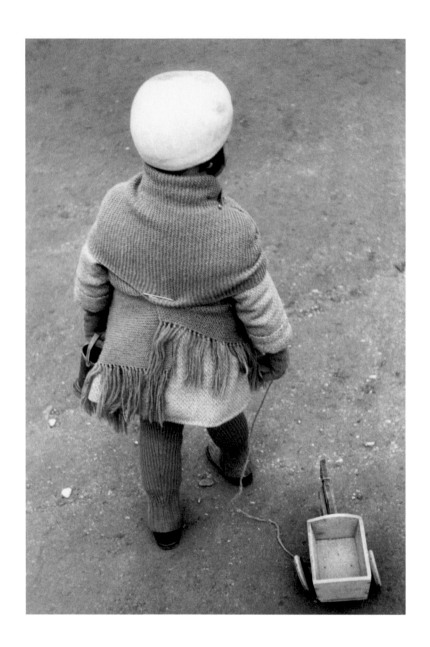

Child with Toy, Paris, 1931

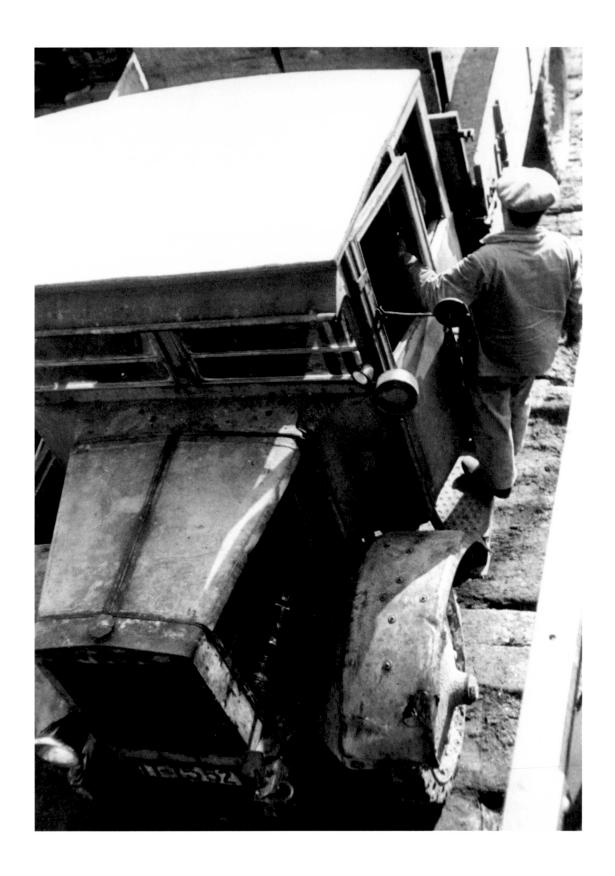

Construction, BudgeHeim, Frankfurt, 1929

Gear, Frankfurt, 1930

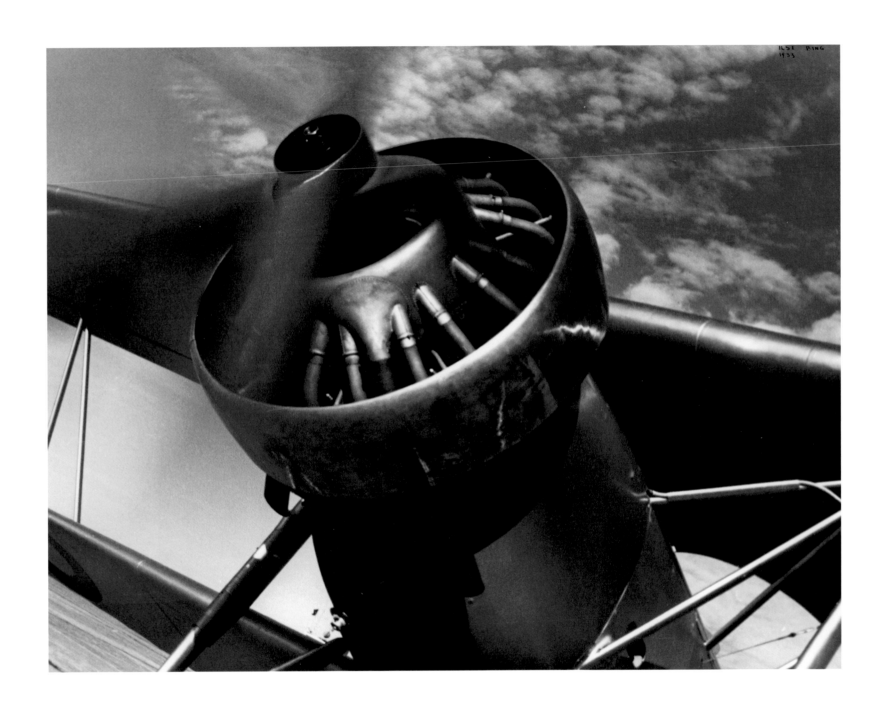

Fokker Plane, Amsterdam, 1933

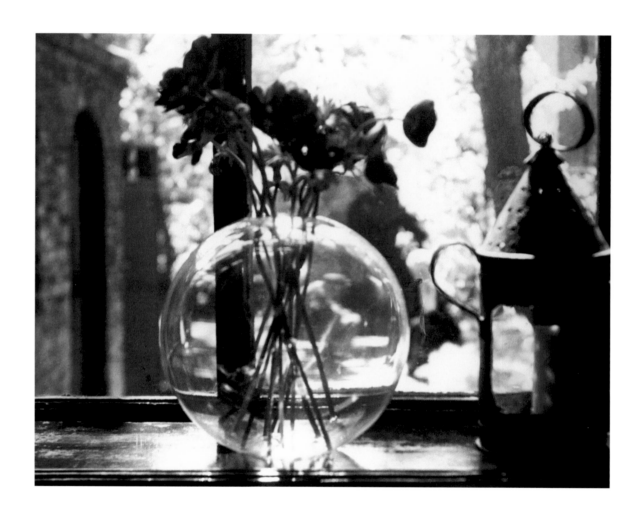

Still Life, Paris, 1931

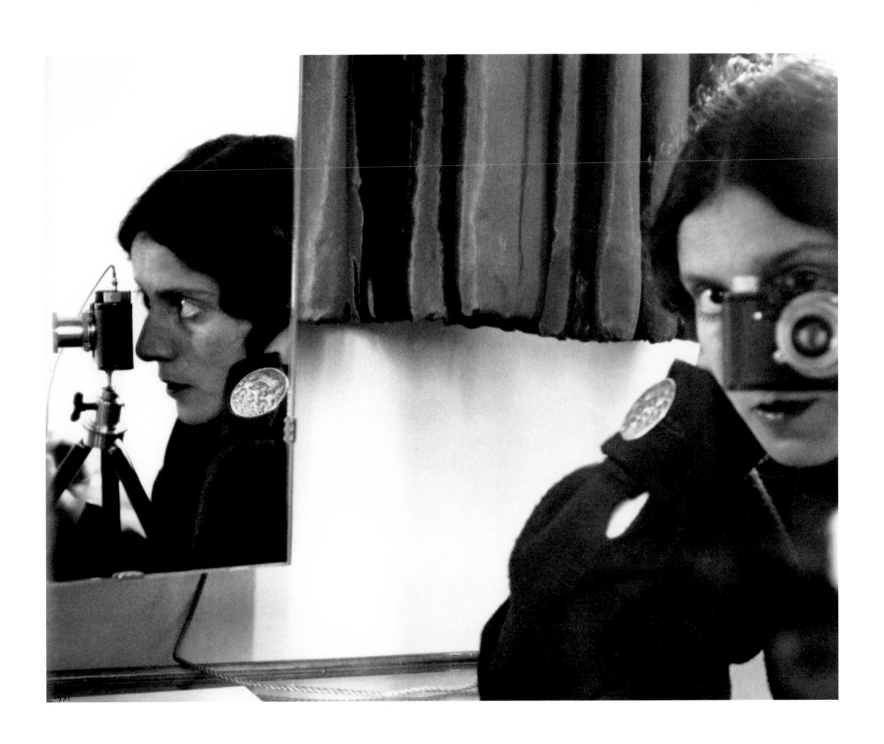

Self-Portrait with Leica, Paris, 1931

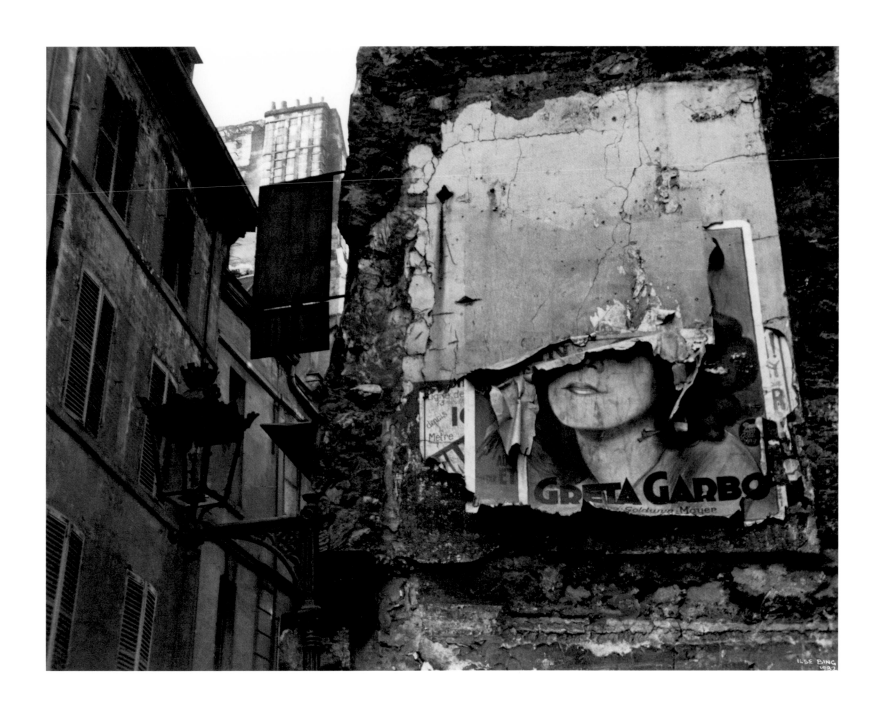

Greta Garbo Poster, Paris, 1932

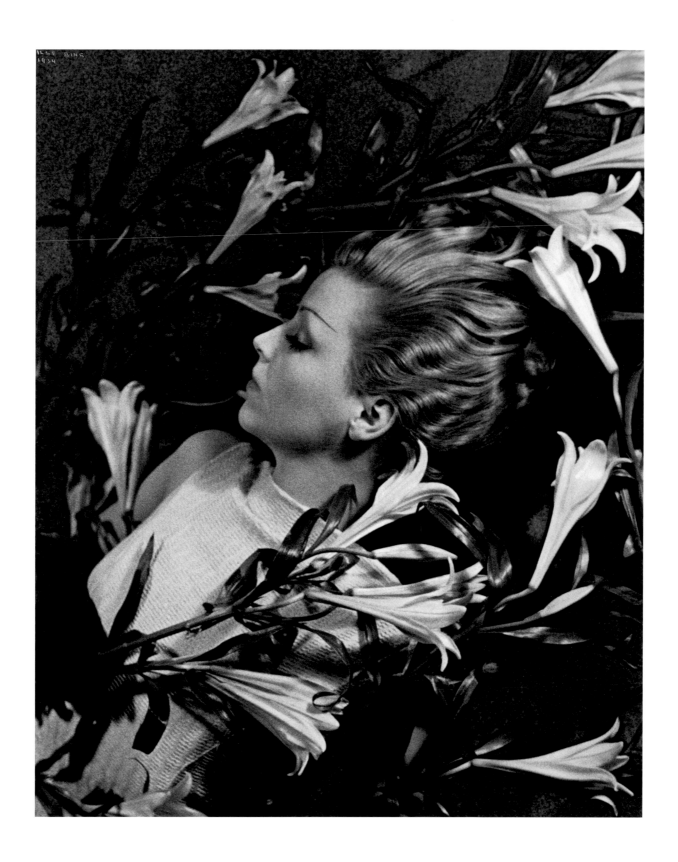

Study for Schiaparelli's Perfume, *Salut*, 1934

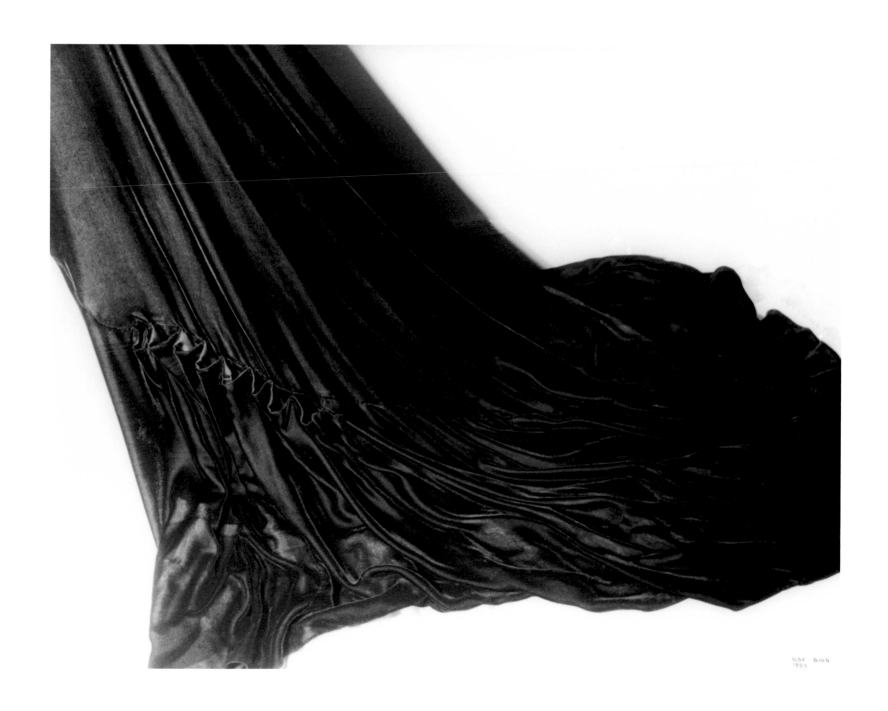

House of Worth, Paris, 1933

.

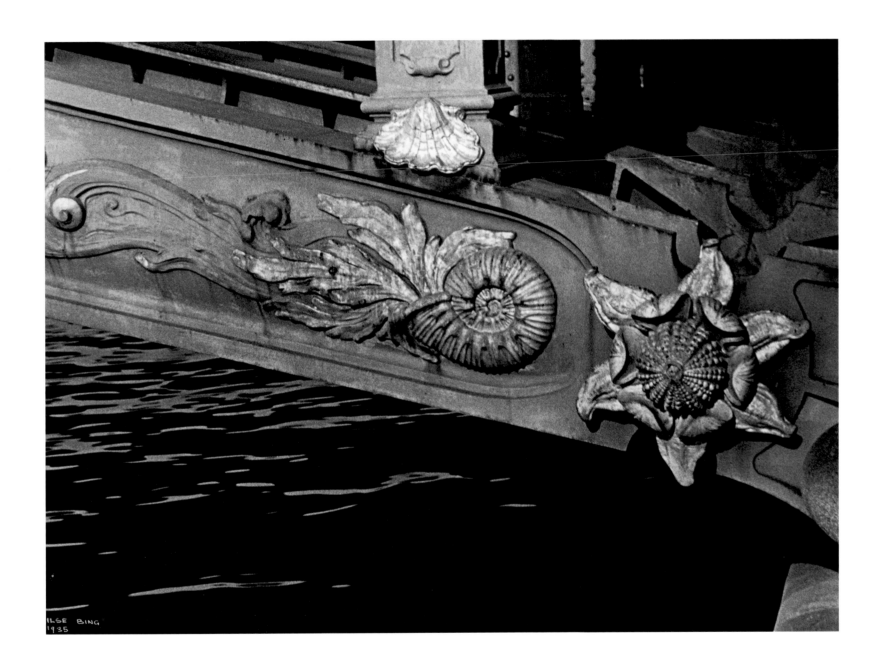

Pont Alexandre-III, Paris, 1935

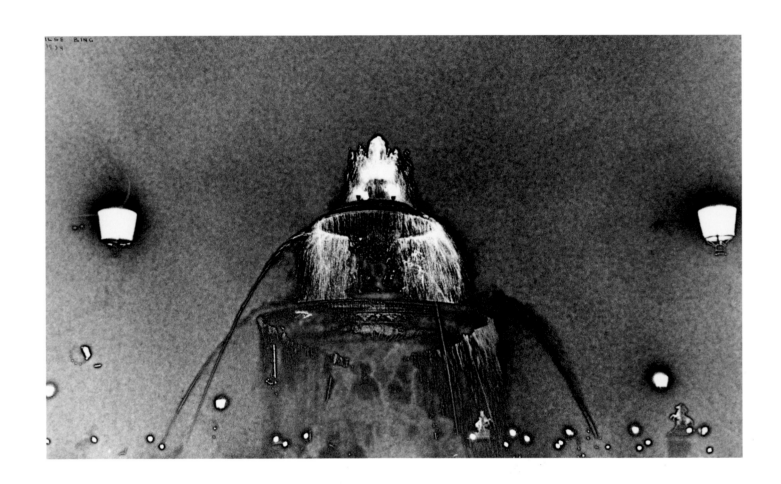

Fountain, Place de la Concorde, Paris, 1934

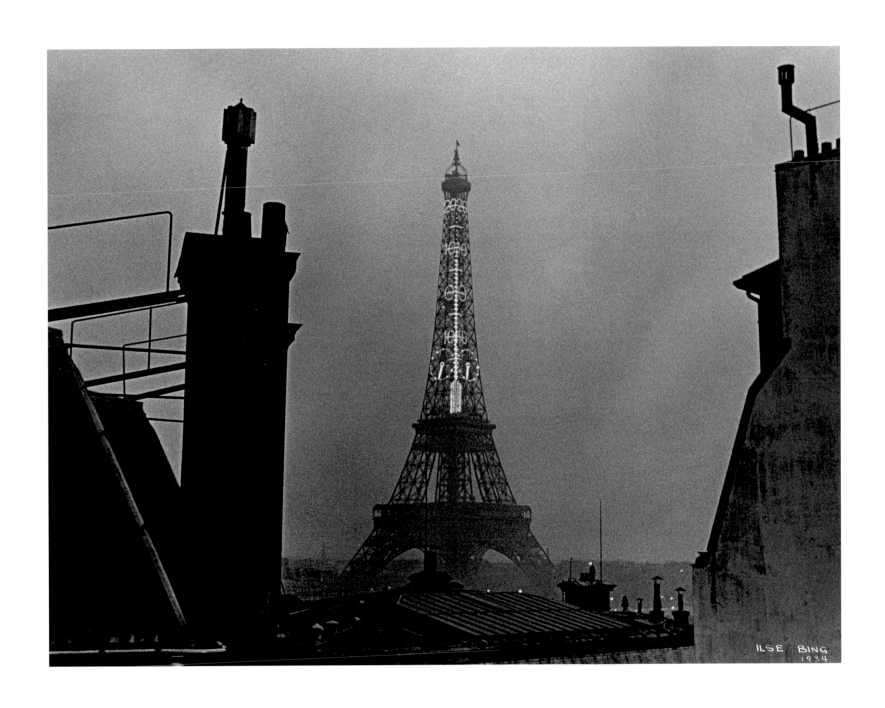

Eiffel Tower at Night, Paris, 1934

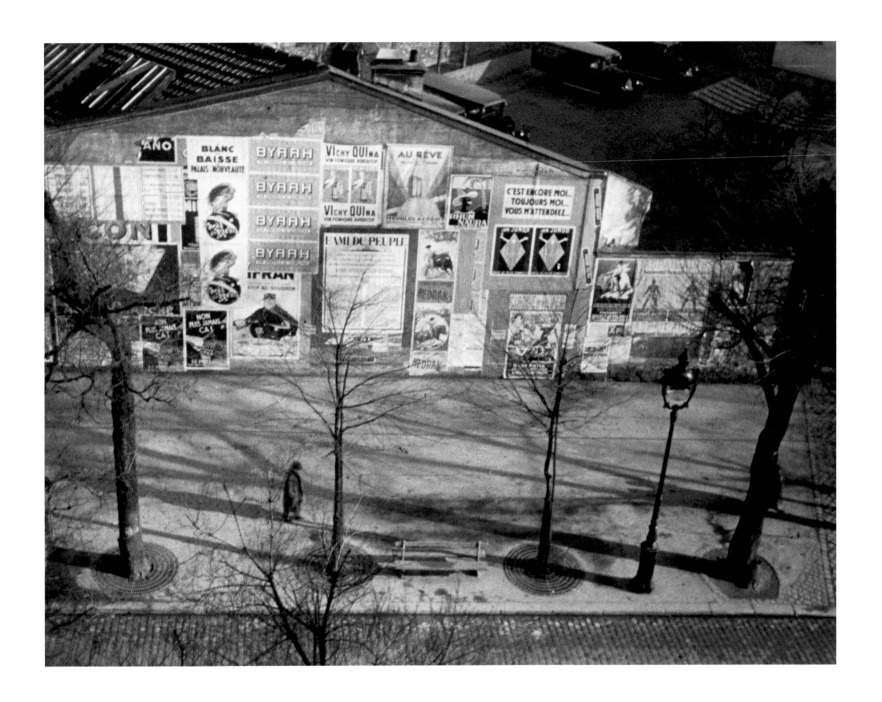

Avenue du Maine, Paris, 1932

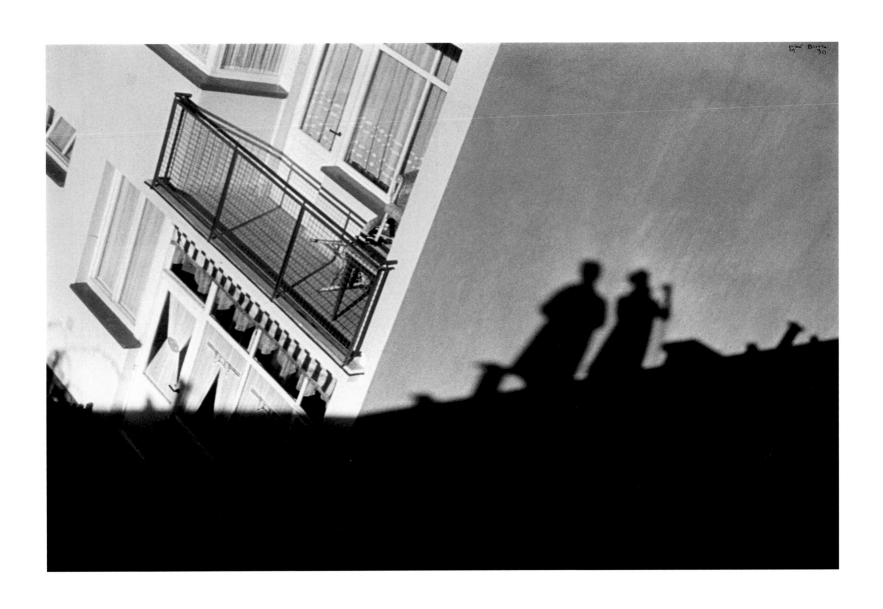

Self-Portrait with Mart Stam and Leica, Frankfurt, 1930

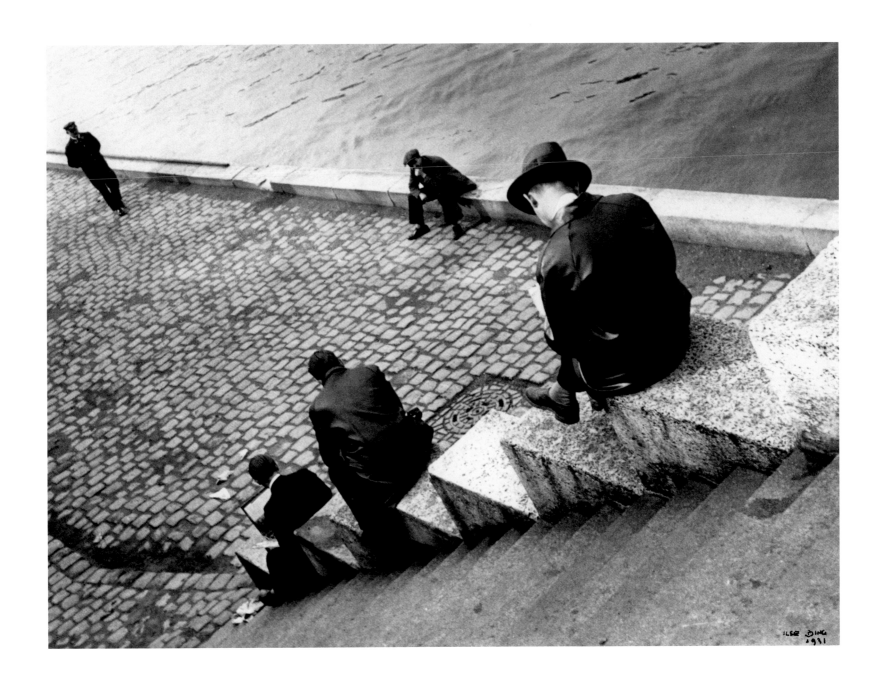

Three Men Sitting on Steps at the Seine, Paris, 1931

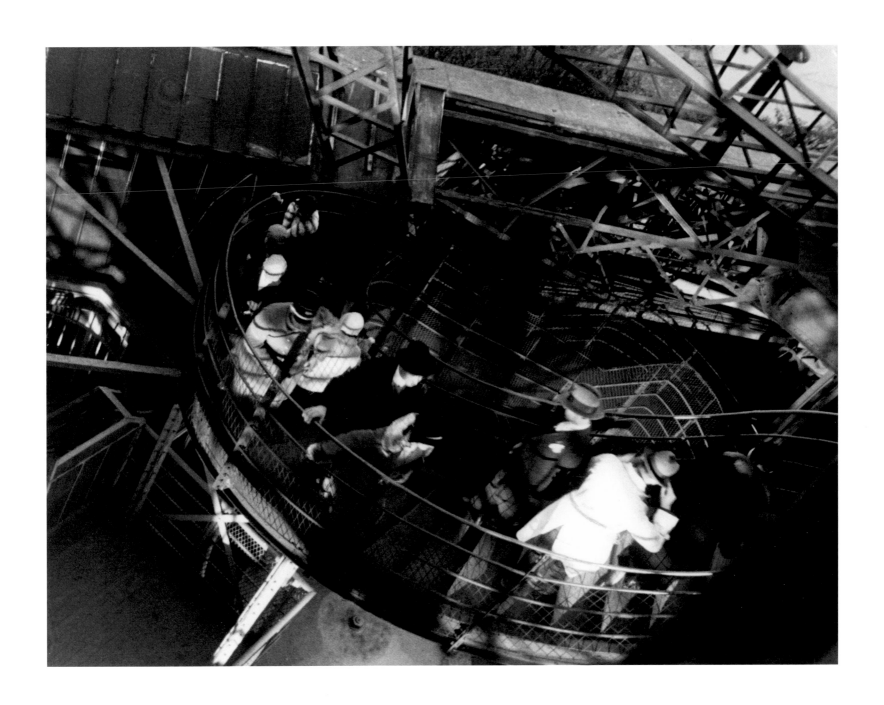

"It Was So Windy in the Eiffel Tower," Paris, 1931

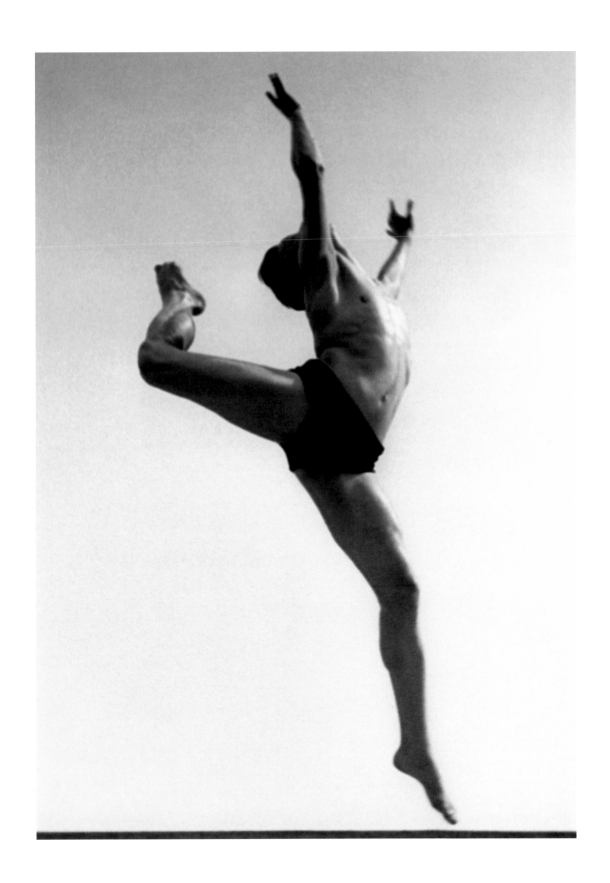

Dancer, Willem Van Loon, Paris, 1932

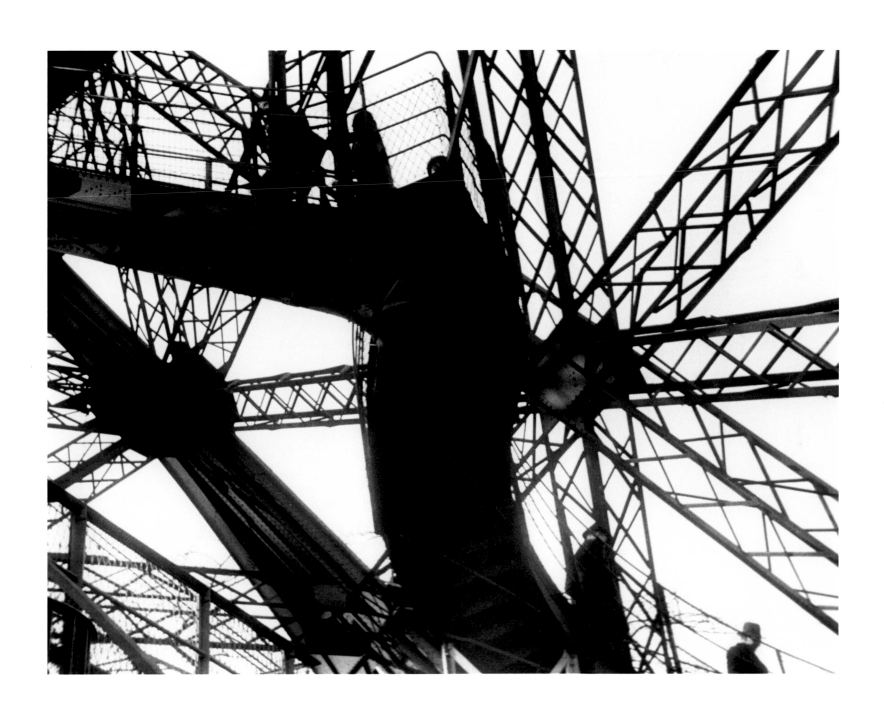

Eiffel Tower, Paris, 1931

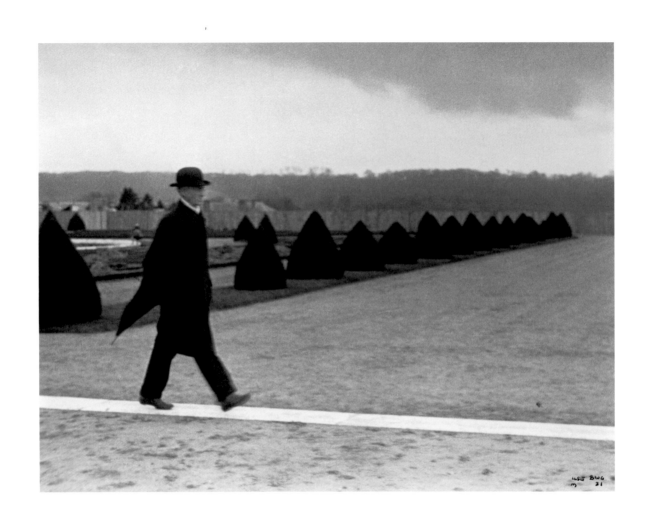

Bourgeois Walking Along Path, Versailles, 1931

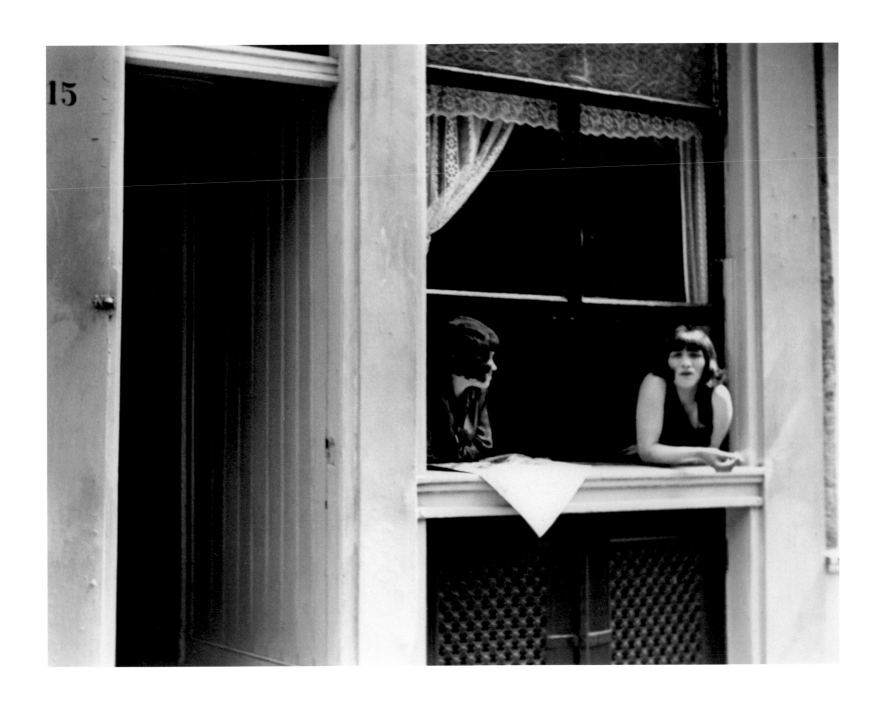

Prostitutes, Amsterdam, 1931

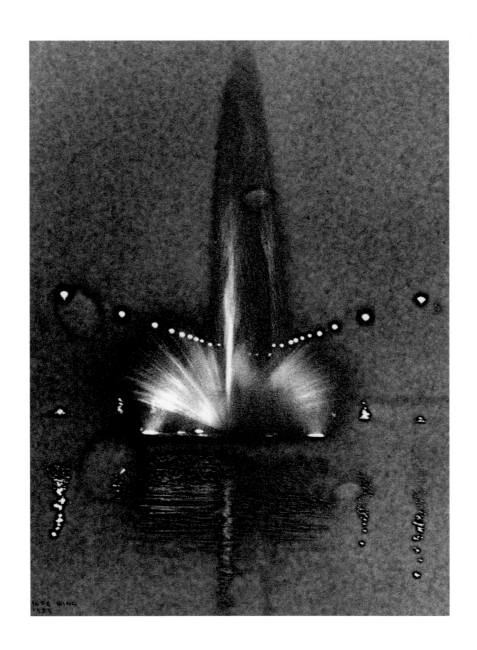

Fountain, Rond-Point des Champs-Elysées, Paris, 1934

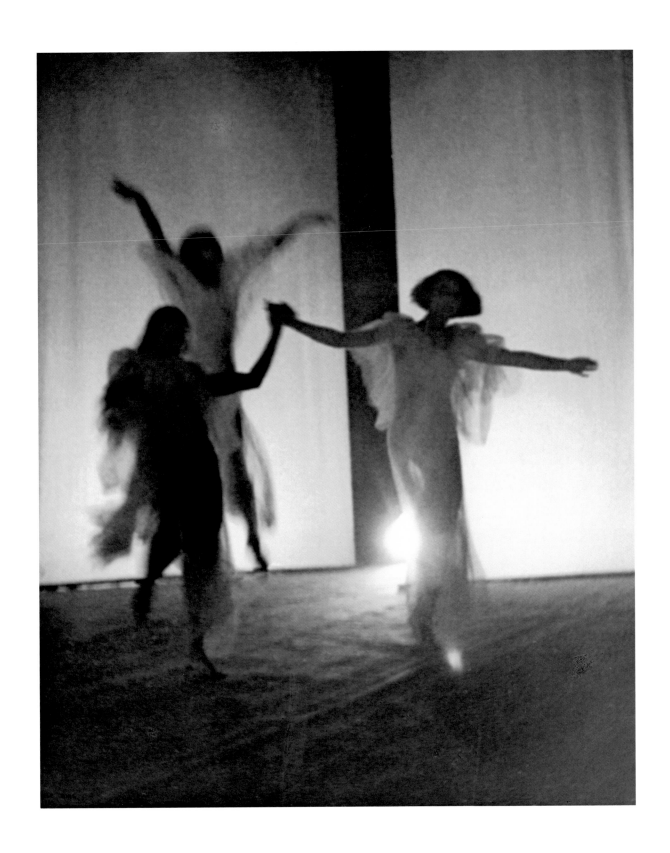

Three Dancers in the Ballet *Errante*, Paris, 1933

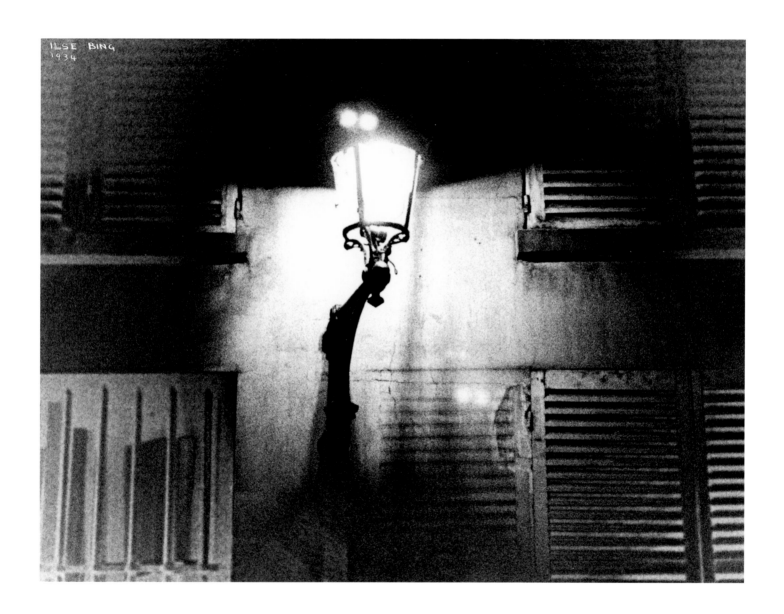

Gaslight, Rue de la Chaise, Paris, 1934

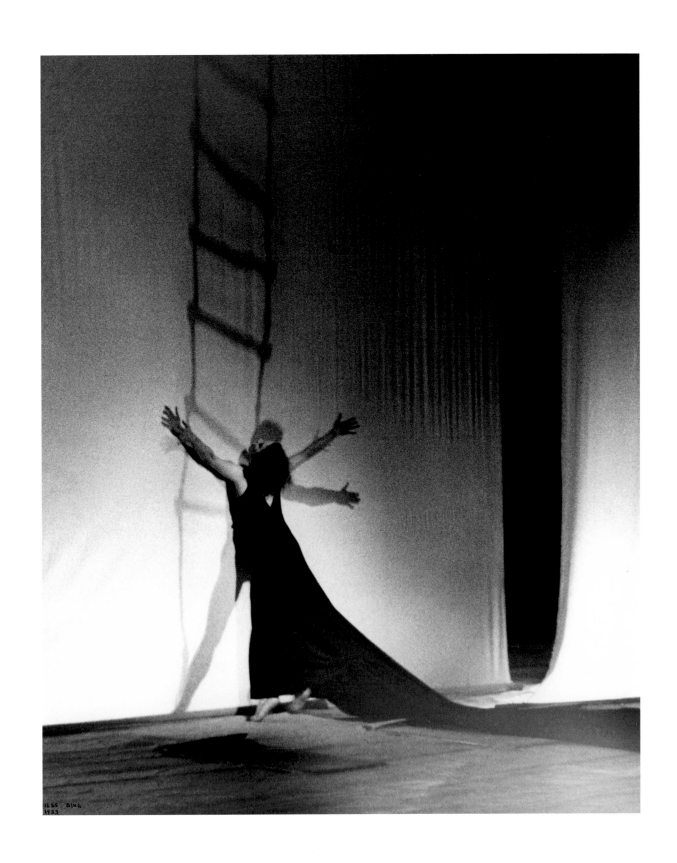

Ballet *Errante*, Paris, 1933

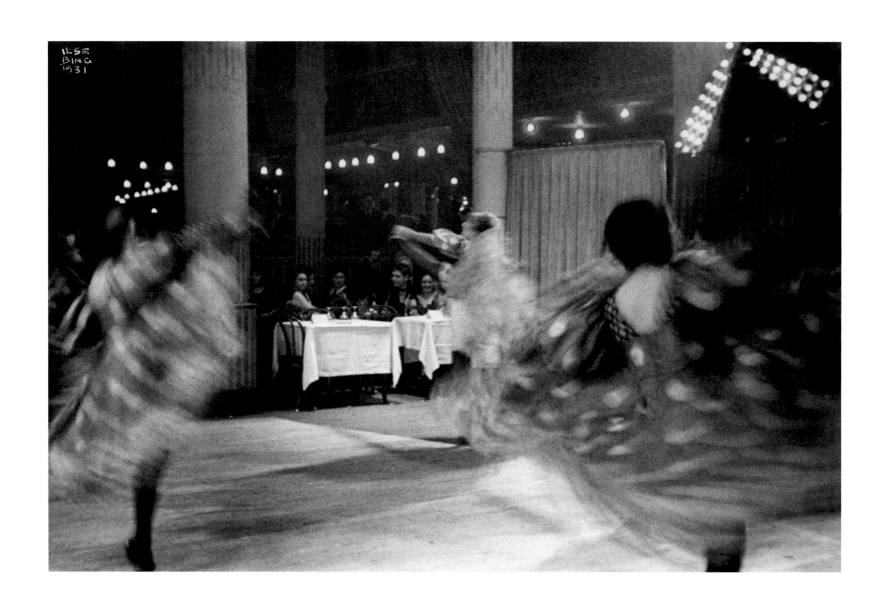

Cancan Dancers, Moulin-Rouge, Paris, 1931

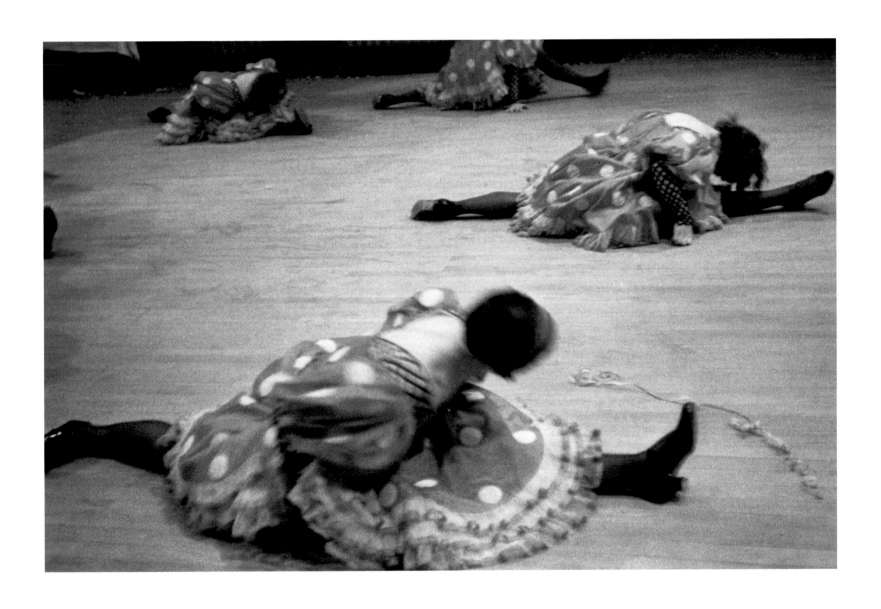

Cancan Dancers, Moulin-Rouge, Paris, 1931

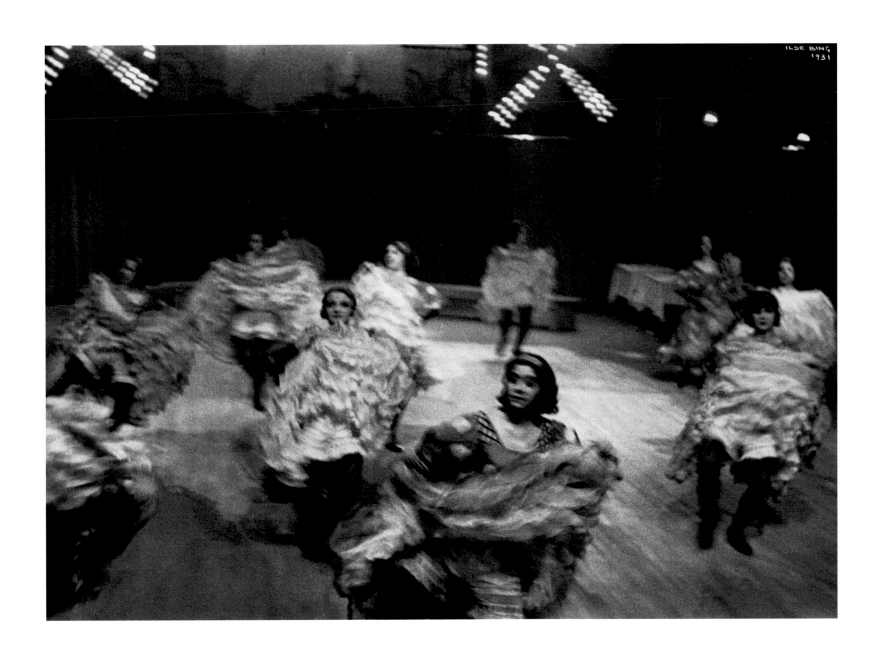

Cancan Dancers, Moulin-Rouge, Paris, 1931

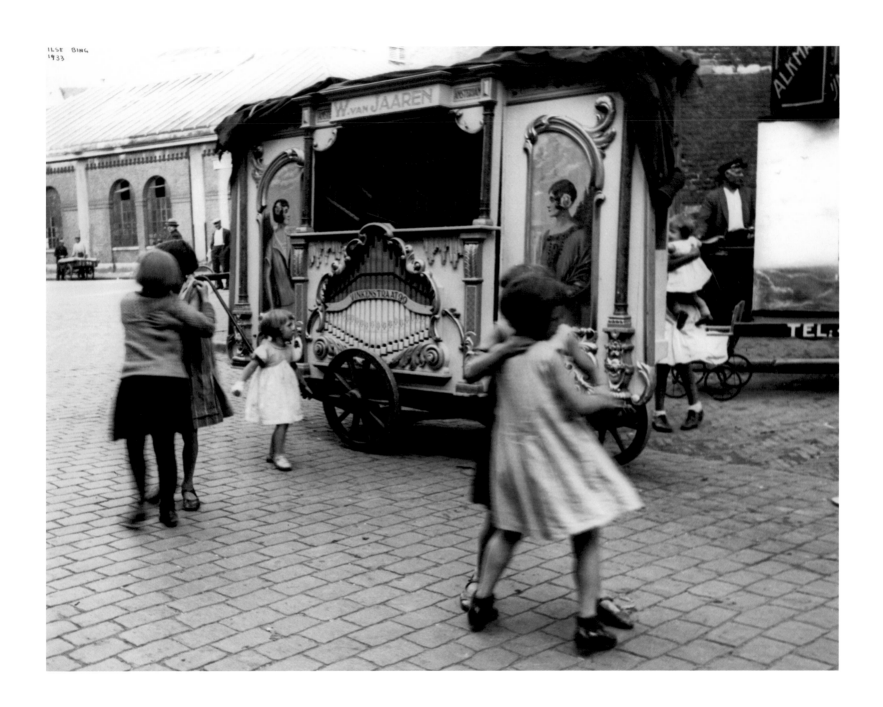

Street Organ, Amsterdam, 1933

Orchestra Pit, Théâtre des Champs-Elysées, Paris, 1933

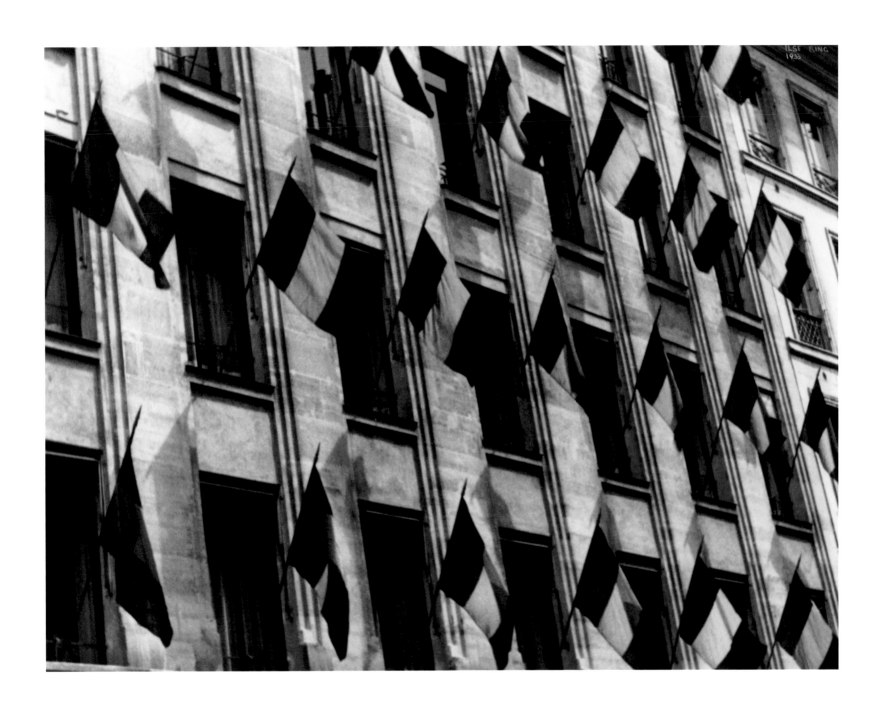

Paris, Bastille Day, 1933

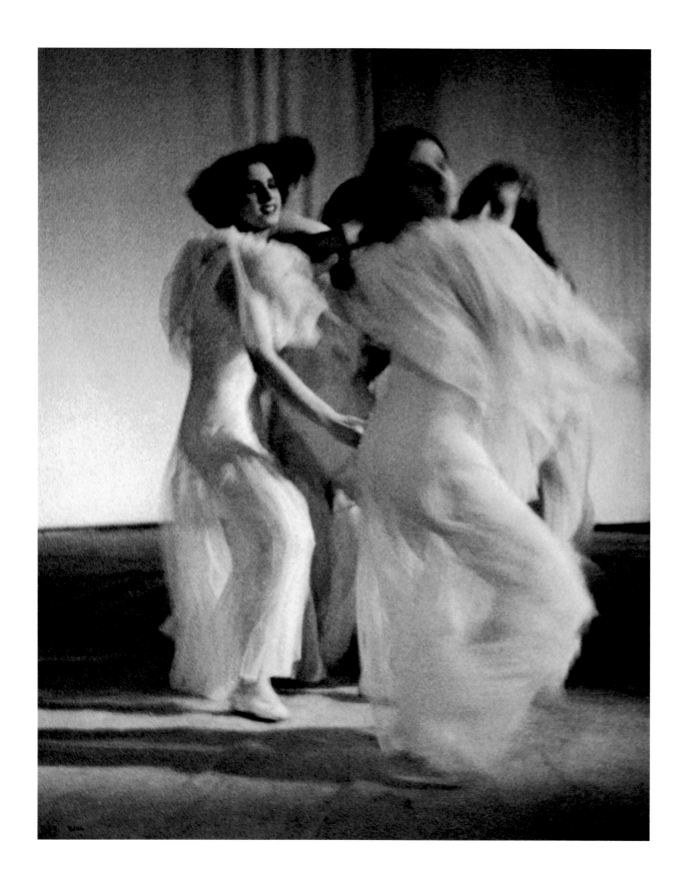

Four Dancers in the Ballet *Errante*, Paris, 1933

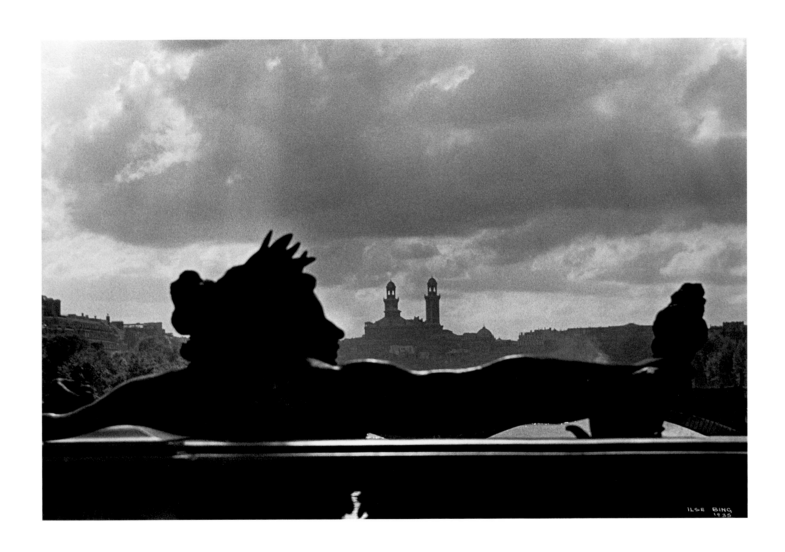

Pont Alexandre-III with View of Trocadero, Paris, 1935

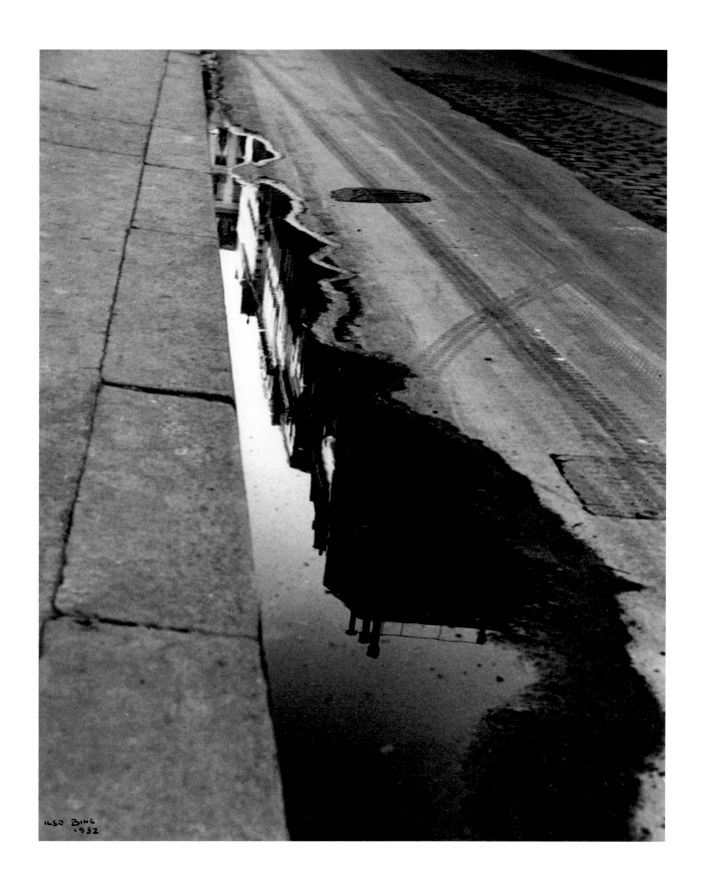

Puddle, Rue de Valois, Paris, 1932

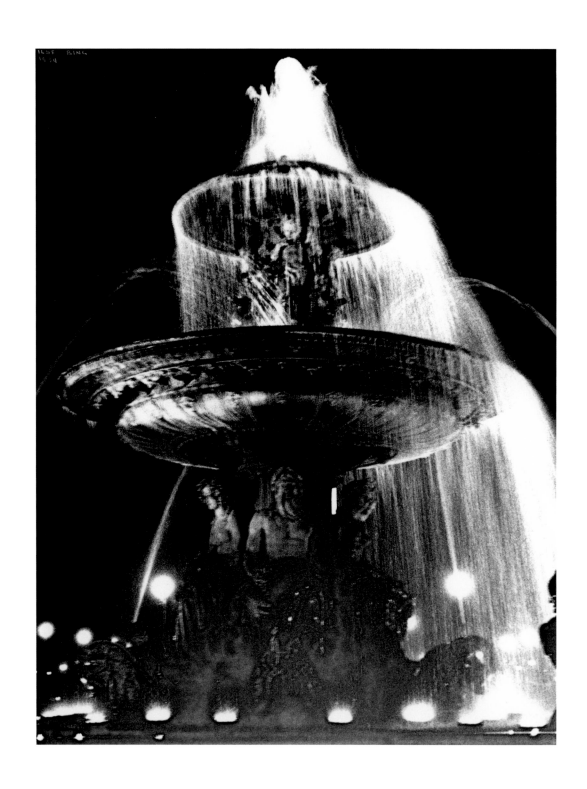

Fountain, Place de la Concorde, Paris, 1934

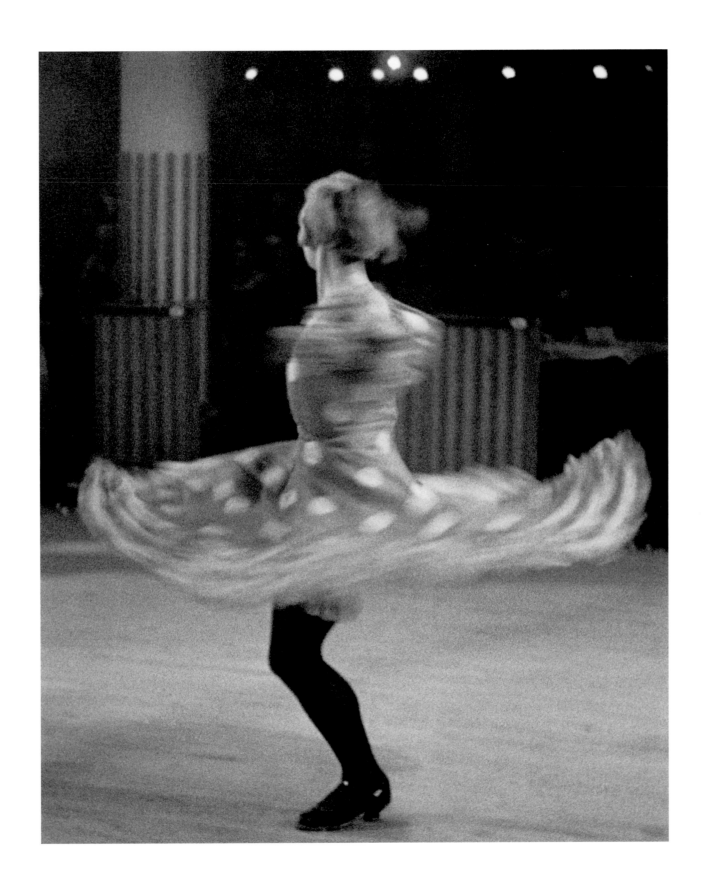

Cancan Dancer, Moulin-Rouge, Paris, 1933

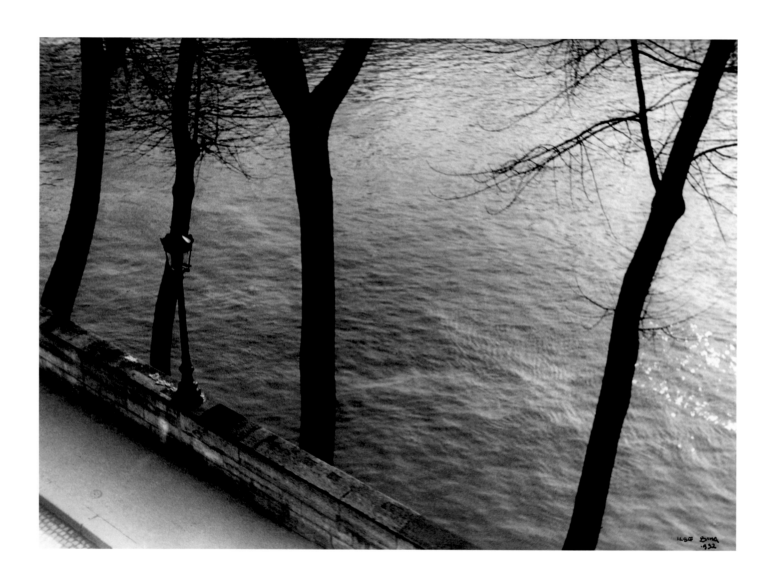

Ile Saint-Louis, Paris, 1932

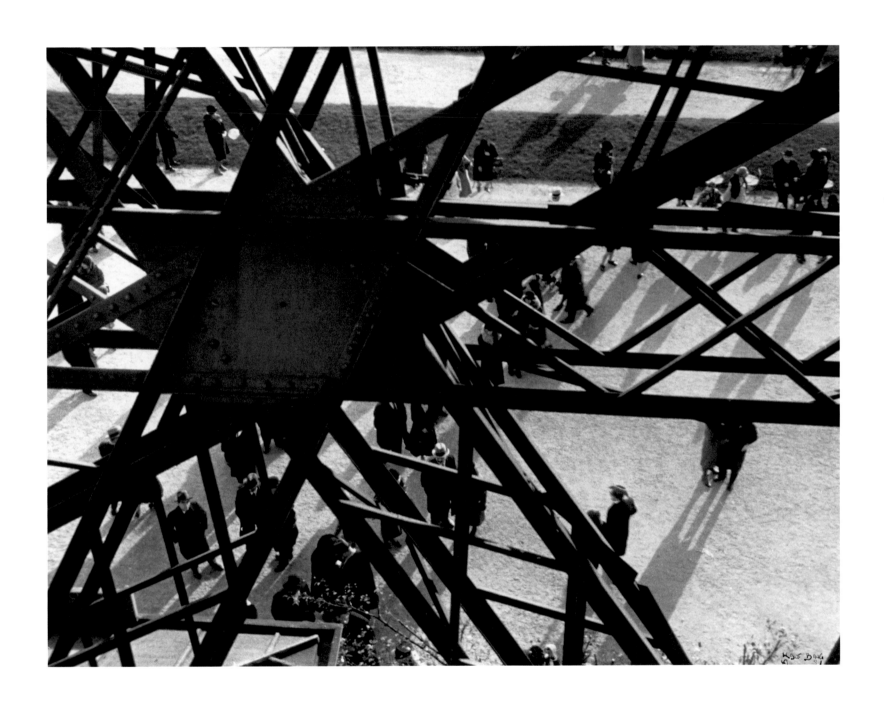

Eiffel Tower, Paris, 1931

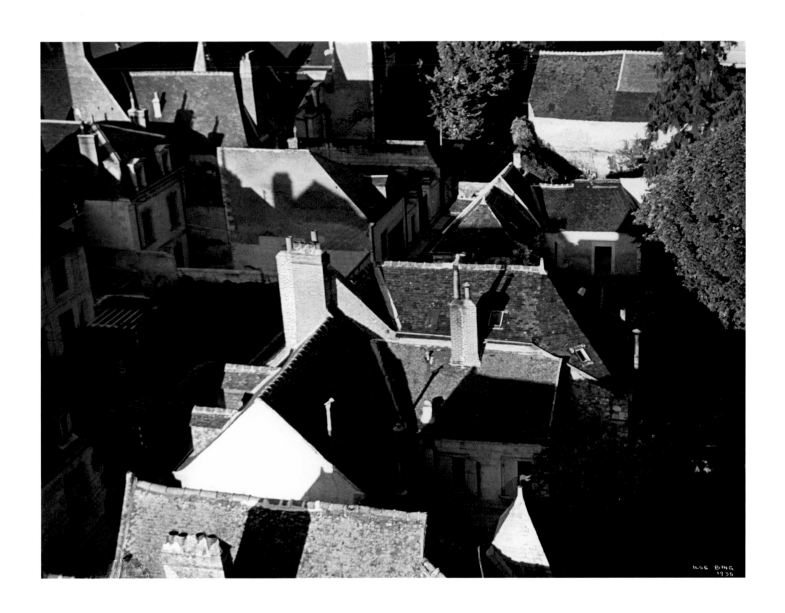

Tours, France, 1935

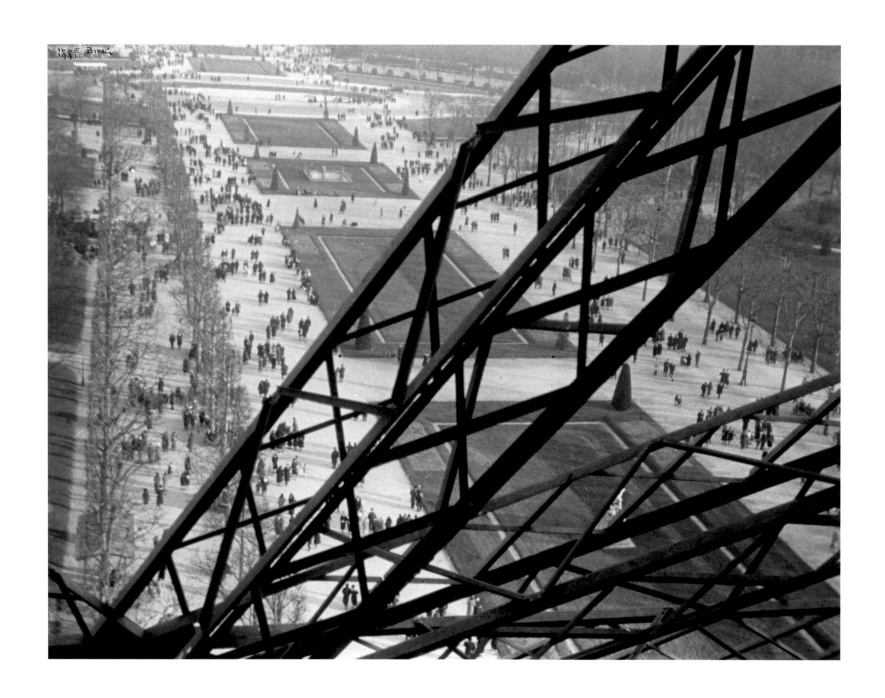

Champ-de-Mars from the Eiffel Tower, Paris, 1931

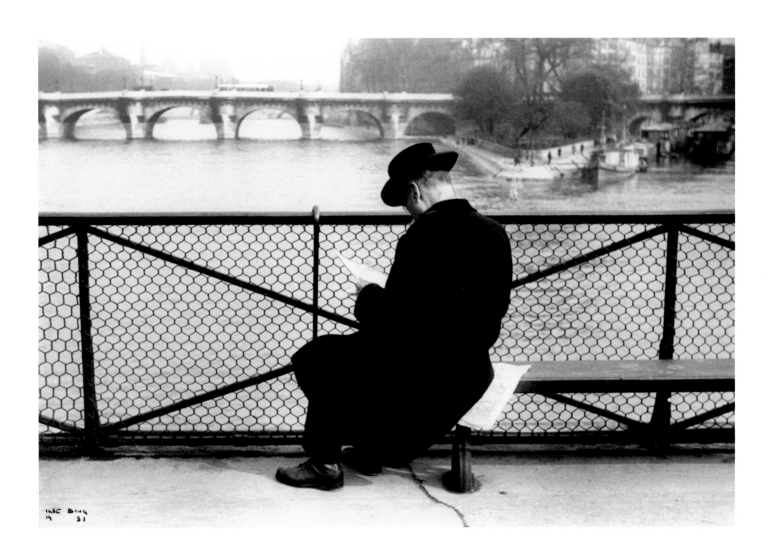

Pont des Arts, Paris, 1931

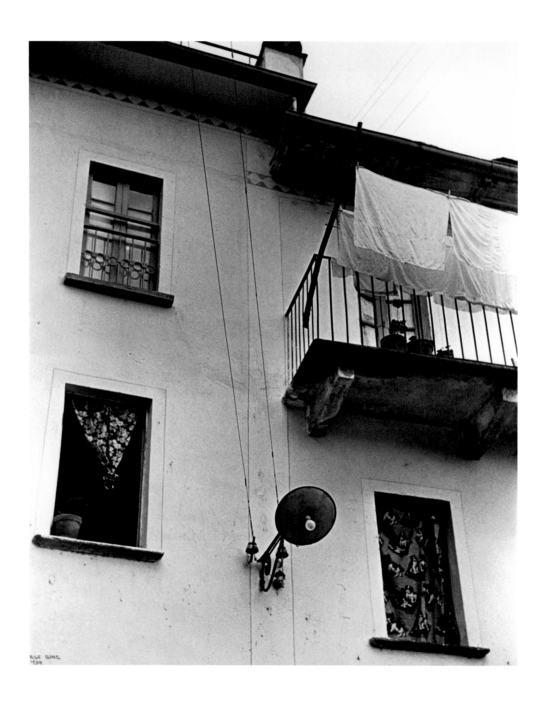

Windows, Balcony, Laundry, Cureglia, Switzerland, 1934

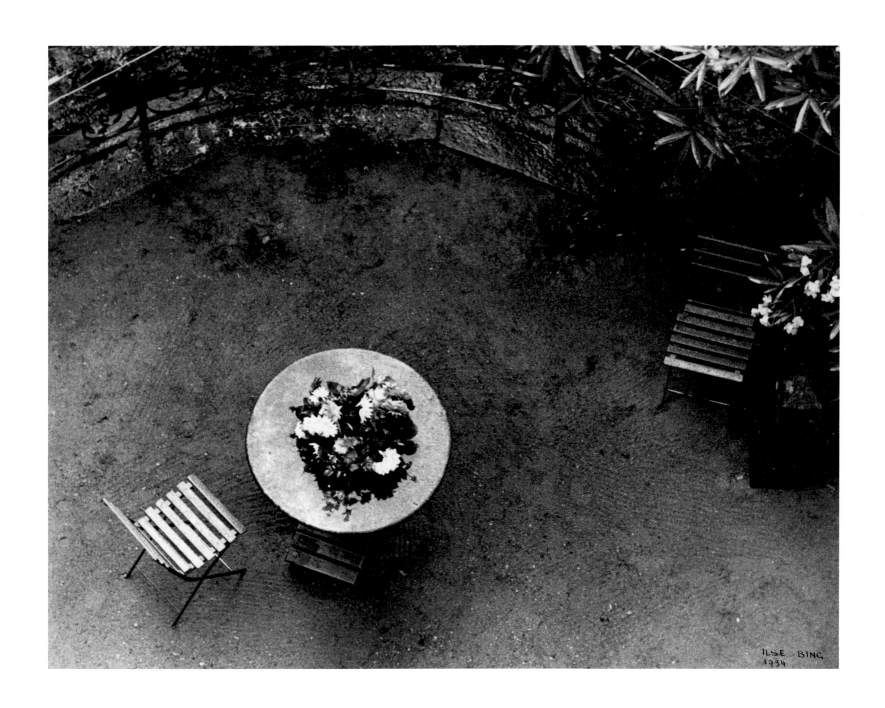

Garden, Brissago, Switzerland, 1934

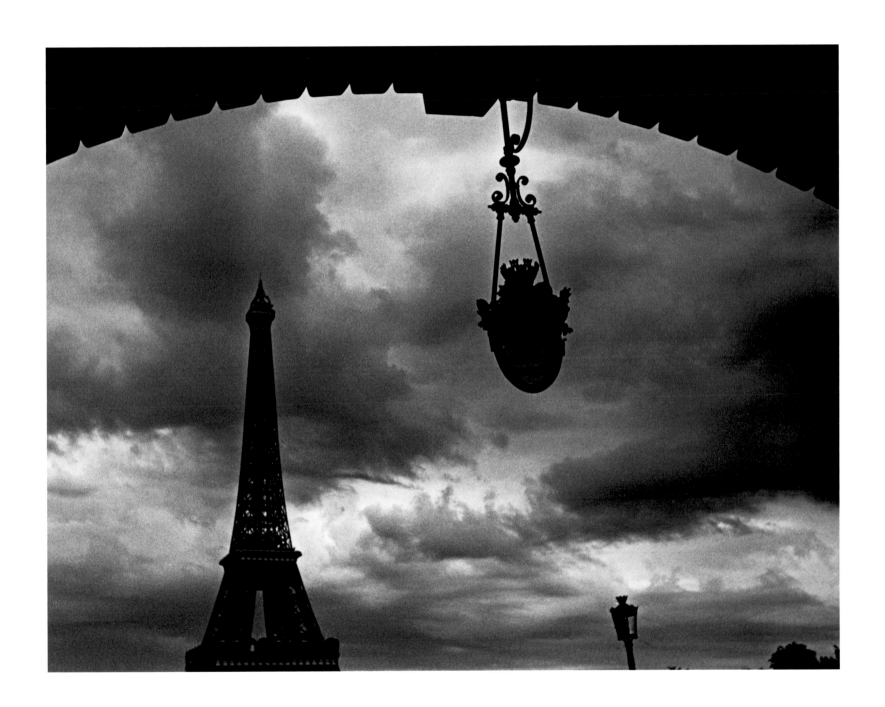

Eiffel Tower, View from Pont de Bir-Hakeim, Paris, 1932

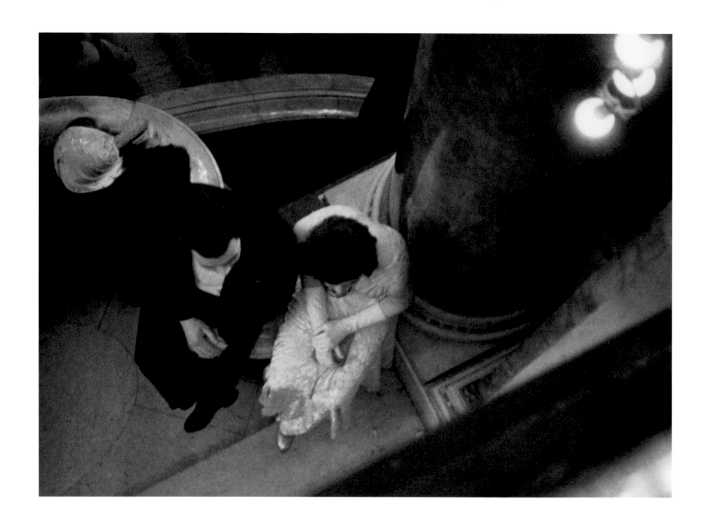

Bal de la Couture, Paris, 1931

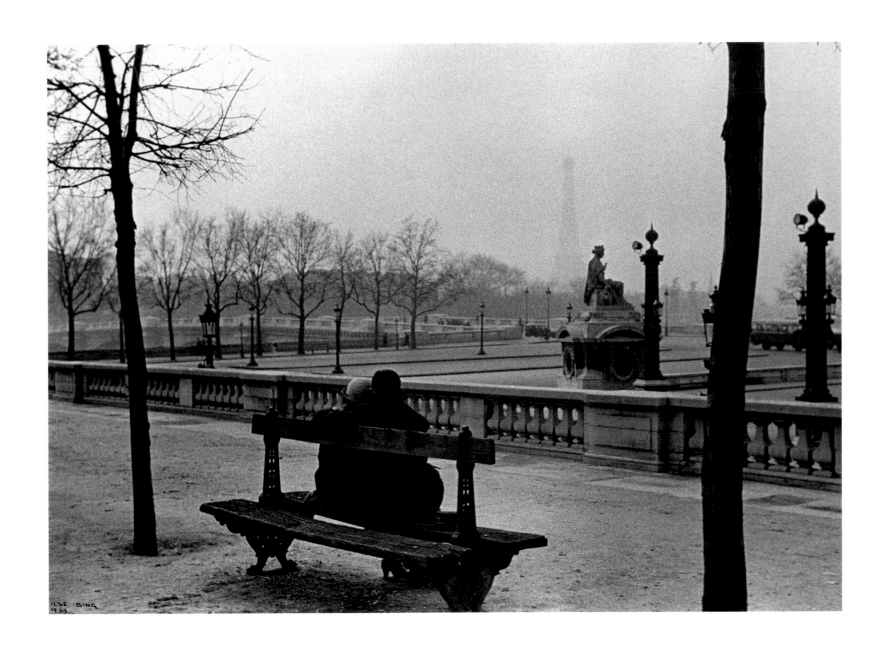

Couple, Place de la Concorde, Paris, 1933

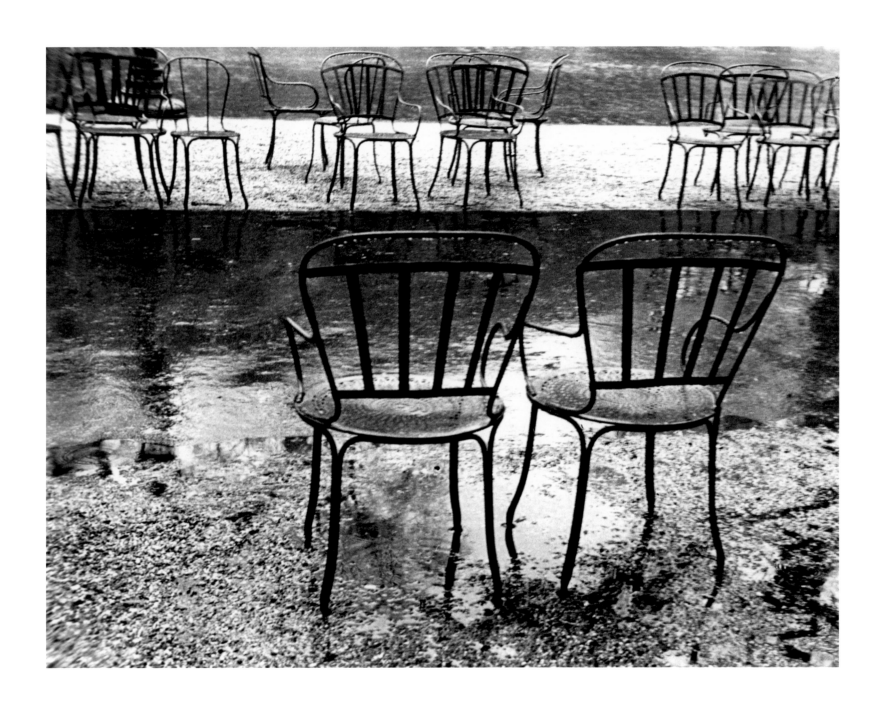

Chairs in Rain, Champs-Elysées, Paris, 1931

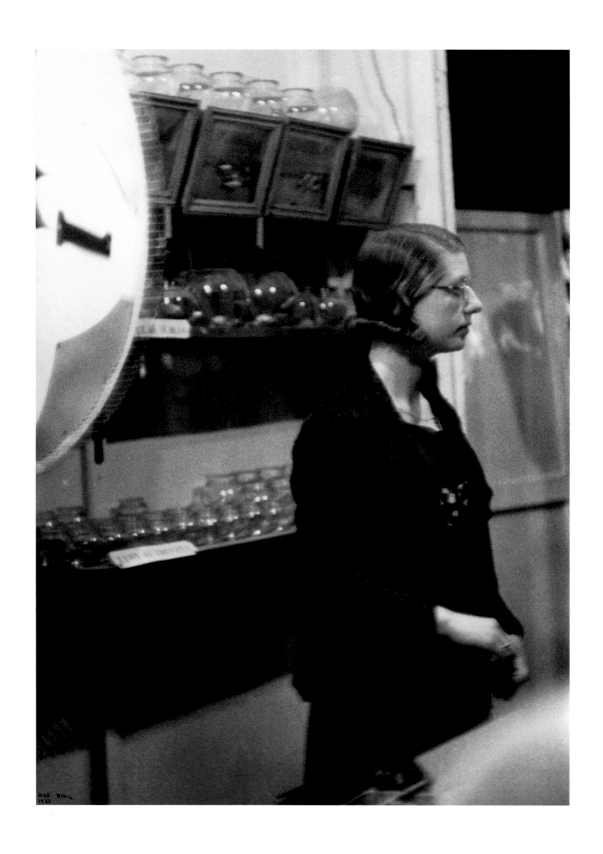

Foire au pain d'épices (Gingerbread Fair), Paris, 1933

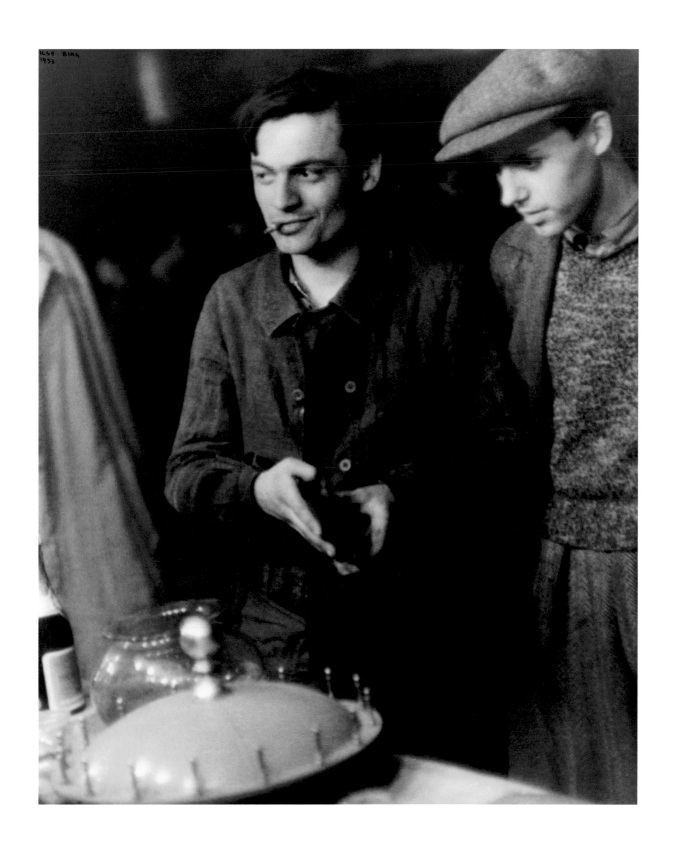

Foire au pain d'épices (Gingerbread Fair), Paris, 1933

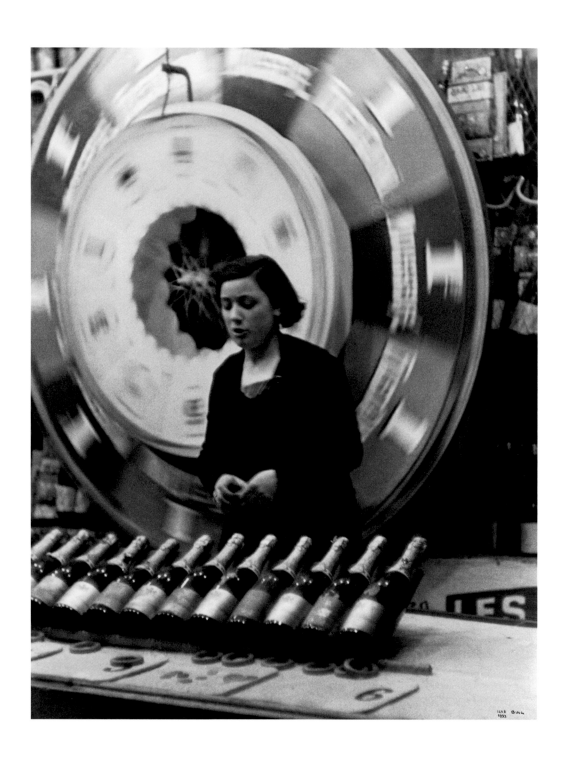

Foire au pain d'épices (Gingerbread Fair), Paris, 1933

Couple at the *Foire au pain d'épices* (Gingerbread Fair), Paris, 1933

The Honorable Daisy Fellowes, *Harper's Bazaar*, 1933

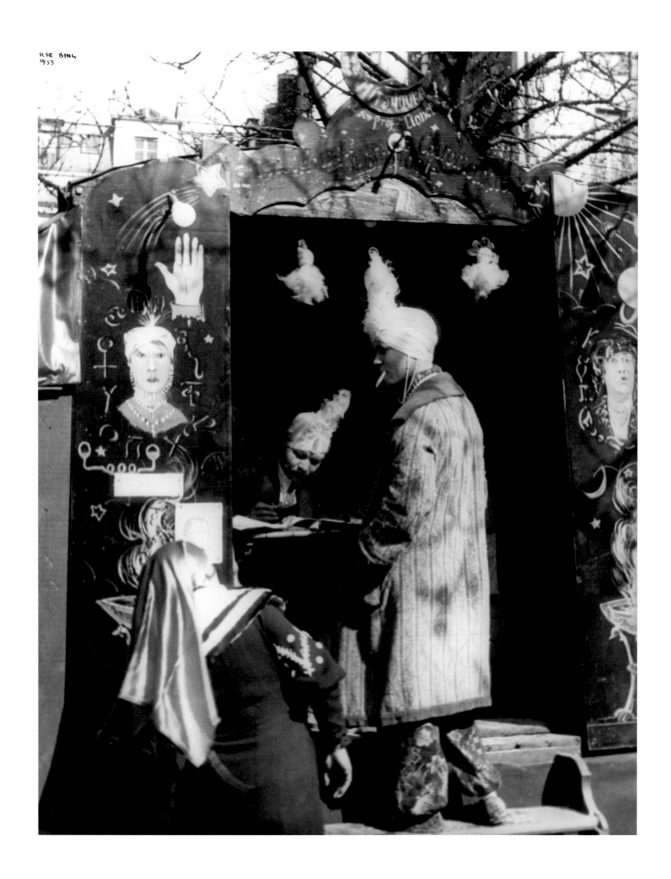

Street Fair, Paris, 1933

Foire au pain d'épices (Gingerbread Fair), Paris, 1933

Quai Along the Seine, Paris, 1931

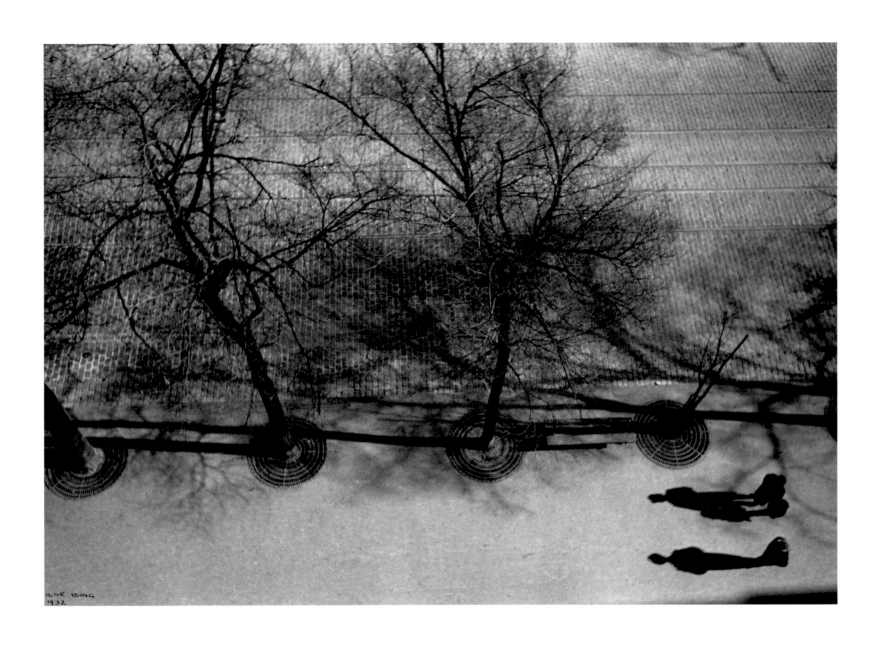

Silhouettes, Avenue du Maine, Paris, 1932

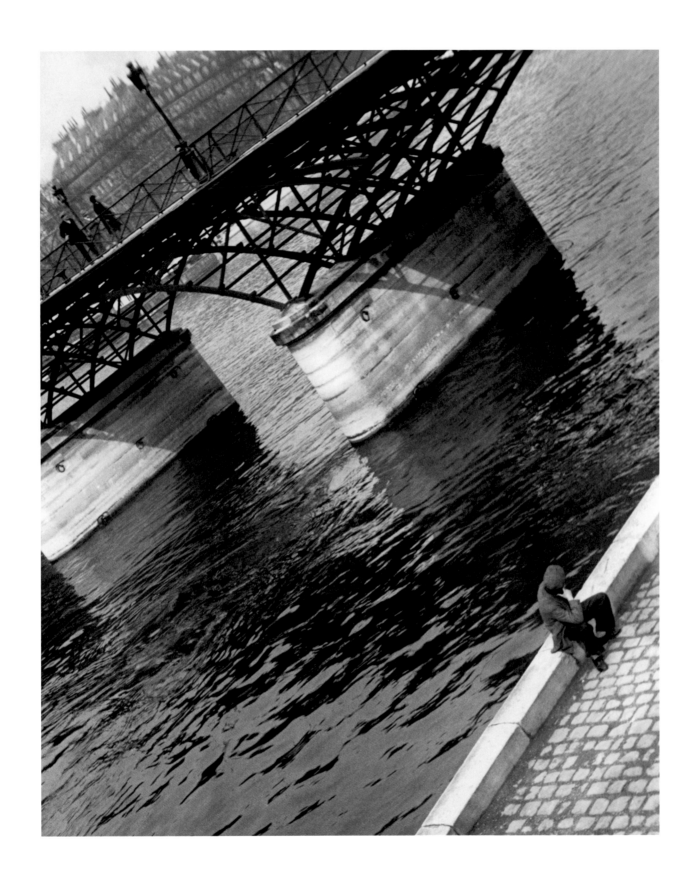

Pont des Arts, Paris, 1931

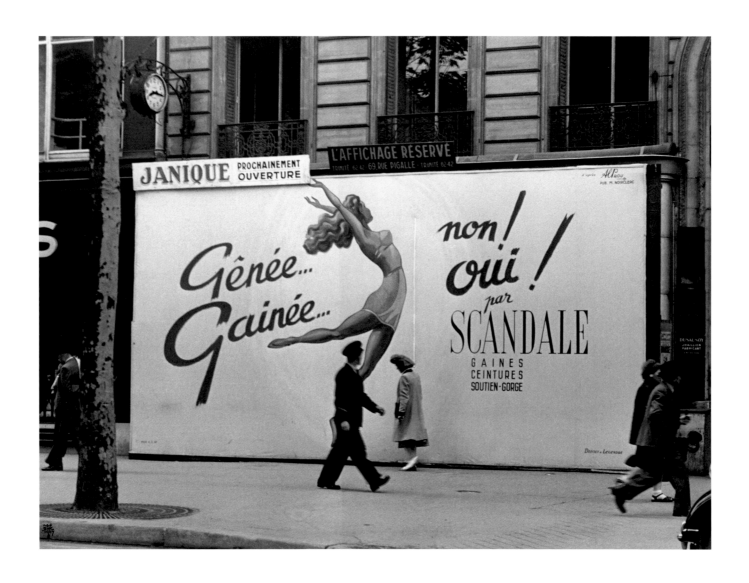

Scandale, Paris, 1947

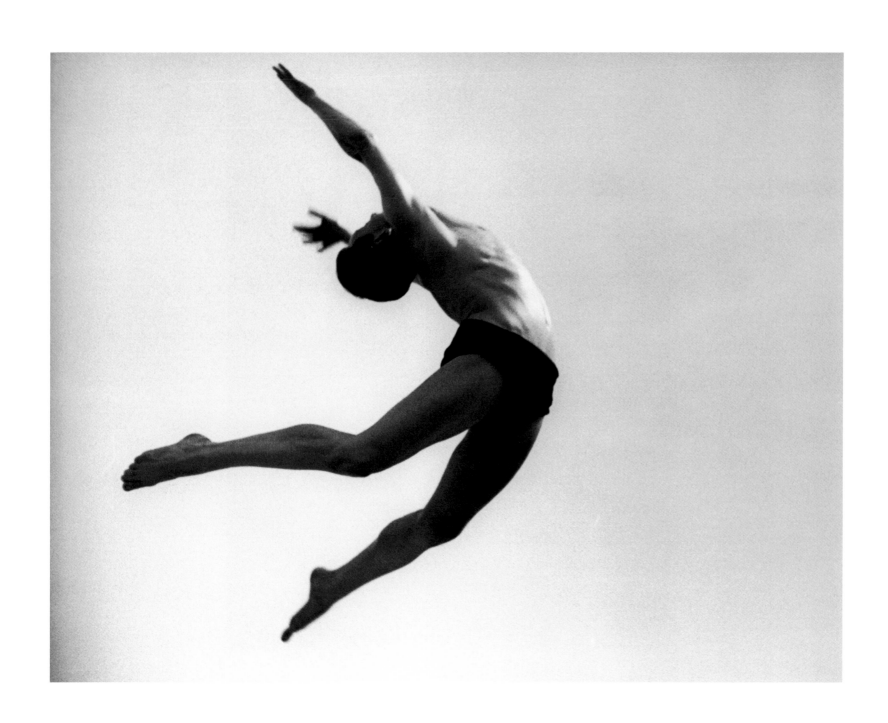

Dancer, Willem Van Loon, Paris, 1932

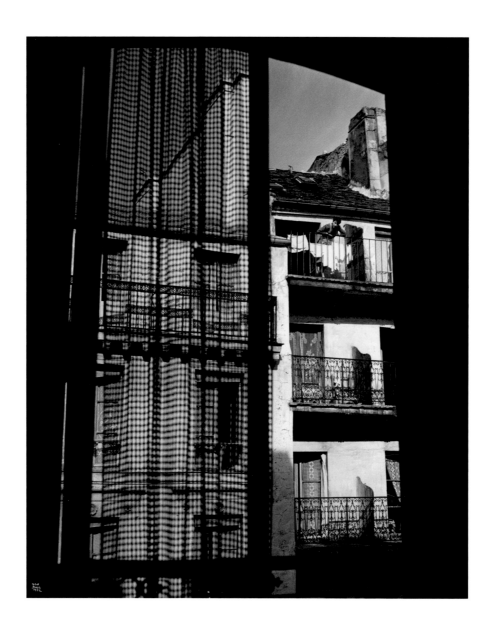

"My Window," Rue de Vaugirard, Paris, 1952

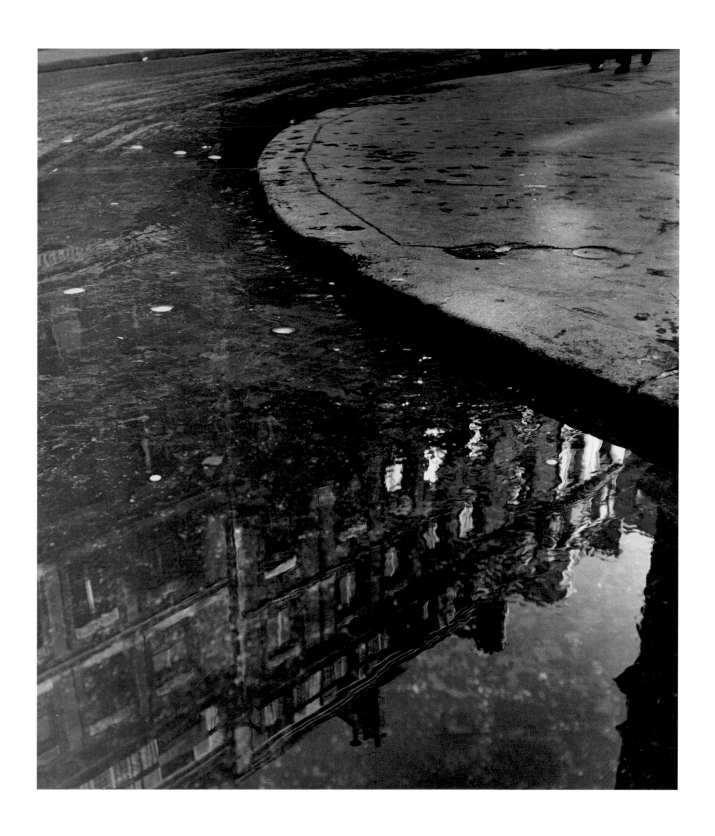

Puddle, Rue de Vaugirard, Paris, 1952

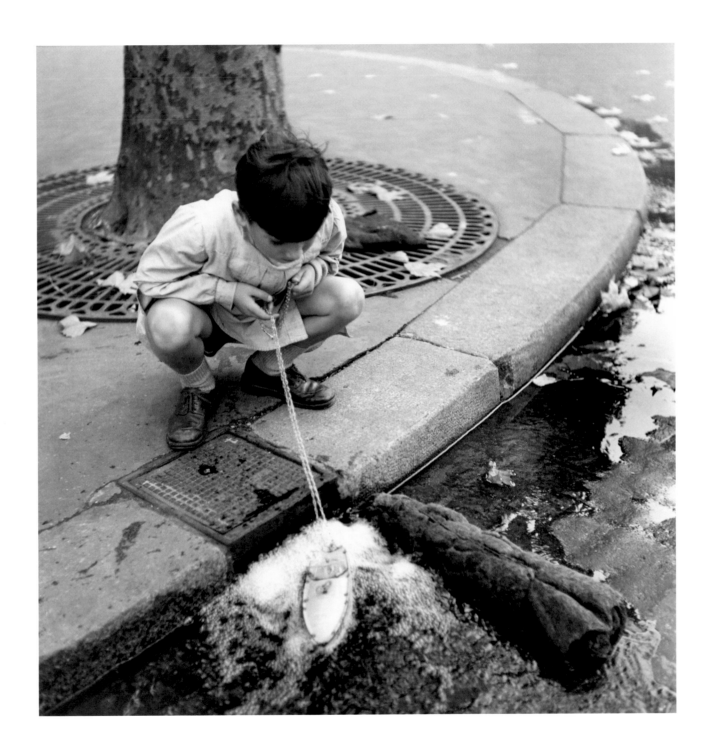

Paris, 1952

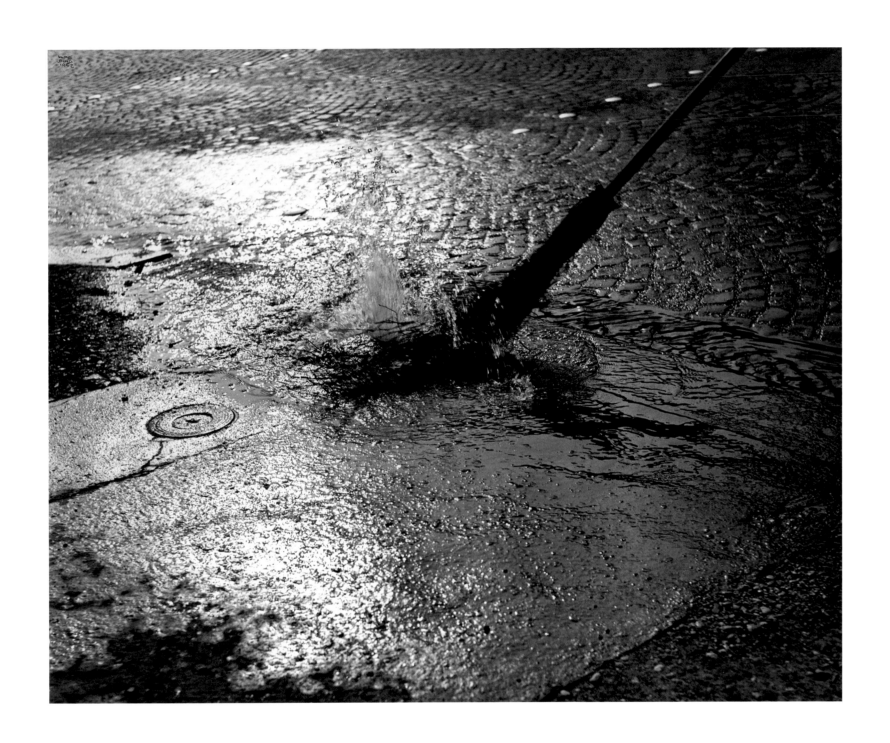

Street Sweeper's Broom, Paris, 1952

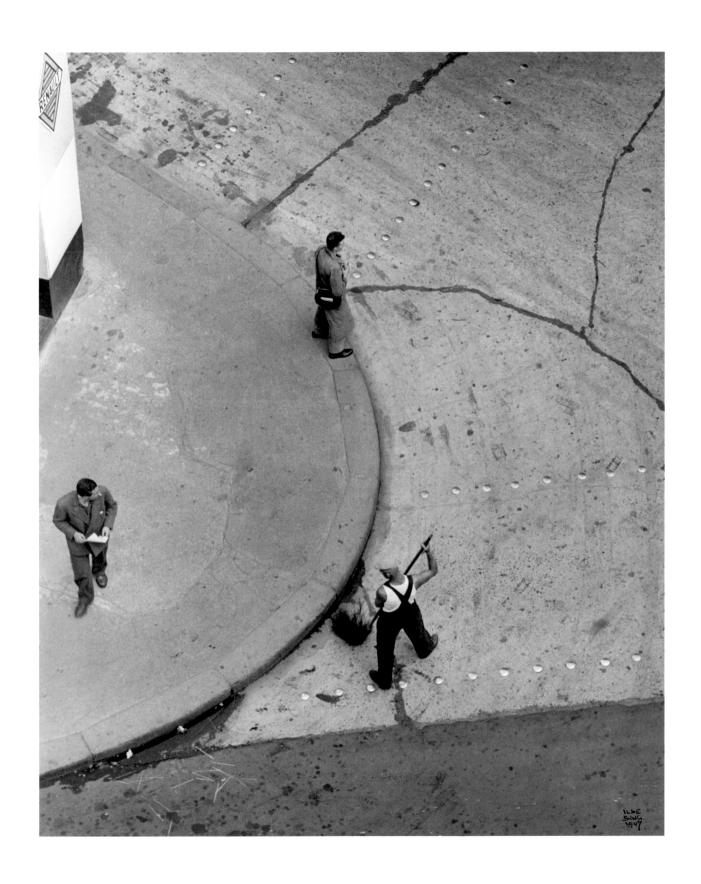

Street Cleaner, Paris, 1947

Storm Clouds over Jewish Cemetery, Frankfurt, 1932

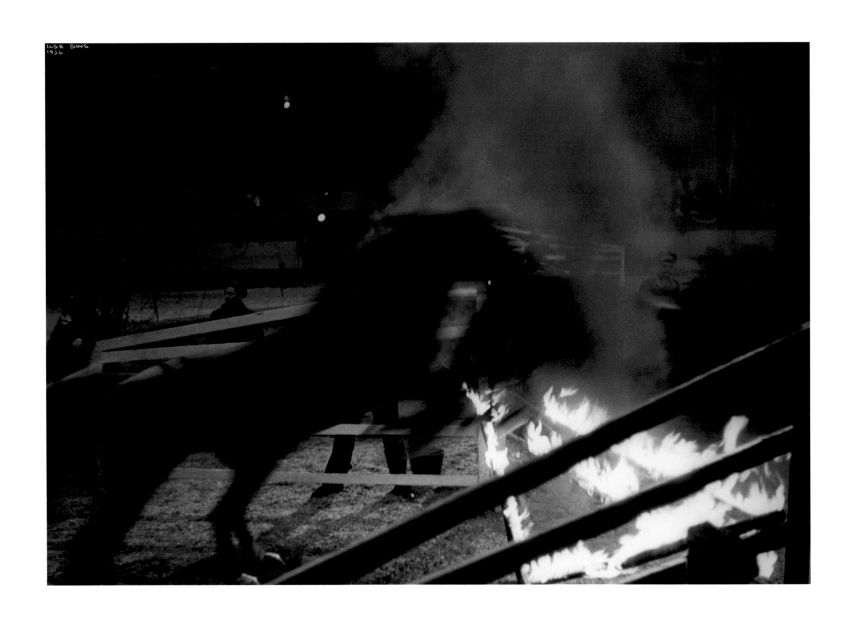

Circus, New York, 1936

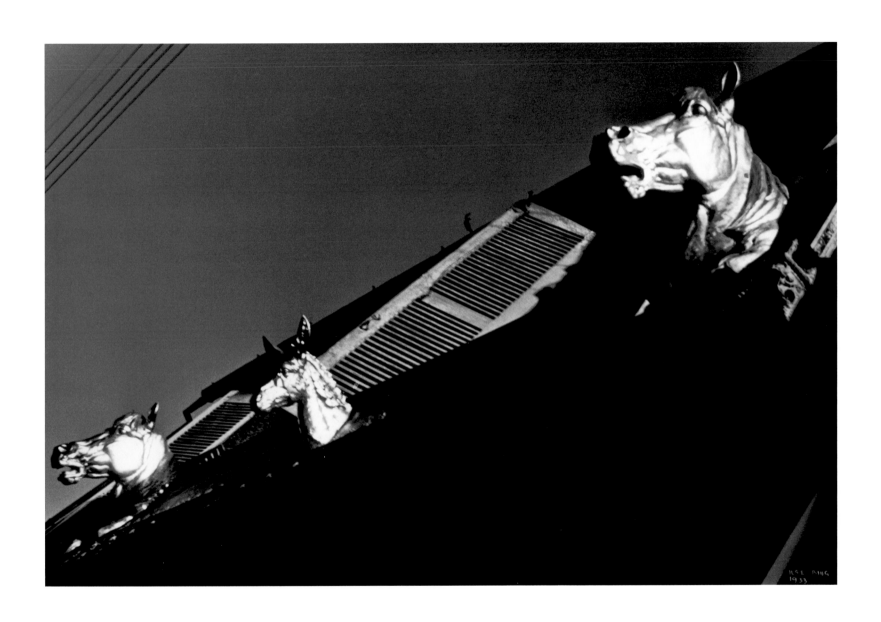

Boucherie Chevaline (Horsemeat Butcher), Paris, 1933

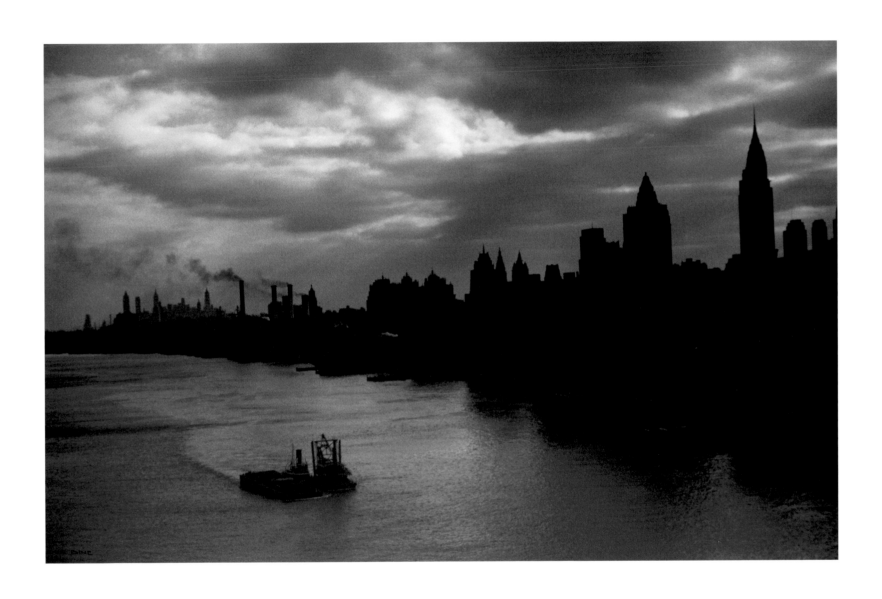

East River with Boat, New York, 1936

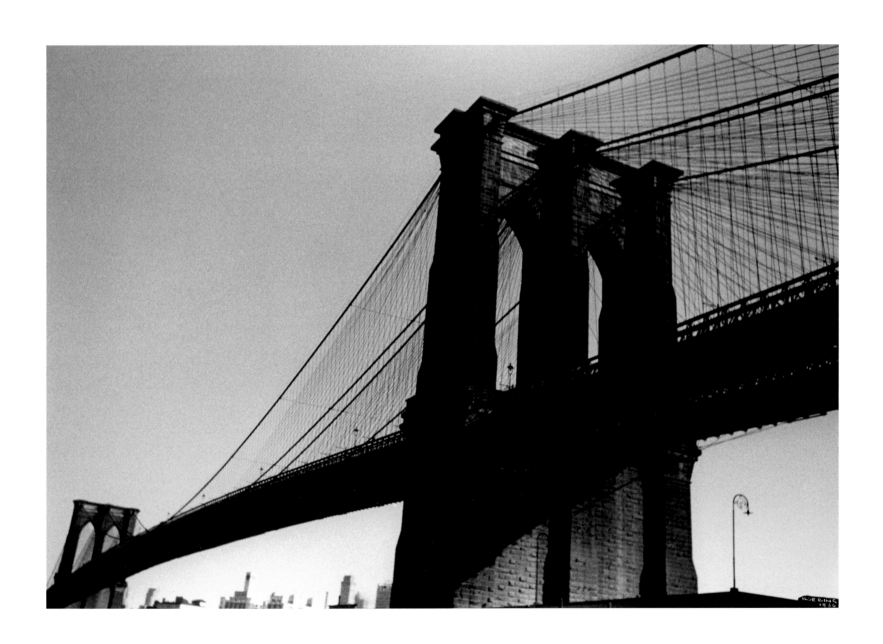

Brooklyn Bridge, New York, 1936

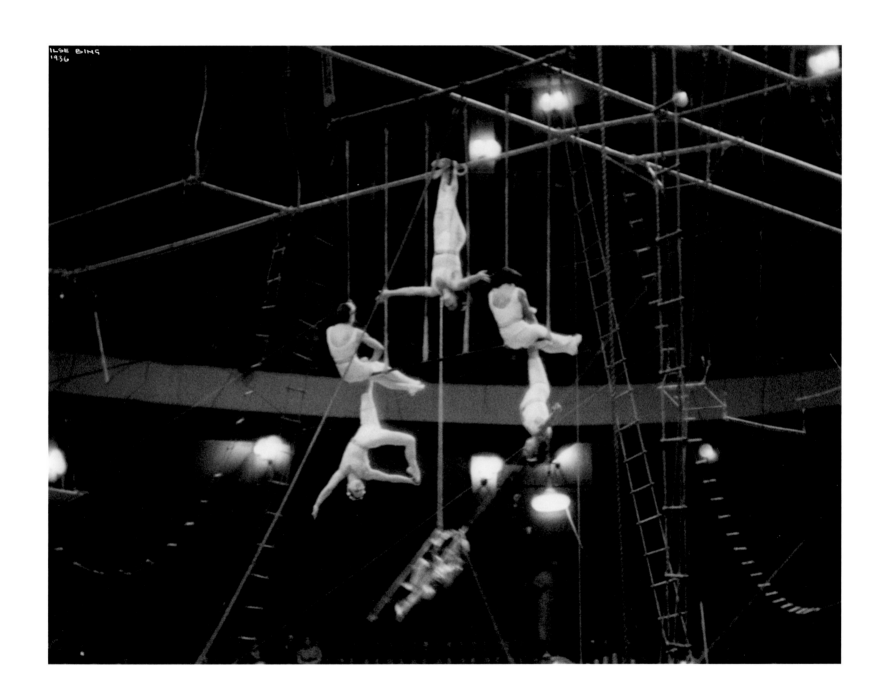

Circus Group, New York, 1936

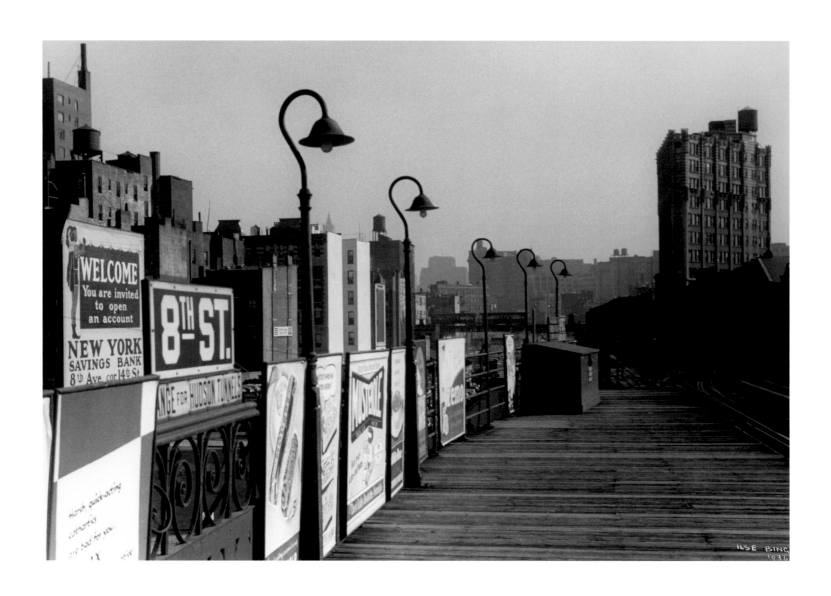

The Elevated, New York, 1936

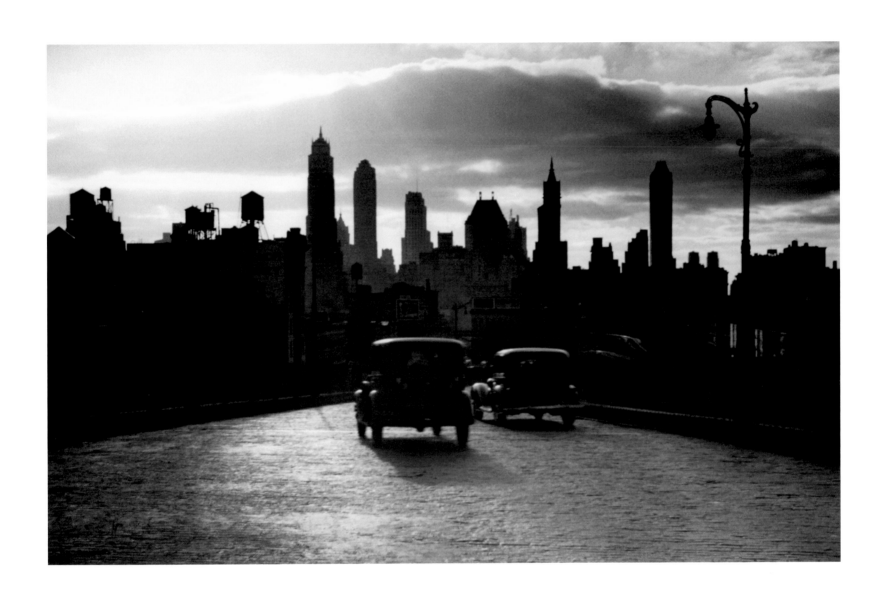

Queensborough Bridge Exit with Two Cars, New York, 1936

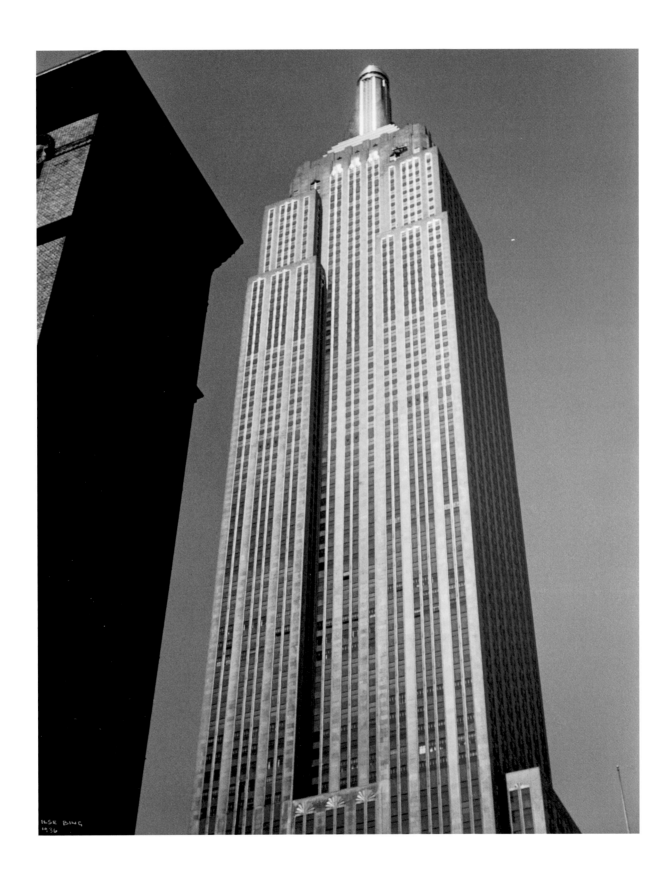

Empire State Building, New York, 1936

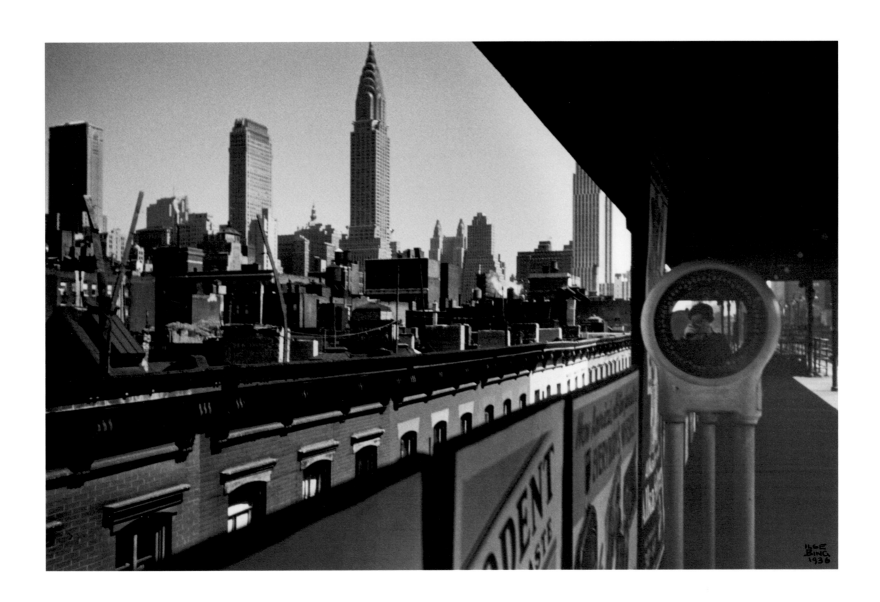

New York, the Elevated, and Me, 1936

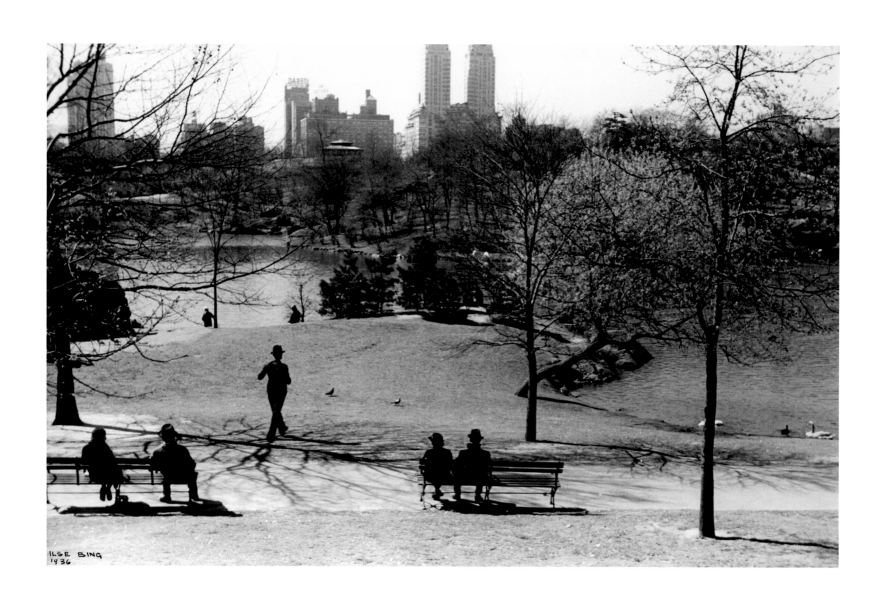

Central Park, New York, 1936

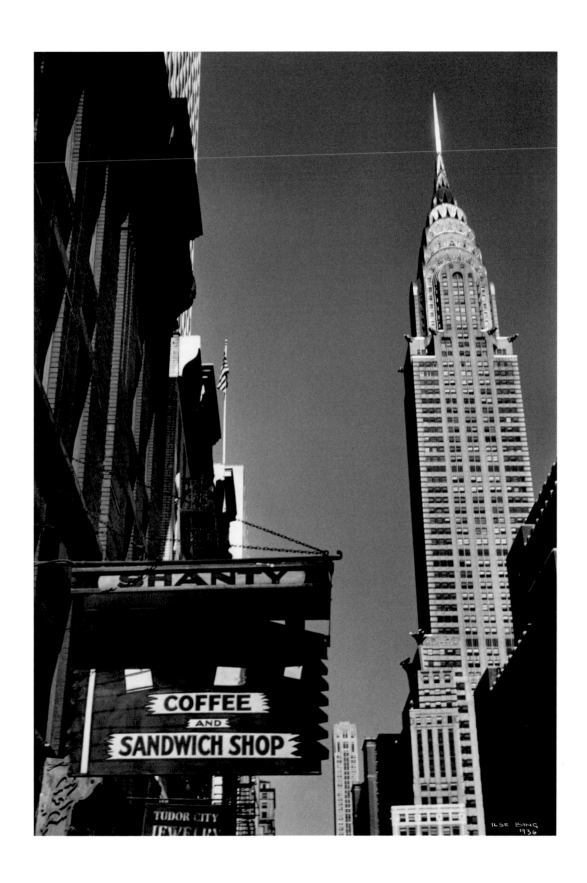

Chrysler Building, New York, 1936

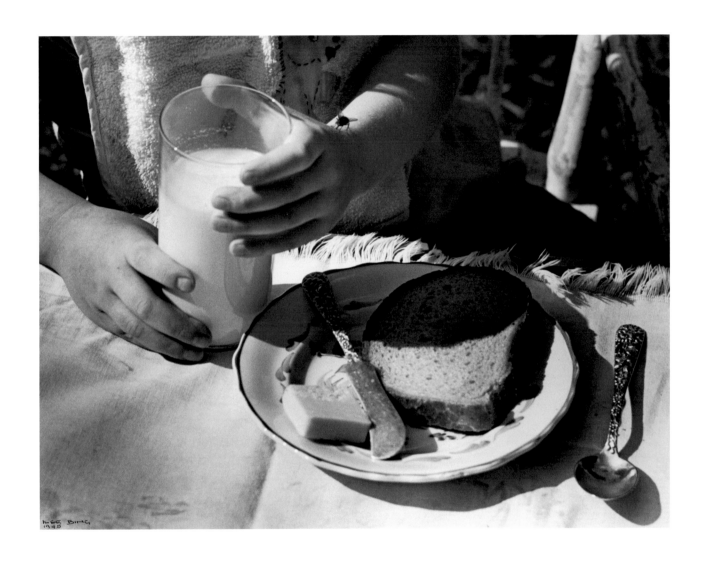

Connecticut, 1945

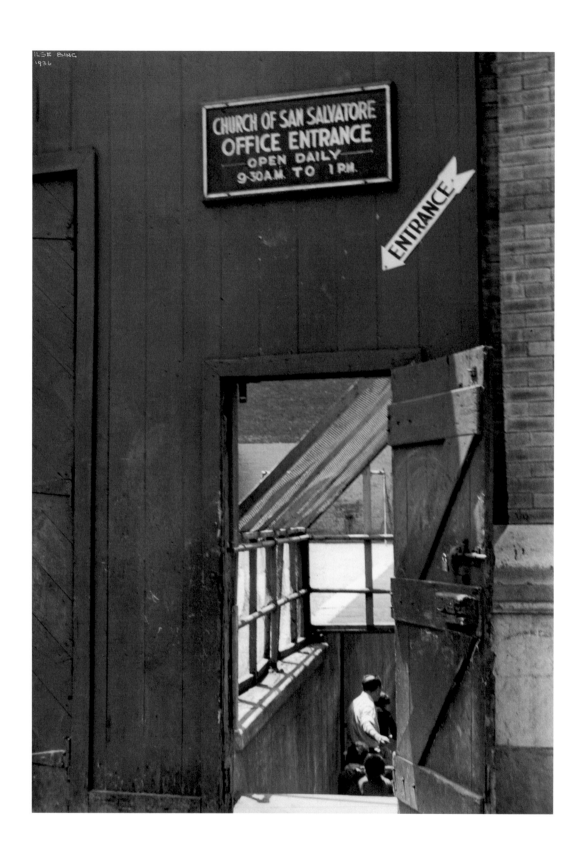

New York, 1936

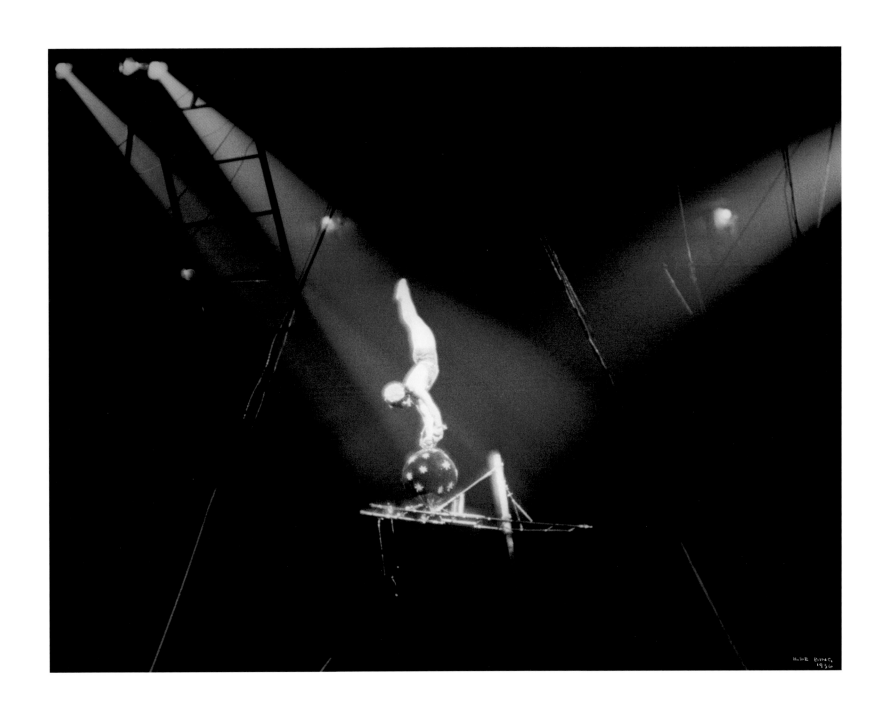

Circus Acrobat with Ball, New York, 1936

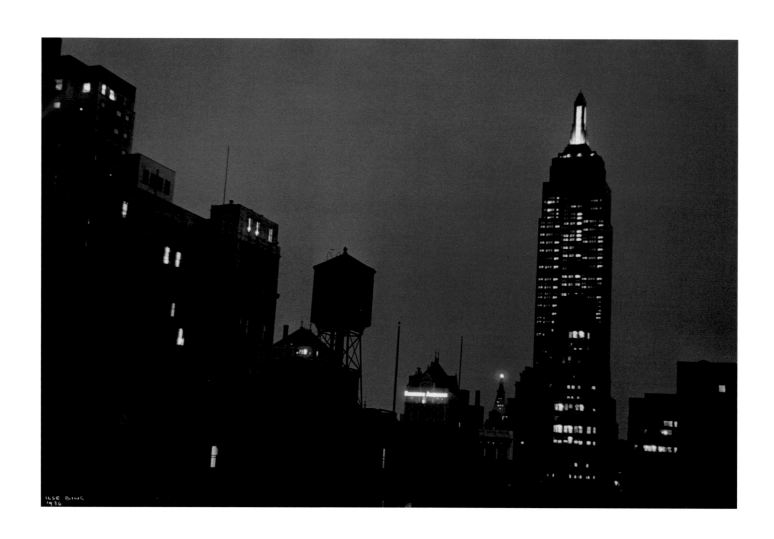

Empire State Building at Night, New York, 1936

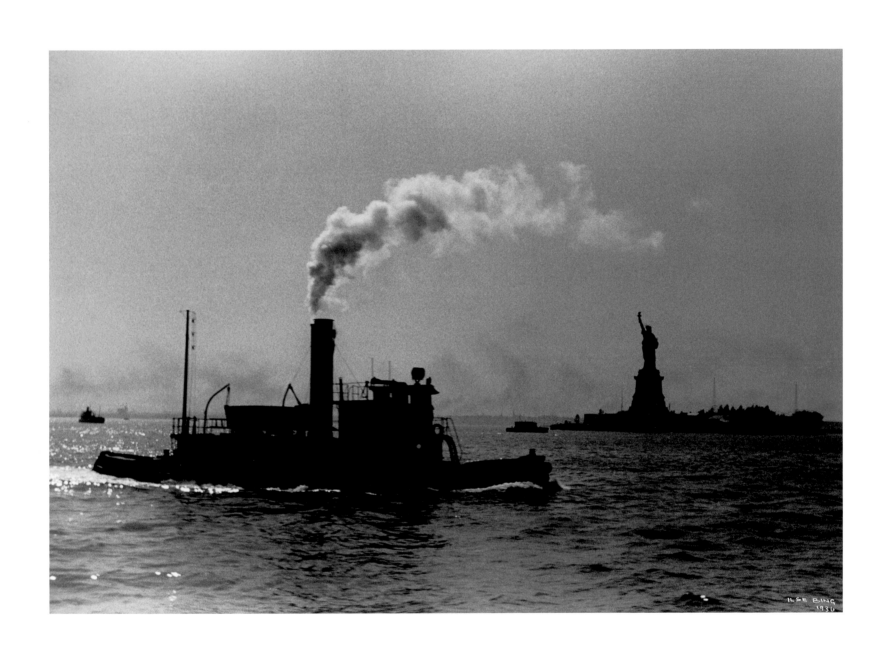

Tugboat and Statue of Liberty, New York, 1936

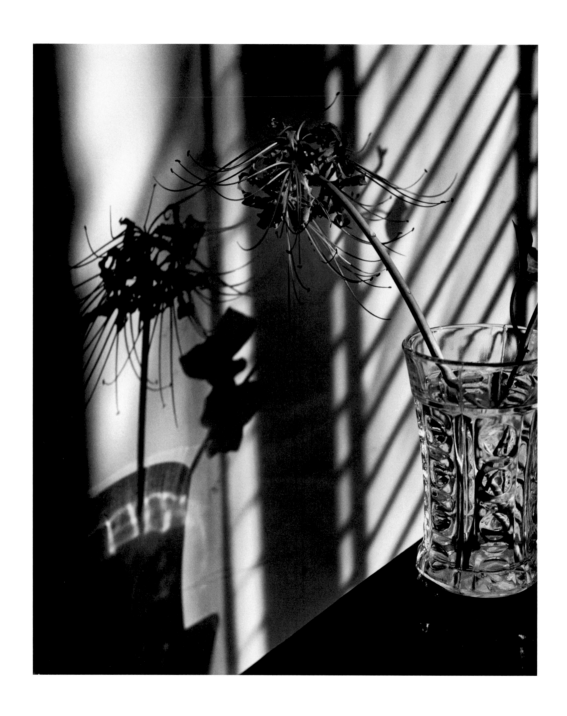

Spider Lily, New York, 1953

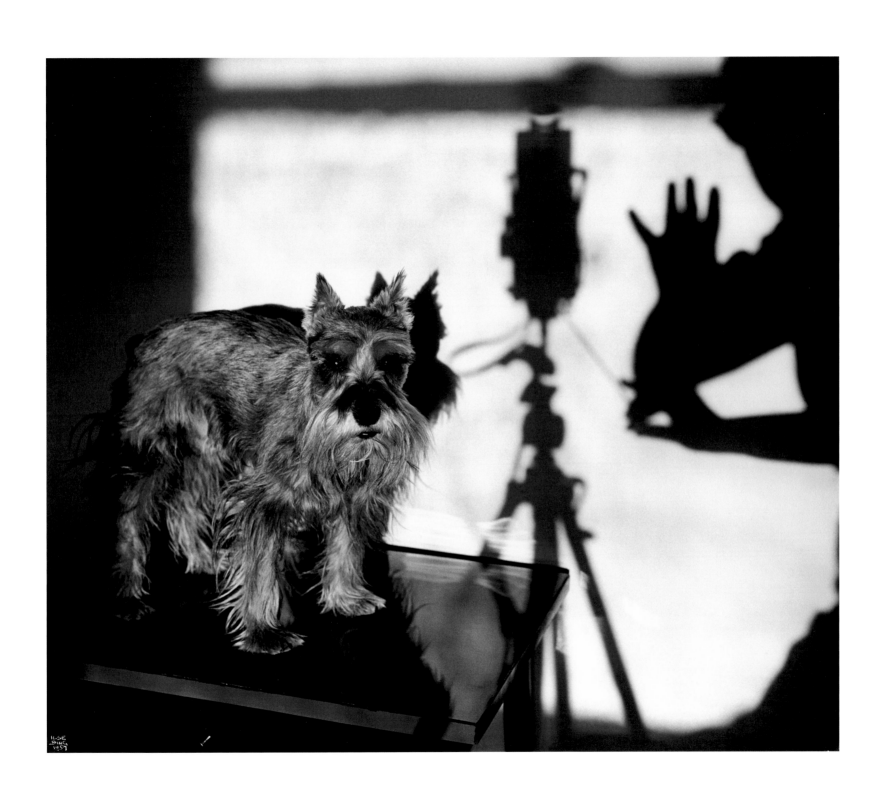

Self-Portrait with Staccato, New York, 1957

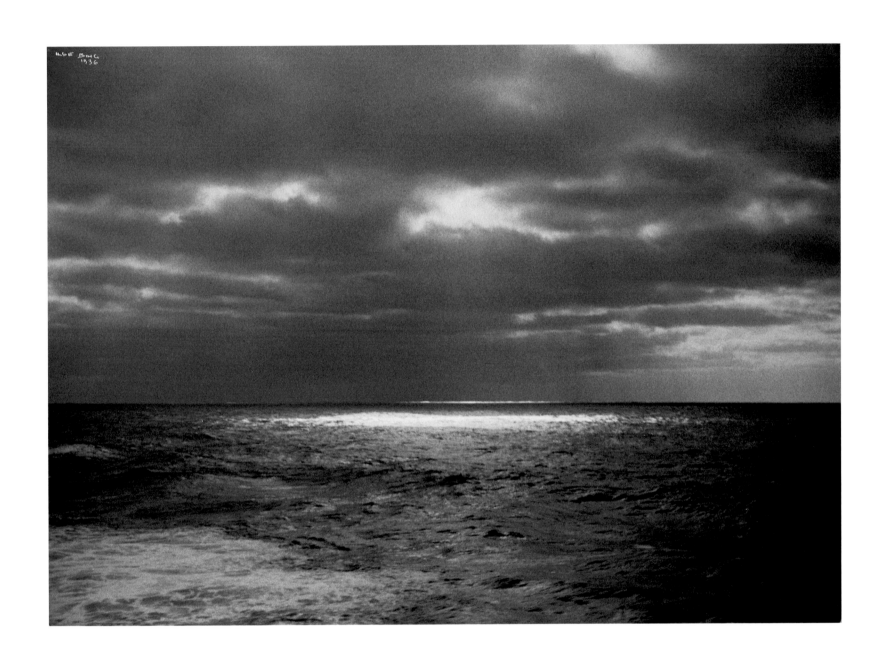

Sun, Clouds, Reflection on Ocean, 1936

ACKNOWLEDGMENTS

This book was made possible thanks to the generous support of the Estate of Ilse Bing, represented by its Executor, Mr. Michael D. Lissner, and with the assistance of Mr. Edwynn Houk.

I am indebted to the friends of Ilse Bing who generously shared with me their recollections of the artist and helped me in the initial stages of my research: first and foremost Madame Françoise Reynaud, Curator of Photography at the Musée Carnavalet; Madame Françoise Friedrich; Mr. Thomas Michael Gunther.

For her advice and guidance, I warmly thank Ms. Gail Buckland.

For their kind support and encouragement, I express my deep gratitude to Ms. Cheryl Pflanzer; Madame Geneviève Anhoury; Madame Dominique Weill; Ms. Lisa Jacobs; Madame Dominique Vellay; Madame Catherine Mathon; Ms. Adrienne Juell; Ms. Tanya Murray; Ms. Jenni Holder; Mr. Peter C. Jones.

I wish to extend my appreciation as well to Ms. Céline Moulard for her attentive supervision of the project, to Ms. Nikki Columbus, and to the staff at Harry N. Abrams, Inc.

And for their enduring patience, I give my greatest thanks to my parents, Joanne and Gerry Dryansky.

—*Larisa Dryansky*

PROJECT MANAGER: Céline Moulard
EDITOR: Nikki Columbus
DESIGNER: Brady McNamara
PRODUCTION MANAGER: Maria Pia Gramaglia

Photographs edited by Edwynn Houk
Quadtone separations by Robert J. Hennessey

Library of Congress Cataloging-in-Publication Data
Dryansky, Larisa.
Ilse Bing : photography through the looking glass / Larisa Dryansky and Edwynn Houk.
p. cm.
Includes bibliographical references and index.
ISBN 10: 0–8109–5546–6 (hardcover : alk. paper) ISBN 13: 978–0–8109–5546–2
1. Bing, Ilse. 2. Photographers—United States—Biography.
3. Photographers—Germany—Biography. 4. Photographers—France—Biography.
5. Photography, Artistic. 6. Art, Modern—20th century. I. Houk, Edwynn. II. Title.

TR140.B47D79 2005
770'.92—dc22

2005021905

harry n. abrams, inc.
a subsidiary of La Martinière Groupe

115 West 18th Street
New York, NY 10011
www.hnabooks.com